This has always been my way,
the life of the city causes me
to recreate my country joys.
If I lived always in the country,
I would not feel the need
of creating an ideal country.

D. W. Tryon, 1916

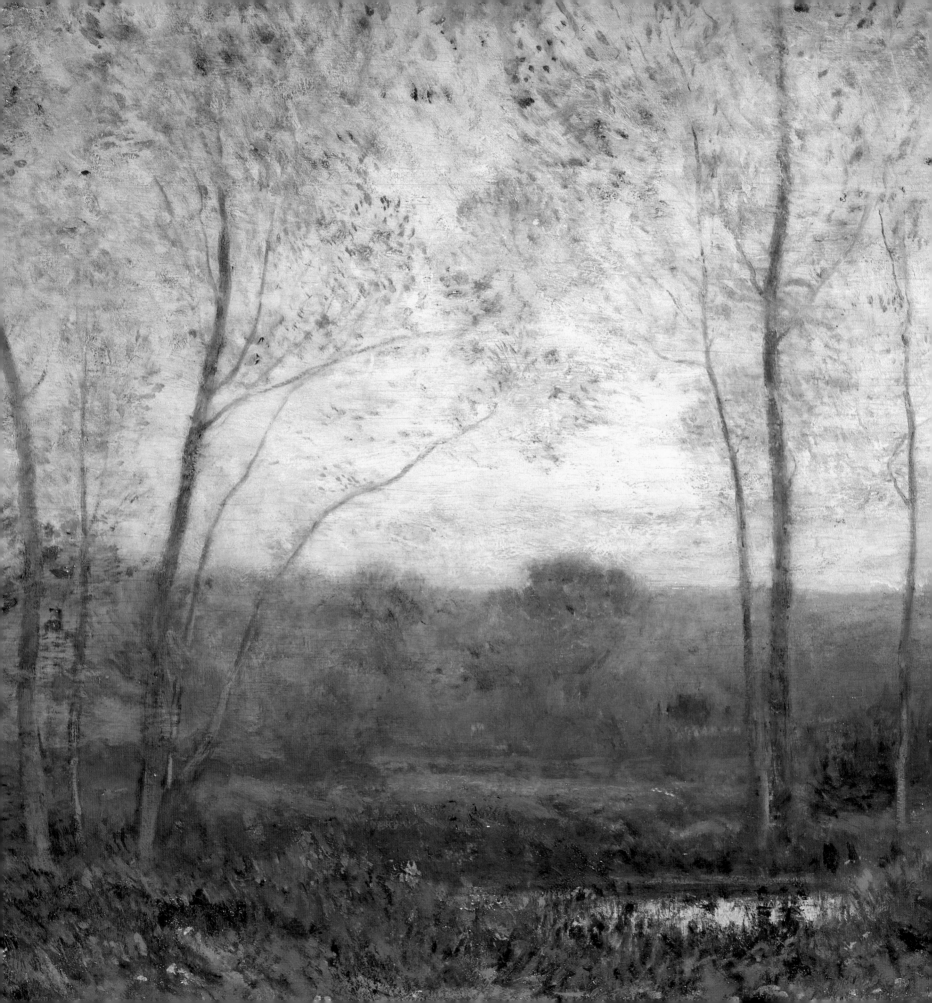

AN IDEAL COUNTRY

Paintings by Dwight William Tryon in the Freer Gallery of Art

❧৸৻❧

LINDA MERRILL

FREER GALLERY OF ART
Smithsonian Institution, Washington, D.C.

Distributed by
University Press of New England, Hanover and London

Cover: Detail of *Sunrise: April,* cat. no. 21.
Frontispiece: Detail of *Evening: September,* cat. no. 42.
Endpiece: "D. W. Tryon Waiting for a Big Catch." Photographic postcard. New Bedford Whaling Museum, Massachusetts.

Library of Congress
Cataloguing-in-Publication Data:

Merrill, Linda, 1959–
 An ideal country : paintings by Dwight William Tryon in the Freer Gallery of Art / Linda Merrill.
 p. cm.
 Includes bibliographical references.
 ISBN 0–87451–538–6 (alk. paper). —
ISBN 0–87451–539–4 (pbk. : alk. paper)
 1. Tryon, Dwight William, 1849–1925—Catalogs. 2. Tonalism—United States—Catalogs. 3. Freer Gallery of Art—Catalogs.
I. Tryon, Dwight William, 1849–1925. II. Freer Gallery of Art.
III. Title.
ND237.T83A4 1990
 759.13—dc20 90–35669
 CIP

The paper used in this publication meets the minimum requirements for the American National Standard for Permanence of Paper for Printed Library Materials, z39.48–1984.

CONTENTS

FOREWORD

CHARLES LANG FREER is best known today as a collector of Asian art, but his interest in Asia emerged from his devotion to a circle of contemporary American artists. Through his friendship with James McNeill Whistler, Freer came to recognize the formal and aesthetic correspondences between certain Asian works and the more familiar art of his own country. Even as his fascination with the arts of China, Japan, Egypt, and the Near East grew, Freer continued to purchase paintings by Whistler and those artists whose genteel style characterized the American Renaissance: Thomas Dewing, Abbot H. Thayer, and Dwight W. Tryon.

The collection of Tryon's paintings and pastels that Freer eventually assembled was second only to his Whistler collection in size and scope; it remains the largest in any museum. Freer was not only Tryon's primary patron but was also his friend. He visited the artist in his New York studio and traveled to his summer retreat in the quiet village of South Dartmouth, Massachusetts, where Tryon found the tranquil landscapes that inspired his contemplative paintings. Scores of letters between patron and painter that survive in the Freer archives constitute a remarkable resource in the field of American art.

When Freer presented his collection to the United States, he stipulated—in hopes of preserving what he considered to be its perfect harmony—that no additions of American art be made. Because he permitted acquisitions of non-American works, the Freer Gallery's Asian art collections have become increasingly prominent in the years since the founder's bequest. The American collection, however, continues to reflect Freer's taste and to shape our understanding of the museum that bears his name.

In 1984 the Freer Gallery exhibited its extensive Whistler holdings and published *James McNeill Whistler in the Freer Gallery of Art* by David Park Curry to commemorate

the 150th anniversary of the artist's birth. The present study, which examines an artist whose work is less well known, is the second in a series of publications and exhibitions intended to give renewed attention to the Freer Gallery's American collections. Linda Merrill, who holds curatorial responsibility for American art at the Freer Gallery, brings to her study of Tryon's art a broad knowledge of late nineteenth-century English and American art and aesthetic theory, and a rare insight into the philosophy behind Freer's collecting. What arise from her exploration of Tryon's accomplishments are an understanding of the artist's tonalist style and an appreciation for the subtle charms of his ideal country.

MILO CLEVELAND BEACH
Director, Freer Gallery of Art and Arthur M. Sackler Gallery

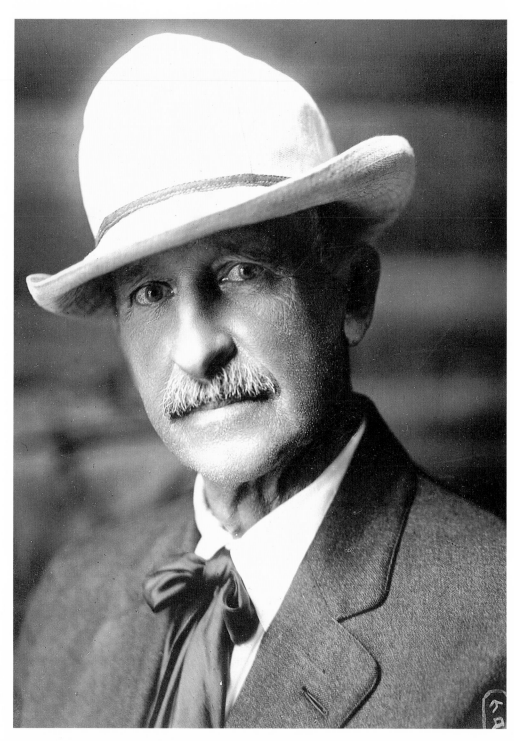

Fig. 1 Dwight W. Tryon (1849–1925), ca. 1923. Tryon Papers/FGA.

PREFACE

ALTHOUGH Dwight W. Tryon is not unknown to historians of American art, he is almost always regarded primarily as an exponent of a stylistic trend called tonalism that flourished from about 1880 through the first decade of the twentieth century. Undoubtedly, Tryon's tranquil landscape and seascape paintings exemplify the tonalist manner, a "style of intimacy and expressiveness, interpreting very specific themes in limited color scales and employing delicate effects of light to create vague, suggestive moods," as Wanda Corn defined it in 1972. But each of the artists identified with tonalism (George Inness, James McNeill Whistler, Thomas Dewing, Alexander H. Wyant, Leonard Ochtman, Henry Ward Ranger, and Birge Harrison, to name a few) developed an individual style, responding in different ways to the challenge of creating intimate, meditative paintings in an unquiet age. Tryon's position among American tonalist painters has been well established in other studies; this one considers his art as the expression of a distinctive aesthetic sensibility arising from his personal experience of nature and fostered by his friend Charles Lang Freer.

The purpose of this book is to introduce the collection of works by Tryon in the Freer Gallery of Art and to relate individual paintings, whenever possible, to the artist's aesthetic intentions as they were conveyed to Freer and other sympathetic friends and patrons. Because the circumstances of Tryon's life and career will be unfamiliar to most readers, a biographical essay precedes the catalogue, which includes entries on all of the Tryon paintings in the Freer collection. In both essay and catalogue I have relied largely on primary source materials, a great strength of the Freer Gallery: the letters, vouchers, press cuttings, photographs, and other papers contained in the archives document the museum's holdings and testify to the tastes and attitudes of a generation of American aesthetes.

An Ideal Country is respectfully dedicated to the memory of Nelson C. White,

1900–1989. The son of Henry C. White, author of *The Life and Art of Dwight William Tryon* (1930), the late Nelson White made his father's papers available through gifts to the Archives of American Art. That generosity encouraged scholarship in the field of late nineteenth-century American art and materially assisted further research into Tryon's art and biography. Soon after I began this project, Nelson and Aida White graciously invited me to their Connecticut home, where I saw an impressive array of paintings by Tryon and heard vivid recollections of the artist and his wife.

I am indebted to the relatives of Dwight and Alice Tryon for illuminating aspects of the artist's character that would not have come to light in the ordinary pursuit of scholarship. Nancy Lincoln Buell and Marjorie Hassell, whose grandmothers were Alice Tryon's sisters, contributed stories passed down through the family about the artist's kindness to children and love of the sea. Mrs. Hassell provided a genealogy, put me in touch with other members of the family, and shared sketches, photographs, letters, and press cuttings; she subsequently presented to the Freer Gallery of Art an important collection of documents relating to Tryon. Carolyn C. Fitch, who inherited the Tryon cottage in Padanaram, also related engaging anecdotes about Aunt Alice and Uncle Dwight and verified legends of Tryon's extraordinary talents as a fisherman.

I remain grateful to my friends at Smith College in Northampton, Massachusetts, who have twice assisted my research. Almost a decade ago, as part of an undergraduate project, I compiled a catalogue of drawings and paintings by Tryon in the Smith College Museum of Art, and a number of people who helped me then recently repeated the process. Helen Searing, who oversaw the initial project, has taken an interest in this one as well. Mary Trott and Maida Goodwin of the Smith College Archives and Diane Lee of the Neilson Library helped me recover the history of Tryon's long and fruitful association with the art department and locate the present whereabouts of his personal library. At the Smith College Museum of Art, Charles Chetham, Louise Laplante, and Ann Sievers made working with the collections a pleasure; and Michael Goodison attended to my constant queries and requests with efficiency and patience.

This project has been assisted by countless colleagues in the field of American art. I have benefited from Mary Ellen Hayward's comprehensive dissertation on Tryon, and Thomas Brunk's meticulously documented article on the Freer house in Detroit. I wish to thank Paul F. Rovetti of the William Benton Museum of Art, University of Connecticut, Storrs, for opening the files of the Tryon retrospective held in 1971; Eugene Gaddis of the Wadsworth Atheneum and Elizabeth Pratt Fox of the Connecticut Historical Society for helping me uncover facts concerning Tryon's life in Hartford; John D. Sanford, archivist of the Albright-Knox Art Gallery, for providing information on Tryon's exhibitions in Buffalo, New York; Kenneth Neal of the University of Pittsburgh

for offering an extensive history of Tryon's association with the Carnegie Institute; Sarah Anne McNear of the Museum of Modern Art, New York, and Anne De Pietro of the Heckscher Museum, Huntington, New York, for answering questions about the work of Edward Steichen; Carolyn Carr of the National Portrait Gallery, Smithsonian Institution, Washington, D.C., for making available copies of catalogues documenting Tryon's exhibits at the Chicago Inter-State Expositions; Lance Mayer and Gay Myers, conservators at the Lyman Allyn Museum, New London, Connecticut, for sharing their knowledge of Tryon's technical methods; J. Gray Sweeney of Arizona State University, Tempe, for supplying a photograph of *Knowledge Is Power* (fig. 68); Jane Calhoun Weaver, for sending me little-known articles by Sadakichi Hartmann; Susan Hobbs, for relating the history of *The Garland* by Thomas Dewing (a work that Tryon once owned) and lending me a photograph of the painting in place in Tryon's New York apartment; Jeffrey Cooley and Robert C. Vose, Jr., for sharing their understanding of the market for Tryon's art; and Richard Kugler and Mary Jean Blasdale of the Whaling Museum in New Bedford, Massachusetts, for showing me Tryon's house and its environs in South Dartmouth. Thomas L. Cheney, whose grandfather partially financed Tryon's trip to France, offered illuminating facts about the artist's early life in Hartford.

I wish to thank the many librarians and archivists who assisted my research at the Library of Congress, Washington, D.C.; the Detroit Public Library, Michigan; the Frick Art Reference Library, New York; and the Inventory of American Paintings and research library of the National Museum of American Art, Smithsonian Institution, Washington, D.C. The following institutions granted permission to quote from unpublished materials: Akron Art Museum, Ohio; Archives of American Art, Smithsonian Institution, Washington, D.C.; The Fuller Museum of Art, Brockton, Massachusetts; Forbes Library, Northampton, Massachusetts; Missouri Historical Society, St. Louis; and Smith College Archives. My work could not have proceeded at all without the resources of the library and archives at the Freer Gallery of Art, where Ellen Nollman, Lily Kecskes, Kathryn Phillips, and Colleen Hennessey helped me identify and locate relevant materials.

Although paintings by Tryon are concentrated in the Freer Gallery and the Smith College Museum of Art, examples can be found in numerous public and private collections across the country. I am grateful to the staffs of the following museums and libraries for making the collections accessible, answering inquiries, and providing photographs and histories of paintings by Tryon: Akron Art Museum; Ball State University Art Gallery, Muncie, Indiana; Museum of Fine Arts, Boston, Massachusetts; The Brooklyn Museum, New York; The Butler Institute of American Art, Youngstown, Ohio; The Carnegie Museum of Art, Pittsburgh, Pennsylvania; The Corcoran Gallery

of Art, Washington, D.C.; The Davenport Municipal Art Gallery, Iowa; The De Saisset Museum, University of Santa Clara, California; The Detroit Institute of Arts, Michigan; The Edward Laurence Doheny Memorial Library, St. John's Seminary, Camarillo, California; Forbes Library, Northampton; The Fuller Museum of Art; Georgia Museum of Art, The University of Georgia, Athens; Grand Rapids Art Museum, Michigan; Indiana University Art Museum, Bloomington; Indianapolis Museum of Art, Indiana; Krannert Art Museum, The University of Illinois at Urbana-Champaign; The Lang Art Gallery, Scripps College, Claremont, California; Los Angeles County Museum of Art, California; Mead Art Museum, Amherst College, Massachusetts; The Metropolitan Museum of Art, New York; Minneapolis Institute of Art, Minnesota; The Montclair Art Museum, New Jersey; Museum of Art and Archaeology, University of Missouri–Columbia; Muskegon Museum of Art, Michigan; National Academy of Design, New York; National Museum of American Art, Smithsonian Institution; New Bedford Free Public Library, Massachusetts; New Britain Museum of American Art, Connecticut; New Jersey State Museum, Trenton; Old Dartmouth Historical Society and Whaling Museum, New Bedford, Massachusetts; Paine Art Center and Arboretum, Oshkosh, Wisconsin; The Pennsylvania Academy of the Fine Arts, Philadelphia; The Philadelphia Museum of Art, Pennsylvania; Princeton University Art Museum, New Jersey; Museum of Art, Rhode Island School of Design, Providence; Memorial Art Gallery of the University of Rochester, New York; The Snite Museum of Art, University of Notre Dame, Indiana; Museum of Fine Arts, Springfield, Massachusetts; Springville Museum of Art, Utah; The Toledo Museum of Art, Ohio; Tweed Museum of Art, University of Minnesota, Duluth; The University of Michigan Museum of Art, Ann Arbor; Wadsworth Atheneum, Hartford, Connecticut; Washington University Gallery of Art, St. Louis, Missouri; Williams College Museum of Art, Williamstown, Massachusetts; The William Benton Museum of Art, Storrs, Connecticut; and Worcester Art Museum, Massachusetts. Among those who shared information about paintings in their collections are: Agnes Shedd Andreae, Gordon T. Beaham, G. P. Mellick Belshaw, Frances Bixby Caldwell, Doug Chambers, Thomas L. Cheney, Mr. and Mrs. Willard G. Clark, Rose K. Coen, Alice T. Enders, Charlotte Cushman Evans, Sally Gross, Lee Harrison, Anne Haughton, Bo Hawkins, James Hill, Jeffrey Lincoln, David A. McCabe, Shirley Beaham Moore, Russell D. Reddig, and Charles H. Talcott.

Thomas Lawton, former director of the Freer Gallery of Art, saw the need for a catalogue of the Tryon collection and initiated the project; his successor, Milo Beach, continued to support my research, and Sarah Newmeyer and Richard Louie were instrumental in facilitating its progress. Many other members of the Freer Gallery staff rendered assistance and expertise: Ann Yonemura offered insight into Tryon's collec-

tion of Japanese prints; Martha Smith patiently removed each pastel from its frame and helped to identify the papers Tryon used; Marty Amt and Jim Smith assisted me with handling the paintings; Gail Price tended to numerous details connected with the preparation of the manuscript; Kim Nielsen and Jim Hayden provided study photos; and John Tsantes took the color photographs. Three undergraduate interns, Liza Martin, Victoria Corbeil, and Jodi Lox, served as research assistants at various stages of the project. Karen Sagstetter arranged for the distribution of the publication; the manuscript was thoughtfully edited by Jane McAllister, and the book beautifully designed by Carol Beehler.

Finally, I wish to thank Wanda Corn for her interest in the project and insightful comments on the text, and Margaret Edson for her constant counsel and encouragement.

<div align="center">⊷§ ξ⊷</div>

All primary source materials are contained in the Freer Papers of the Freer Gallery of Art/Arthur M. Sackler Gallery Archives unless otherwise indicated. Carbon copies of Charles Freer's letters are contained in thirty letter books, indicated LB in the notes; Dwight Tryon's correspondence is numbered. Full references for works cited by author and date of publication can be found in the Selected Bibliography.

Abbreviations

AAA	Archives of American Art
FGA	Freer Gallery of Art
MHS	Missouri Historical Society
NAD	National Academy of Design
SAA	Society of American Artists
SC	Smith College
SCMA	Smith College Museum of Art

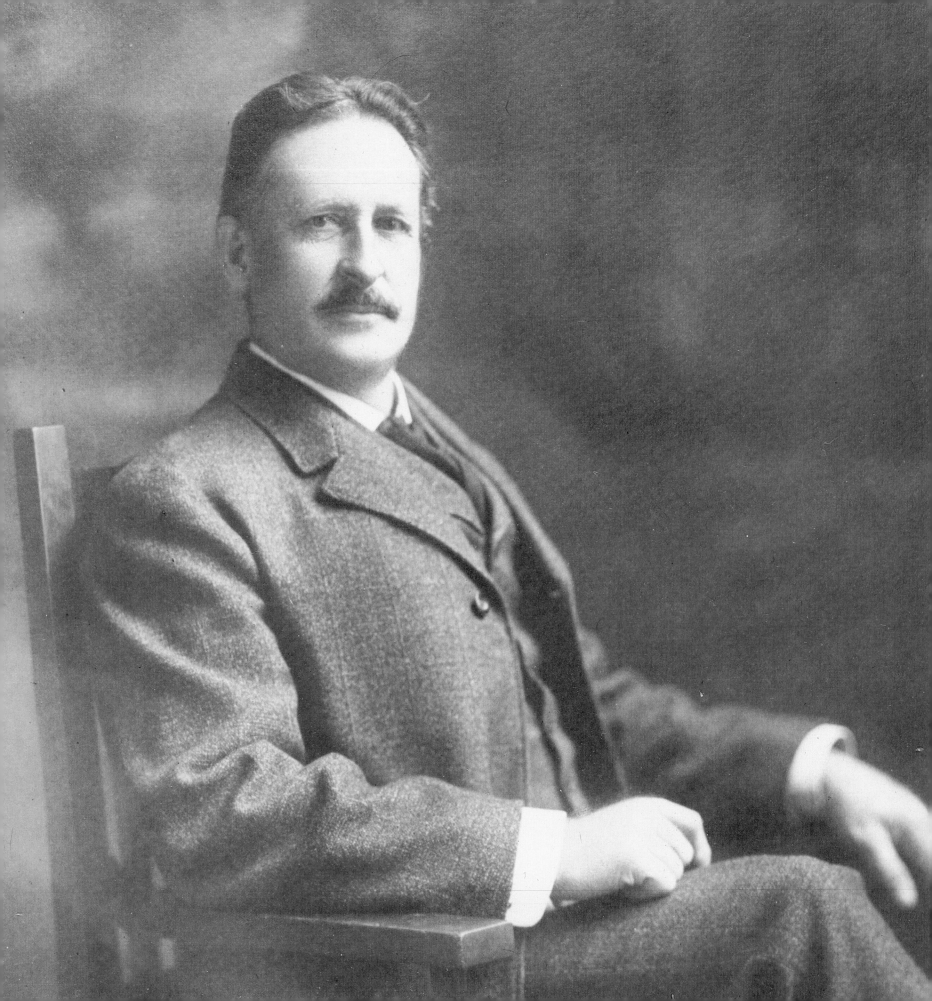

INTRODUCTION

All men are in some degree impressed by the face of the world; some men even to delight. This love of beauty is Taste. Others have the same love in such excess, that, not content with admiring, they seek to embody it in new forms. The creation of beauty is Art.

RALPH WALDO EMERSON, "Nature"

A FEW MONTHS before his fortieth birthday the artist Dwight William Tryon became acquainted with Charles Lang Freer, a businessman from Detroit. Though younger than Tryon, Freer was already on his way to retirement, having made something near a fortune in the manufacture of railroad cars. Tryon was poised to become a painter of landscapes so refined that only those especially susceptible to beauty could appreciate their quality; Freer was about to become a connoisseur of art, and was carefully cultivating his aesthetic sensibilities. The progress of their association from patronage to friendship is reflected in a voluminous correspondence in which business letters directing shipment and payment for paintings gradually become personal: after the artist and his wife spent the Christmas holidays with Freer in 1893, Tryon began to sign his letters, "sincerely your friend."

The first of Tryon's visits to Detroit was in 1892, when he and Thomas Wilmer Dewing undertook the decoration of reception rooms for Freer's new house. Tryon went again in April 1904 to participate in what he called an "artistic debauch"—several days in succession spent studying Freer's art collection; Whistler's celebrated Peacock Room was for sale in London that spring, and it may have been Tryon who finally persuaded Freer to buy it.[1] Freer and Tryon met more frequently in New York, where Tryon spent the winters and Freer came on business or en route to other destinations, and occasionally in South Dartmouth, Massachusetts, where the artist had a summer

Dwight W. Tryon, January 1912. (Detail of fig. 2)

home. "We can promise you a whiff of the salt air," Tryon wrote Freer in 1894, knowing that business was bad, "which will go far toward curing all ills of mind and body and make financial depressions of small account." When Freer visited the Tryons that autumn, he spent a day he would remember as "filled with beautiful impressions and sympathetic companionship."[2]

Particularly when he was in residence at South Dartmouth, Tryon would not have seemed the sort of man for whom the fastidious Freer would feel affinity. Tryon wore clothes renowned for their longevity and frequented a country store where his companions were farmers and fishermen; as a rule, he never went anyplace he couldn't wear his rubber boots to the table.[3] He lived in a cottage furnished with wicker chairs in poor repair, and placed art, for the most part, low on his list of priorities. Tryon missed seeing an important Whistler show in New York one summer, for instance, because he was too busy with his sailboat and the "beauties of the new season" to go to the city for an art exhibit.[4]

But if Tryon was as countrified as Freer was cosmopolitan, the two understood each other so well that Tryon felt they were "connected . . . mentally,"[5] and similarly susceptible to the highest qualities of beauty. "Many times of late while walking about the fields I have thought of you," the artist wrote Freer one day in May,

> specially the past two days while studying the tender tracery of the trees against the sky with the young buds and embryo leaves with their infinite color. It seems almost impossible to find means in terms of paint and panel to express such wonders yet I am always hoping to do so. Only through the sympathetic eyes of others can the finer qualities be understood. This is probably why when confronted by specially rare and beautiful things I always think of a few who have eyes to see.[6]

Freer's sympathetic vision never failed to appreciate Tryon's poetic translations of nature into art: over the course of thirty years he acquired seventy-eight paintings by Tryon in the belief, as he expressed it to the New York art dealer William Macbeth, that the "work of this artist is of a kind calculated to bring much joy to those who possess it."[7] Indeed, Freer considered each purchase to be a gift of inestimable value. "I don't know how I am ever going to do anything for you in return for the great happiness you have added to my life," he wrote Tryon in gratitude.[8]

But the collector discovered countless ways to reciprocate. In 1892 he made available to Tryon twenty-five shares of preferred stock in the newly formed Michigan-Peninsular Car Company; together with Freer's generous patronage, the investment helped to make Dwight Tryon's fortune.[9] It was toward the making of Tryon's reputa-

Fig. 2 Dwight W. Tryon, January 1912. Freer Papers/FGA Archives.

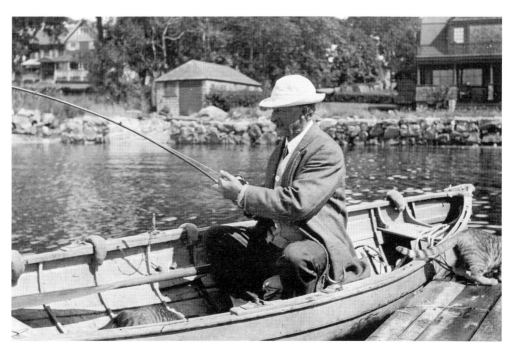

Fig. 3 Tryon fishing in Padanaram, ca. 1923. Tryon Papers/FGA.

tion, however, that Freer concentrated his efforts. Freer allowed works by Tryon in his collection to be shown at important exhibitions and international expositions all over the United States and Europe. Considering himself less the owner than the guardian of these paintings, he was vigilant in assuring their proper appearance in public. He also recommended Tryon's works to worthy art museums and private collectors, occasionally making purchases on their behalf, and commissioned wood engravings after selected Tryon paintings so that adequate reproductions would be available for distribution to the discriminating public. And because he recognized that the popular press demanded illustrations of a "more showy kind" than Tryon's art could offer, Freer underwrote a monograph "intended for lovers of beauty": three hundred copies of *The Art of Dwight W. Tryon: An Appreciation* by Charles H. Caffin were printed in May 1909 for dissemination in "appreciative circles." [10]

Freer's most considerate action in Tryon's regard, however, was providing for the paintings' perpetual preservation in a national gallery together with works of Asian art that were, Freer believed, harmonious in spirit. The plans that Freer and the architect Charles A. Platt devised for the museum included four rooms for the exhibition of American art (in addition to separate galleries devoted to works by Whistler), one of

Fig. 4 Charles L. Freer (1854–1919) at Villa
Castello, Capri, ca. 1900. Albumen photograph.
Freer Papers/FGA.

which was meant to display paintings and pastels by Tryon alone. The Freer Gallery of Art opened in May 1923 with the American galleries arranged according to plan, but by the following January almost all of the paintings by artists other than Whistler had been removed to storage, a situation the Secretary of the Smithsonian rightly believed to be "contrary to the wishes of Mr. Freer and to the spirit of his understanding with the committee of the Board of Regents."[11]

Tryon's displacement was of course inevitable. Even before the inauguration of the Freer Gallery his genteel paintings were beginning to look old-fashioned, and relative to the revelations afforded by the Asian collections Tryon's New England meadows must have appeared ordinary indeed. Although they might have been better appreciated in a different context, Freer's stipulation that the objects in his collection never be sold or even lent for exhibition elsewhere—a provision he assumed would be in the paintings' best interest—meant that Tryon's works, once removed from the walls of the Freer, virtually disappeared from sight.

As Nelson C. White pointed out in the catalogue of a Tryon retrospective held at the University of Connecticut in 1971, Freer's attempt to ensure Tryon's place in a national collection was the first of two ill-fated incidents in the artist's career that happened to defeat the memory they were intended to sustain.[12] The second involved Smith College, where Tryon had taught painting and drawing for nearly forty years; he donated funds to the college for an art museum and bequeathed to the collection a large number of works from every phase of his production. Like the Freer Gallery in Washington, the Tryon Gallery at Smith initially included a room dedicated to the exhibition of Tryon's art, but by 1938, if not before, Tryon's paintings had been replaced, one critic complained, by "modernistic banalities like the geometrical nightmare by Picasso which when first purchased was called 'The Table' and now passes under the elusive title of Abstraction."[13] In the ensuing decades many of Tryon's paintings (together with other late nineteenth-century American works) were sold from the Smith College collection, and in the early seventies the Tryon Gallery itself was demolished to make room for a new museum.

These ironic events undoubtedly assisted the eclipse of Tryon's reputation in the twentieth century, but his were by no means the only works of art allowed to drift toward obscurity in the wake of modernism. Michael Quick observed in a recent essay on the late style of George Inness that the first phases of American art to be rediscovered by scholars were naturally the most accessible—the Hudson River school and American impressionism; an understanding of the poetic painters of the late nineteenth century involves a different approach and presents a greater challenge.[14] Indeed, an appreciation of Tryon's paintings requires not only continued acquaintance but also the

sort of emotional participation that Freer enjoyed, subjective responses that serious scholars hesitate to communicate in print.

Even in his own age Tryon's paintings were difficult to discuss. One contemporary critic justified the artist's neglect by the periodical press in reasoning that his art transcended ordinary language: "We should have to coin our adjectives as he mixes his colors, with many compounds, and they would all have to be qualified adjectives, for his golden-rod is not actually golden, his grass not really green."[15] Freer believed that Tryon's works were simply "above the heads of the public."[16] The artist himself, an elitist in some respects, never expected or even desired popular appreciation. Like James McNeill Whistler, whom he emulated in many ways, Tryon placed little faith in art critics. "Those who understand the psychology as a rule miss the technical side," he told his friend George Alfred Williams, "and those who are sufficiently trained in technique are often weak in analysis." Williams did produce a manuscript on the subject of Tryon's pastels that was "much superior to the general run of art talk," the artist declared, but so far above the heads of the average reader that he doubted it could find a place in a periodical—as evidently it could not, since the essay was never published.[17] After Caffin's *Appreciation* of 1909 no other book-length study of Tryon's work appeared until 1930, when Henry C. White's authorized biography, *The Life and Art of Dwight William Tryon,* was published.

Modern art historians have considered Tryon's art in contexts as varied as French landscape painting and Asian art.[18] Wanda Corn's pioneering essay in *The Color of Mood* established his place among American artists who "confronted nature as a private and extremely personal experience," a tendency she named "tonalism."[19] Others have titled Tryon's contemplative, nostalgic, poetic style "quietist" and "intimist," suggesting the qualities of "repose, suavity, moderation, and the gentle key of color synthetized [*sic*] to a tone as pure as it is transparent" that Royal Cortissoz assigned to Tryon's art in 1895: "It is [Tryon's] belief that true art never enforces itself upon the beholder, but drifts as quietly as it does irresistibly into the mind."[20] Tryon's gentle art does not demand attention but repays it unfailingly, resting modern minds as it soothed the souls of the Gilded Age. "It may not satisfy you," the critic Frederic Fairchild Sherman observed in 1917, "may not be food for your thought or light to your path, but unless you are blind surely you cannot fail to sense its beauty."[21]

Notes

1. White 1930, 80. *Harmony in Blue and Gold: The Peacock Room* (now in the FGA) was offered to Freer in January 1904 but not purchased until May.

2. Tryon to Freer, 17 June 1894 (60); Freer to Tryon, 7 September 1894, Nelson White Papers/AAA.

3. White 1930, 115–16.

4. "Contents of House at South Dartmouth, Mass." and "List of household effects conveyed to Trustees of Smith College by Bill of Sale dated April 14, 1920, from Dwight W. Tryon and Alice B. Tryon," appraisals by Henry C. White, 11 July 1925, SCMA documentary files; Tryon to Freer, 21 May 1894 (59).

5. Tryon to George Alfred Williams, 16 September 1923, Nelson White Papers/AAA. Tryon also wrote of sending Freer "telepathic letters" (Tryon to Freer, 7 August 1918 [209]).

6. Tryon to Freer, 1 May 1913 (171).

7. Freer to W. Macbeth, 6 March 1893 (LB 1). Freer eventually gave away six works by Tryon; seventy-two remain in the FGA collection.

8. Freer to Tryon, n.d. [September 1894], Nelson White Papers/AAA.

9. Tryon to Freer, 22 July 1892 (33), 7 August 1892 (34), and 27 August 1892 (36); Freer to Tryon, 3 August 1892 (LB 1).

10. Freer to N. E. Montross, 15 February 1909 (LB 26); Freer to Tryon, 15 February 1909 (LB 26); Freer to Caffin, 27 April 1909 (LB 27). Because the plates taken from paintings in Freer's collection did not meet the patron's standards, no second edition was issued, and the book's distribution remained limited to a select few (Freer to J. M. Bowles of the Forest Press, 17 March 1910 [LB 29]). Sandra Lee Underwood provides further information on Charles Caffin's art criticism in *Charles H. Caffin: A Voice for Modernism, 1897–1918* (Ann Arbor: UMI Research Press, 1983).

11. Charles D. Walcott (Secretary, Smithsonian Institution) to John E. Lodge (director, Freer Gallery of Art), 8 February 1924, in Smithsonian Institution, *Material Papers Relating to the Freer Gift and Bequest* (Washington, D.C.: Smithsonian Institution, 1928), 51.

12. Nelson C. White, "D. W. Tryon: The Man," in Connecticut 1971, 11–13.

13. [Alfred Vance Churchill], "The New Building in Use," *Bulletin of Smith College Museum of Art,* June 1927; Loring Holmes Dodd, "College Benefactor Artist of World-Wide Fame," *Worcester* (Mass.) *Sunday Telegram,* 27 November 1938, Tryon Papers/SC Archives.

14. Michael Quick, "The Late Style in Context," in Cikovsky and Quick 1985, 64 and 67.

15. "American Studio Talk," *International Studio Supplement* (March 1900): iii–iv.

16. Freer to Tryon, 15 February 1909 (LB 26).

17. Tryon to G. A. Williams, 24 January 1923, Nelson White Papers/AAA. A typescript copy of Williams's manuscript, "The Pastels by Dwight William Tryon: An Appreciation" [1924], is in the Nelson White Papers/AAA.

18. See Bermingham 1975, 63–65, and Hayward 1979, 107–42.

19. Corn 1972, 1. William Gerdts provides an overview of American tonalism—both its history and historiography—in Gerdts, Sweet, and Preato 1982, 17–28.

20. Richardson 1956, 306; Quick, "Late Style," in Cikovsky and Quick 1985, 67; Cortissoz 1895, 170.

21. Sherman 1917, 66.

LINES IN PLEASANT PLACES
The Life and Art of Dwight W. Tryon

My lines have been cast in pleasant places.

<div align="right">DWIGHT W. TRYON</div>

DWIGHT TRYON's luck was legendary. If he fell down a sewer, people used to say, he would find a gold watch at the bottom.[1] Tryon, however, did not leave happiness to chance, but consciously mastered the art of living. Calculating his existence as carefully as he balanced the rigging of a sailboat or arranged the forms of trees across a canvas, the artist spent summers in the country and winters in the city making the most of every season, so that life to him at seventy-three was as interesting as ever, and painting continued to possess the excitement, he said, "of sport beaten to a frazzle."[2] His art, however, is characterized by composure, his biography by contentment. "I know no one who gets more pleasure or less woe," Charles Freer said, recognizing Tryon's tranquil paintings as revelations of a happy state of mind.[3]

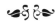

ALTHOUGH Tryon included few recollections from childhood in the biographical notes he prepared during the final months of his life, he did remark that his most pleasant memories were of a shaded stream near the village schoolhouse where, abiding by his mother's admonition never to swim more than once a day, he spent Saturdays from morning till night.[4] The image is laden with nostalgia for a perfect past Tryon seems not to have had. His father Anson, a builder and craftsman from Glastonbury, Connecticut, who specialized in modeling plaster ornaments, was killed by his own gun in a hunting accident when Dwight was nearly four—old enough to remember, though

Detail of *Fishing* (fig. 31), ca. 1880.

Fig. 5 Tryon's boyhood home, ca. 1920. Henry White Papers/AAA.

in later years he recollected that the episode occurred when he was "about two."[5] The only clearly discernible effect of this event on Tryon's later life was an abhorrence of hunting for all his love of fishing;[6] but if Anson had lived, the boy might well have become a mason like his father.

As it happened, Dwight was brought up by his mother, Delia O. Roberts Tryon, who would be described in her obituary as an "estimable lady, with a large circle of relatives and friends."[7] After her husband's death Delia took Dwight to her parents' house in a section of East Hartford called Hockanum, where her father, a former shipbuilder, tended a small farm.[8] In his reminiscences, Tryon said little about her personality, mentioning only occasional spells of wrath from which he was shielded by his Aunt Martha; at the age of four he would not have recognized expressions of grief. It may have been Delia Tryon's loneliness and sorrow, however, that induced her to wander alone through woods and fields, as Tryon's biographer Henry White relates, to "brood upon the mystery of dawn, evening, and moonlight, responsive to the changing moods of hour and season."[9] Tryon would eventually adopt the practice himself, having inherited his mother's sensitivity to nature. From an early age he spent hours sketching scenes around Hockanum. Tryon particularly remembered drawing a picturesque gristmill and a farmhouse set in front of maple trees, but his favorite subjects to

depict were the sloops, schooners, and scows on the Connecticut River, less than a mile across the meadow from his grandfather's house. Tryon's precocious talent did not go entirely unobserved: on a trip down the Hudson when he was ten years old, his drawing of an island inspired a "decided enthusiasm" among the other passengers.[10]

Despite a preference for art and leisure, Tryon managed to acquire a "little Latin and less Greek," he said, before leaving school at the age of fourteen to move with his mother to the city, where he would be expected to support them both. Hartford was prosperous in 1863, with business booming from the war, and Tryon took a job at the flourishing Colt's Firearms Factory. He also enrolled in evening classes at Hannum's Business School, and displayed such a talent for calligraphy that before long he was able to supplement his income by lettering visiting cards and engrossing diplomas. The desire to emulate examples of expert penmanship provided one of the first motives of Tryon's career; years later he would observe a connection between the "pictographic writing of the Japanese and the amazing fluency of their ink painting."[11] A pen-and-ink drawing after an illustration to "Rip Van Winkle" (fig. 6) suggests that he was already applying his calligraphic skill to pictures.

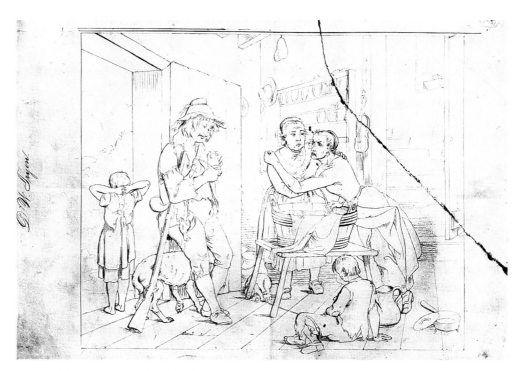

Fig. 6 After an engraving by F. O. C. Darley (1822–1888), *Rip Van Winkle's Return*. Pen and ink on paper. Henry White Papers/AAA.

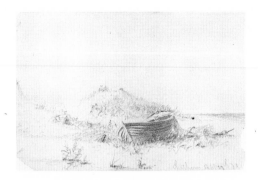

Fig. 7 *A Beached Dory,* 1873. Graphite on paper, 5 9/16 × 8¾ in. (14.2 × 22.2 cm). Smith College Museum of Art (1916:11–1A); Gift of Dwight W. Tryon.

Fig. 8 Sketch of a sailboat. Graphite on paper, 4⅞ × 7⅜ in. (12.3 × 19 cm). Tryon Papers/ FGA.

Tryon's lack of a formal education scarcely impeded his progress: at the close of his career, after receiving an honorary degree from Smith College, he declared that the "work any real artist goes through before he can become a power is much more than the equivalent of any college course"—that knowledge was not necessarily derived from books.[12] Tryon admitted, nevertheless, that his "serious education" began only after he left the manufacture of firearms in 1864 to become clerk and bookkeeper at the finest bookstore in Hartford, where he commenced a methodical course of reading during summer months, when business was slow. Brown & Gross, Booksellers, also afforded introductions to the Hartford literati who congregated there. Over the years Tryon became acquainted with Harriet Beecher Stowe, Charles Dudley Warner, and Samuel L. Clemens, with whom he played billiards from time to time.[13] And in the wealth of illustrated books that surrounded him, Tryon discovered a "new world of beauty."

The next decisive event of Tryon's youth was an exhibition in the Wadsworth Atheneum picture gallery of works by the "most celebrated Ancient and Modern Masters." Owned by James G. Batterson, the first president of the Travelers Insurance Company, the collection was distinguished and eclectic (the catalogue promised "original works of the Italian, Flemish, French, German, Düsseldorf, Belgian and English Schools, many of which have had places in European galleries of great celebrity"), including paintings by Nicholas Poussin, Claude Lorrain, Rembrandt, Jacob van Ruysdael, and Albert Bierstadt.[14] Tryon's autobiographical notes contain a jumble of recollections, as if even in memory the effect of the exhibition was overwhelming. He recalled pictures of skaters on frozen canals; still-life and genre paintings; coastal scenes and marine views; and a vision of cattle grazing in sunny meadows.[15] Neither the Italian nor the French paintings in the collection appears to have made any impression upon Tryon, though he was irresistibly attracted to the humble Dutch pictures, which may have reminded him of scenes around East Hartford. As a mature artist, Tryon would admit that the paintings in Batterson's collection were not, in fact, exceptionally fine works of art. But the fifteen-year-old beheld in them "all that was wonderful and inspiring." As a consequence of that assorted exhibition, Tryon became fired with ambition, he said, to produce paintings of his own.

Aside from the Batterson show, Tryon had little to say about art in Hartford. Curiously, the Wadsworth Atheneum hardly figures in his recollections. Perhaps he hoped to defeat the idea that he had derived inspiration from the magnificent works on display there: in addition to two views of Niagara Falls by John Trumbull, Tryon could have seen landscapes by Frederic Edwin Church and as many as seven works by Thomas Cole—paintings an aspiring artist would find difficult to overlook.[16] That

Fig. 9 *Little Bay,* 1872. Watercolor on paper, 6 × 10 in. (15.2 × 25.4 cm). The New Britain Museum of American Art, Connecticut; Charles F. Smith Fund.

Delia Tryon became employed by the Atheneum as custodian in 1867 adds a sentimental dimension to the picture of a young artist lingering before masterpieces of American painting, and Tryon's artistic inclination has been ascribed, accordingly, to her presence in the museum.[17] But Dwight probably stimulated his mother's interest in art rather than the other way round, for by the time he was eighteen years old Tryon's love of landscape painting was already well established.

According to his own account, Tryon learned by the book the principles of painting, using sources in stock at Brown & Gross, where he practiced art in spare moments. A fellow clerk at the bookstore, Leverett Belknap, remembered that Tryon's desk was always littered with sketches, mostly of boats (see figs. 7 and 8), which Tryon would later call "curiosities" from "prehistoric times."[18] From charcoal and pen-and-ink drawings Tryon progressed to watercolor paintings (see fig. 9); from watercolor to oil, he said, was a small step forward. He gathered material on Sundays and holidays, when he would row a boat down the Connecticut River to sketch the scenery of his childhood, and return from Hockanum in the evenings on foot.[19] His custom of storing impressions for later use was cultivated from necessity: with so little time to sketch from nature, Tryon said, he "formed the habit of painting from memory."

In 1870, when Tryon began to show his work in public, a young artist named William Bailey Faxon noticed a small Venetian marine on display in the window of a local frame merchant. Tryon's painting, inspired by a reproduction of a work by

Fig. 10 Dwight W. Tryon, ca. 1872. Albumen carte de visite. Tryon Papers/FGA.

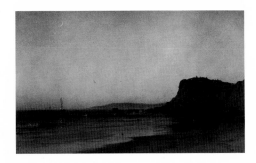

Fig. 11 *Twilight on the Maine Coast,* 1874. Oil on canvas, 18 × 30 in. (45.7 × 76.2 cm). Smith College Museum of Art (1930:3–112); Bequest of Dwight W. Tryon.

J. M. W. Turner, appealed to Faxon, who was exactly Tryon's age. After a bit of negotiation Faxon bought it as a twenty-first birthday present to himself;[20] that ten-dollar sale inaugurated Tryon's career as a professional artist. Two years later he officially entered the local art community as secretary of the Hartford Art Association, contributing six paintings to its first annual exhibition at the Charter Oak Life Insurance Building and two more the following year to the exhibition of the Connecticut School of Design.[21] Before long Tryon was sending works to the nation's cultural center, New York City. Samuel P. Avery, a dealer known at the time for collecting works by James McNeill Whistler, purchased one of Tryon's watercolors, *Gunning Rock—Narragansett River.* And in 1873, Tryon exhibited two paintings at what was then the largest and most important show of recent works by living artists, the annual exhibition of the National Academy of Design. One, called *A Misty Morning,* belonged to a Hartford patron, F. W. Cheney of the Cheney Brothers Silk Manufacturing Company, and the other, *Evening off Point Judith,* was exhibited for sale.[22] Its purchase that year signaled the start of Tryon's new life. He married a girl he met in the bookstore, Alice Hepzibah Belden, and abandoned the world of commerce for art.[23]

Tryon had remained at Brown & Gross until the income from his paintings became larger than his bookstore salary—"and if people would pay me more for doing what I liked to do than for what I didn't," he said, "I was willing to please them."[24] At least one of his well-meaning friends in Hartford thought he was making the mistake of his life. "Here you are making an honest and comfortable living and like a fool you throw it up for a career in art, which of all things in this world is the most fickle," Samuel Clemens said. "You will probably starve to death in a garret."[25] Prudently, Tryon offered private instruction in painting and drawing; two of his pupils were the daughters of his patron, Cheney, who assured Tryon's appointment as instructor in the Hartford Art Society.[26] But Tryon would always remain relatively unconcerned with material prosperity: when he had to acknowledge the extent of his wealth years later, he became quite unhappy, the story goes, because he had never wished to be rich.[27]

The works Tryon produced just after his retirement from business show the influence of those "commonplace Dutch paintings" that he had admired in the exhibition of Batterson's collection.[28] They also suggest a contemporary American inspiration— paintings by artists we now call luminists, which Tryon would have seen in Hartford and New York.[29] *Twilight on the Maine Coast* (fig. 11), an oil painting dated 1874, exhibits the qualities identified with the luminist manner: an open-ended composition, measured recession into space, emphatic horizontality, a mood of stillness and silence, and clear, cool, palpable light.[30] Like the mature works of Martin Johnson Heade, *Twilight* conceals every trace of the artist's hand in its smooth, gleaming surface. Other pre-

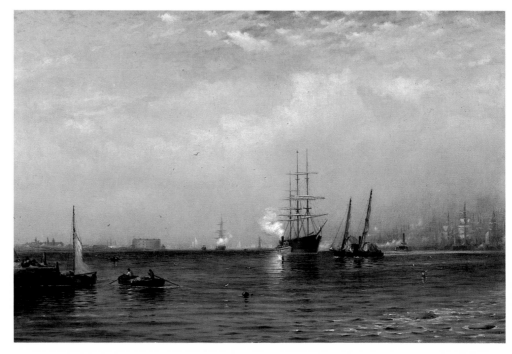

Fig. 12 *Morning on the East River from the Brooklyn Side,* 1874. Oil on canvas, 24 × 37 in. (61 × 94 cm). Private collection.

Fig. 13 *Boston Navy Yard,* 1873. Oil on canvas, 18 × 30 in. (45.7 × 76.2 cm). The William Benton Museum of Art, The University of Connecticut, Storrs; Gift of Nelson C. White.

Fig. 14 Fitz Hugh Lane (1804–1865), *Boston Harbor,* 1855–58. Oil on canvas, 26¼ × 32 in. (66.8 × 106.7 cm). Museum of Fine Arts, Boston, Massachusetts; M. and M. Karolik Collection of American Paintings, 1815–1865, by exchange.

cisely delineated marines such as *Morning on the East River from the Brooklyn Side* and *Boston Navy Yard* (figs. 12 and 13) vividly call to mind the harbor scenes of Fitz Hugh Lane (see fig. 14).

Especially in comparison to the highly subjective and painterly works that follow, the brilliantly luminous, linear, precisely ordered compositions of that period appear almost primitive, and may in fact betray Tryon's lack of formal training. Barbara Novak has shown that luminism was not a movement but a sensibility shared by a number of contemporary artists; as an art-historical construct, it recognizes similarities suggestive of an indigenous style. Tryon could, then, have arrived at the technique on his own, deriving elements of style from the same set of influences as the luminists: Dutch and Hudson River school paintings. He appears, however, to have been especially impressionable during that phase of his self-education. By the mid-1870s, Tryon had abandoned the luminist style for the more subtle aesthetic developed by a second generation of American landscape painters.

Although he never professed allegiance to any artist in particular, Tryon did admit that Alexander H. Wyant's works appeared more advanced than the paintings he was

Fig. 15 *Landscape, Lafayette Range, White Mountains at Sunset,* 1876. Oil on canvas, 18⅛ × 30⅛ in. (46.1 × 76.5 cm). Williams College Museum of Art, Williamstown, Massachusetts; Gift of James A. Taylor.

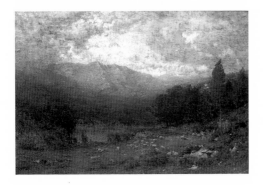

Fig. 16 Alexander H. Wyant (1836–1892), *Scene in County Kerry, Ireland,* ca. 1873. Oil on panel, 20 × 30⅛ in. (50.8 × 76.5 cm). Smith College Museum of Art (1900:12–1).

usually able to see in Hartford. Tryon's admiration continued undiminished through 1920, when he declared in a letter to Frederic Fairchild Sherman that no other artist had "arranged so many works of a high order of merit. . . . He seemed to transmute into jewels all he touched."[31] The paintings Tryon produced from 1874 through 1876 as a result of sketching trips to such popular scenic spots as Mount Desert (where he lived all summer on codfish and potatoes) and the White Mountains show traces of Wyant's influence. *Landscape, Lafayette Range* (fig. 15), for example, displays the same romantic attitude as one of Wyant's early compositions, *Scene in County Kerry, Ireland* (fig. 16), which Tryon would help to obtain for the Smith College collection.[32]

Wyant's own mentor, George Inness, was at Kearsarge House in North Conway, New Hampshire, when Tryon visited there in 1875.[33] A landscape Tryon probably conceived that summer (fig. 17), a traditional view of Moat Mountain across green meadows under inclement skies, is reminiscent in subject and mood of Inness's *Saco Ford: Conway Meadows* (fig. 18) of 1876.[34] Although Inness's landscapes are often compared with Tryon's mature tonalist paintings,[35] the resemblance between these earlier works appears to have been overlooked. In Inness's highly personal landscapes, Tryon may have detected the direction his own style would follow.

As Nicolai Cikovsky has said of Inness, Tryon began in the latter half of the 1870s to emphasize "natural moments" over "natural monuments."[36] Dismissing the conventionally picturesque places that elicited a response of recognition, Tryon sought unfamiliar scenes that might inspire emotion instead. From the White Mountains, which had always attracted landscapists, Tryon turned to Block Island, which was, he said, little known at that time. *Clay Cliffs at Sunset, Block Island* (fig. 19) presents a stunning sunset above crimson cliffs with surf breaking on the beach. Beside the placid, luminous *Twilight on the Maine Coast* (fig. 11) that Tryon had painted two years earlier, the display of nature in *Clay Cliffs at Sunset* appears impassioned indeed. Tryon later pronounced it the most powerful work of his pre-European period—"so complete and impressive," he wrote Freer in 1917, "that I would not hesitate to exhibit it now and among any company."[37]

Clay Cliffs at Sunset was exhibited at the National Academy of Design in 1876, but according to Henry White had been painted expressly for the Philadelphia Centennial Exposition. That exhibition, Charles Caffin wrote, "revealed to the multitude of people the artistic resources of the Old World, and the comparative barrenness in this respect of our own country."[38] The taste for American scenery so carefully cultivated by the Hudson River school no longer suited a nation that had grown rich in the postwar era and bored with local products. By the 1870s, French landscape paintings had almost supplanted the native tradition in American minds, largely through the efforts of Wil-

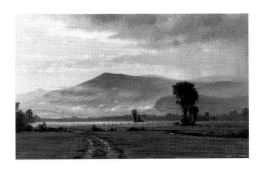

Fig. 17 *Landscape,* ca. 1875–76. Oil on canvas, 15⁷⁄₁₆ × 26⅛ in. (39.2 × 66.4 cm). Wadsworth Atheneum, Hartford, Connecticut; Gift of Newton C. Brainard.

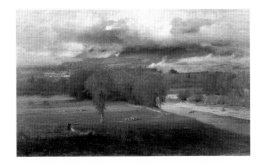

Fig. 18 George Inness (1825–1894), *Saco Ford: Conway Meadows,* 1876. Oil on canvas, 38 × 63 in. (96.3 × 159.8 cm). Mount Holyoke College Art Museum, South Hadley, Massachusetts; Gift of Miss Ellen W. Ayer.

liam Morris Hunt, an artist who had worked with Jean-François Millet and returned to Boston to popularize the ideas of the School of 1830. Tryon's well-worn first-edition volume of *W. M. Hunt's Talks on Art* (1875), complete with marginalia, survives in the library of Smith College; the progressive compendium of European ideas on aesthetics may have provided the stimulus for Tryon's decision to study abroad.[39]

Tryon must have felt he had progressed in painting about as far as he could on his own, and opportunities for studying art in America were admittedly limited; in 1875, there were only ten art schools in the United States. He might have attended the Pennsylvania Academy of the Fine Arts but seems never to have entertained the idea, probably because his heart was already set on Paris. In the autumn of 1876, Tryon sold his life's work at auction and accepted a generous contribution from Cheney; and on the fourth of December, bolstered by two thousand dollars and boundless hope, Tryon and his wife set sail for France.[40]

TRYON was typical of the aspiring artists of his generation who went to Europe "that they might glean knowledge from the galleries, to Paris that they might learn to paint,"

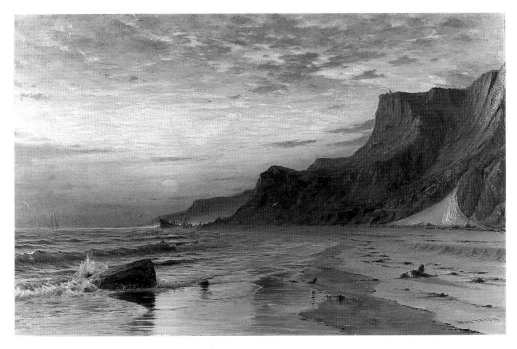

Fig. 19 *Clay Cliffs at Sunset, Block Island,* 1876. Oil on canvas, 30 × 48 in. (76.2 × 121.9 cm). Private collection.

Fig. 20 *The Cnidian Venus*, 1878. Charcoal on paper, 17⅛ × 11¾ in. (43.5 × 29.8 cm). Smith College Museum of Art (1916:12–2); Gift of Dwight W. Tryon.

Fig. 21 *Seated Nude*, 1877. Charcoal on paper, 19 × 15½ in. (48.2 × 39.5 cm). Smith College Museum of Art (1916:12–16); Gift of Dwight W. Tryon.

as Charles Caffin put it, "and such was their concentration and receptivity, characteristic of the race, that the Americans speedily came to be recognized as the aptest of the Paris students."[41] Whatever the talents of the Americans, their numbers were so overwhelming that by 1880 the French had attempted to have them disqualified from award competitions.[42] Tryon, then, was not alone in his hope of obtaining academic instruction to improve his technique, credentials to certify his talent, and the distinction of having shown his work in the illustrious Paris Salon.

Although he owned a copy of Henri Murger's *Scènes de la vie de bohème*,[43] the book that had inspired Whistler to take up an artistic existence on the Left Bank, Tryon's disposition would not admit the eccentricities Whistler enjoyed. He was studious, diligent, and frugal, and never mingled in the life of the Quartier Latin.[44] Indeed, the Tryons' quiet, comfortable apartment on the rue Guy Lussac became a refuge for those unmarried American friends who were more easily distracted by the pleasures of Paris.

For a man who had hardly ventured beyond the outskirts of Hartford and could not have spoken more than a word or two of French, Tryon adapted to a foreign environment with remarkable ease, a self-assurance Caffin ascribed to the "warrantable belief in himself that belongs to the self-made man" together with a "clear conviction of what he meant to do."[45] Never having had a drawing lesson, Tryon enrolled at once in the small, comparatively expensive atelier of Jacquesson de la Chevreuse, probably on the recommendation of his friend William Bailey Faxon, who had begun studying in Paris the previous year.

Nothing in Tryon's self-taught course would have prepared him for academic training, in which the human figure formed the foundation of art. Jacquesson, who had been a favored student of Jean-Auguste-Dominique Ingres, was known to be an "exhaustively scientific teacher,"[46] and fifty years later Tryon could recall his first critique, which he would never have reason to hear again: Tryon drew well enough, the master said, but his work lacked system. Consequently, Tryon worked three long winters from eight in the morning till dark, reconstructing his approach to art.[47]

Tryon began by drawing from the antique, and in efforts to reproduce ideal proportions produced a series of drawings of the Cnidian Venus (see fig. 20), each rendered the same size as the cast. In only six months Tryon progressed to the life class: a nude of 1877 (fig. 21) exhibits an Ingres-like surety of line and mastery of form. As part of his academic training, Tryon attended lectures on architecture, anatomy, and history at the École des Beaux-Arts, and like other artists of his generation copied paintings in the Louvre.[48] An uncharacteristic drawing of a monk (fig. 22) recapitulates the lessons Tryon learned in Paris: the surfaces of the coarse serge gown, earthenware water jar, and supple hands are competently rendered, the experience of mystical vision

convincingly conveyed.

Later, in the light of his own history, Tryon would argue that the discipline of the French regime was not entirely unrelated to his work as a landscape painter. If nothing else, his study of the human figure led to an almost scientific understanding of what he came to call the "anatomy of nature." But like many another student, Tryon tired of the conventional methods of the ateliers and began to long for "more individual freedom" and, he said, "more advanced and liberal standards of criticism."[49] Undoubtedly, he missed the solace and familiarity of landscape as well. Once he decided to "consult some painter whose work gave evidence both of technical skill and natural artistic endowment," Tryon chose an artist of the "so-called Fontainebleau-Barbizon school," which represented what he considered to be "unquestionably the most important epoch in the history of landscape-painting which the world has yet known."[50]

Tryon may have decided to seek the freedom exemplified by the Barbizon school even before he left Hartford. Countless American artists, including Inness, had pointed the way to the Forest of Fontainebleau. Indeed, Tryon was one of the last to follow that course: by 1877, Charles-François Daubigny was almost the only first-generation Barbizon artist still alive.[51] Daubigny, one of the first exponents of plein air painting in France, was not in fact an inhabitant of Barbizon. He preferred the vicinity of his boyhood home at Auvers, north of Paris on the banks of the river Oise, which he sketched from his floating studio, the *Botin.* Tryon, already enamored of boats of all kinds, must have been captivated by tales of "Captain Daubigny," an artist afloat; moreover, Daubigny's work had charmed him for years, Tryon said, "with its freshness, virility, and truth."

Tryon remembered Daubigny as a "kindly, unpretentious person" who had welcomed him into his studio on the rue Notre Dame de Lorette, astonished that his name was known well enough in America for a student to come seeking counsel. "After a few moments he examined my work," Tryon said, "and remarked of my academic studies: 'We all go through more or less of that work. I think you have had enough, and are ready to go to the country.' " Liberated from the routine of Paris and encouraged by so admired a master, Tryon painlessly practiced the art of landscape. Daubigny "seemed oblivious to the bad in work," Tryon said, "but invariably found whatever good there might be, and this he praised without reserve."[52] Their happy association was brief, however, for Daubigny died in February 1878.

Tryon's next teacher was Henri-Joseph Harpignies, a landscape painter and engraver occasionally classified with the Barbizon school; but Tryon would credit the artist J. B. Antoine Guillemet with directing him away from the academic path toward a style of his own.[53] Guillemet, who appears with Berthe Morisot in Édouard Manet's

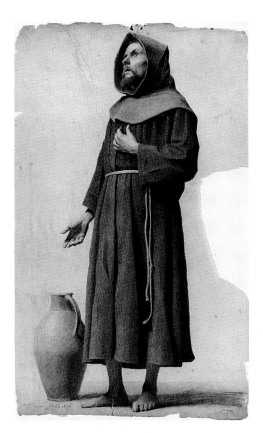

Fig. 22 *Standing Monk,* 1879. Charcoal on paper, 24½ × 15½ in. (62.2 × 38.7 cm). Smith College Museum of Art (1916:12–8); Gift of Dwight W. Tryon.

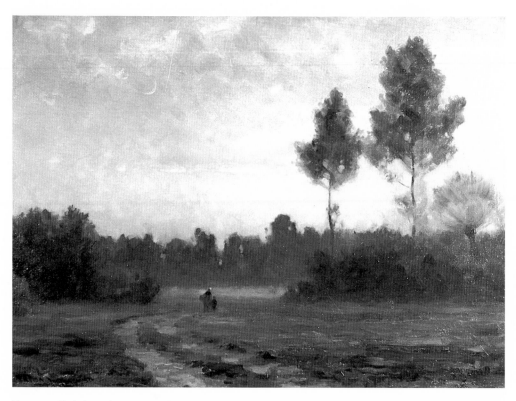

Fig. 23 *Twilight at Auvers,* 1878. Oil on canvas, 20¼ × 29¾ in. (51.4 × 75.6 cm). The Montclair Art Museum, New Jersey; Gift of William T. Evans.

Balcon and who insisted that a portrait by Paul Cézanne be admitted to the Salon in 1882,[54] would surely have introduced Tryon to the tenets of impressionism even if Daubigny—an early defender of the *impressionistes*—had not. Considering the artistic ferment in Paris at the time, it seems remarkable that Tryon's art emerged untouched by the avant-garde; during his years in Paris, Tryon could have attended four of the eight impressionist exhibitions. Apparently, as Henry White remarked, Tryon simply decided not to be distracted by the "fads or sensationalism of the moment."[55] A relatively old-fashioned painting exhibited at the Salon in 1881, *Harvest in Normandy,* suggests that Tryon worked to meet the demands of the French art establishment instead.[56]

Tryon was not only conservative but also romantic, and the realist inclination of impressionism—the artists' intention to record nature as impersonally as possible, to prefer optics to imagination as the inspiration of art—may have offended his instinct to treat nature subjectively. The pale palette and hazy, tonal atmosphere of *Twilight at Auvers* (fig. 23) suggest that Tryon was working under a new influence as early as 1878:

Harpignies or Guillemet may have introduced Tryon to the art of Camille Corot, whose poetic interpretations of nature were gradually replacing the prose renditions of Daubigny in Tryon's estimation. That he had more than a passing familiarity with Corot's style is supported by an anecdote Tryon recounted to Henry White, in which he disputed the attribution of a "Corot" during his student days and had his opinion validated by the renowned Paris art dealer Georges Petit. Later Tryon would advise a potential patron to hang his work next to a painting by Corot, and return it if his piece couldn't hold its own there.[57] Corot's lyrical landscapes became the measure of quality, for like Tryon's best work, they were convincing feats of the imagination—inventions based on nature.

Tryon gathered materials for compositions during the summer months when the Atelier Jacquesson was closed and he had time to explore the Continent. Sketchbooks

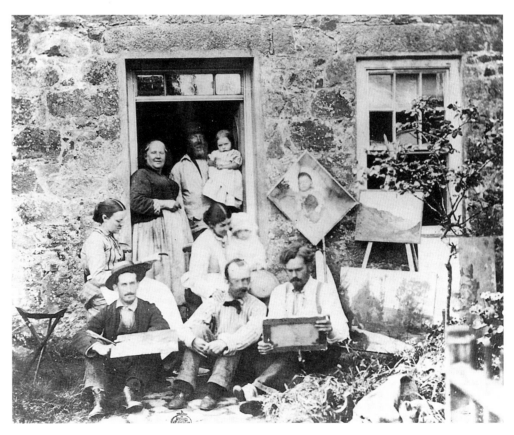

Fig. 24 The Tryons and the Abbott Thayers on the island of Guernsey, 1877. Seated, from left to right, are Tryon, Abbott Thayer, and Arthur Bell. In the second row, from left to right, are Alice Tryon, and Kate Thayer holding her daughter, Mary. The others are unidentified. Nelson White Papers/AAA.

Fig. 25 *Granville (Mouth of the Bay),* 1878. Oil on panel, 10½ × 15¼ in. (26.7 × 38.8 cm). Smith College Museum of Art (1930:3–126).

in the Smith College Museum of Art testify to his travels: they contain countless drawings of villages and beaches, boats and windmills, fishermen, washerwomen, sheep, goats, horses, skulls and skeletons, and landscapes in pen and ink or pencil, sometimes inscribed with elaborate color notations and other mnemonic messages. The Tryons spent their first summer abroad with the English artist Arthur H. Bell and another married couple from America, the Abbott Thayers, in a cottage on the island of Guernsey. Tryon made dozens of drawings of Guernsey cattle from various points of view, but did not depict the landscape. Indeed, the island seems to have meant most to him as the setting for one of his favorite novels, Victor Hugo's *Toilers of the Sea.*[58]

On holiday the next summer, the Tryons visited Normandy and Brittany, and Tryon depicted the fish market at Granville. Uncharacteristic of the artist in subject and handling, *Granville (Mouth of the Bay)* (fig. 25) suggests a fleeting influence of the French painter Eugène Boudin, whose Normandy seascapes Tryon must have known. When he presented this picture together with some other French sketches to Smith College in 1916, Tryon explained that they were "rather black and heavy partly from being excluded from the light for thirty years or more but mainly . . . because I was at that time more interested in form and value than color."[59] But in Venice, the next city on the Tryons' tour, color captivated his attention.

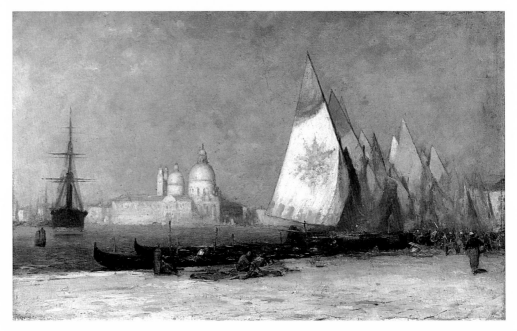

Fig. 26 *Venice,* 1879. Oil on panel, 16½ × 27¼ in. (41.9 × 69.2 cm). Smith College Museum of Art (1930:3–121); Bequest of Dwight W. Tryon.

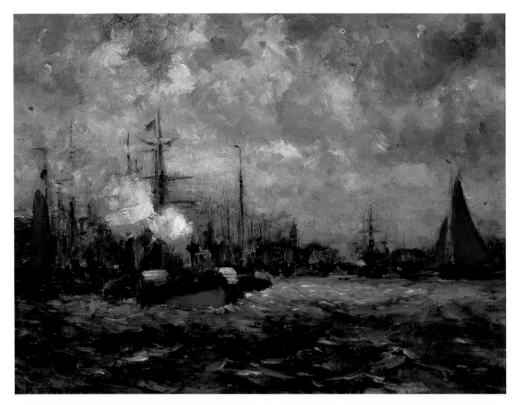

Fig. 27 *On the Maas,* ca. 1880–81. Oil on canvas, 9¾ × 12¾ in. (24.8 × 32.4 cm). Collection of Mr. and Mrs. Willard G. Clark.

Tryon would later remark that because the city itself was a work of art, representations of it were merely imitative. Venice, he maintained, was not "paintable."[60] Nevertheless, he extolled the "abstract creative vision" that informed a Venetian picture by Turner that he saw during the last year of his life, speaking to Henry White "in glowing terms of the rare charm of misty opalescent color in which the distant city hung, suspended between sea and sky."[61] Tryon maintained that he had neglected Turner temporarily during the course of his academic education, but in Venice he could hardly have ignored Turner's influence. Indeed, Tryon's praise of the artist echoes the notation he made upon a Venetian sketch of his own that summer of 1879: "The city seems to float in this warm haze and takes delicate golden and pink tints with shadows of blue grey scarcely darker than sky."[62] Acknowledging the difficulty of rendering the atmospheric effects of Venice, Tryon selected for a more "paintable" subject a fleet of sailboats arriving from nearby Chioggia on a rainy day, their sails wet and drenched with color (fig. 26).

Fig. 28 James McNeill Whistler (1834–1903), *The Kitchen*, 1858. Watercolor and graphite on paper, 12⅜ × 8¾ in. (19.3 × 14.2 cm). FGA (98.153).

Fig. 29 *Monchaux*, 1880. Charcoal on paper, 8¼ × 13¼ in. (21.1 × 33.7 cm). Smith College Museum of Art (1916:10–1); Gift of Dwight W. Tryon.

Fig. 30 *Sketch at Monchaux*, 1880. Charcoal and chalk on paper, 9⅛ × 12 in. (23.2 × 30.5 cm). Smith College Museum of Art (1916:12–10); Gift of Dwight W. Tryon.

Like Venice, the "picturesque city" of Dordrecht, where the Tryons spent three months the following summer, was a traditional artists' haven. Tryon would have known views of the port by Daubigny, if not by Dutch marine painters of the seventeenth century such as Aelbert Cuyp and Jan van Goyen. Dordrecht provided material quite to his taste, as Tryon put it, and the studies of the town and the river he produced there (see fig. 27) bespoke his love, he said, of shipping and the sea.[63] That same summer Tryon traveled to the village of Monchaux on the French coast, where he drew several scenes of rural domesticity that have the air of seventeenth-century Dutch genre pictures. Whistler had been inspired by the same models two decades earlier; *The Kitchen* (fig. 28) employs a compositional scheme similar to that of Tryon's "interior sketch for light and shade" (fig. 29). Tryon's charcoal drawing resulted in the first painting he sold in Paris, but notes in the margins of landscape sketches (see fig. 30) tell the greater importance of Monchaux to Tryon's future: it was in the stream beside the village that the artist learned to fish.

In a "piscatorial epistle" Tryon wrote to Henry White, he confessed that he had known almost nothing about fishing when he went to France, since his life till then had been too full of work to admit much sport. Happily, he had made the acquaintance of an artistically inclined Parisian who owned the country through which the beautiful stream at Monchaux ran, and who encouraged the artist to try his luck in the fishing hole just above the cottage where the Tryons lived in the summer of 1880. "My tackle was an ordinary string and common hooks such as I could get in a small village," Tryon recalled, admitting that the twelve- to eighteen-pound trout he caught would

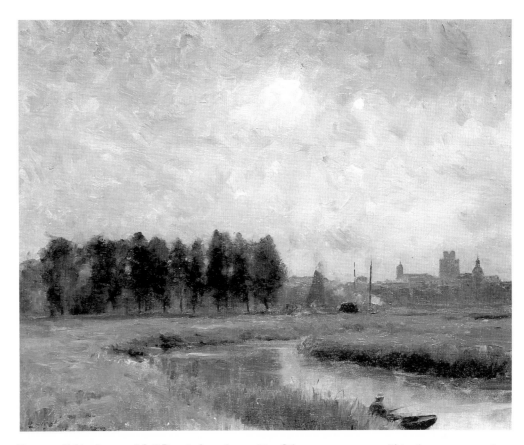

Fig. 31 *Fishing* (verso of *Self-Portrait,* fig. 96), ca. 1880. Oil on canvas, 22 × 17¾ in. (55.9 × 45.1 cm). Smith College Museum of Art (1891:3–1).

invariably escape by entangling the primitive line on tree stumps in the hole. Nevertheless, he said, "by main strength and stupidity, I yanked out trout of three to five pounds, quite often, about dusk."[64] It was probably at Monchaux that Tryon painted the picture (fig. 31) recently discovered on the back of his Smith College *Self-Portrait* (fig. 96). The figure fishing from a little boat at the edge of the stream must be the artist himself, a more personal portrait by far than the formal image on the other side of the canvas.

Although Tryon had begun to sell paintings in Paris,[65] the two thousand dollars he had brought to Europe was nearly exhausted by 1881. The Tryons escaped destitution only through a providential encounter with a collector who purchased four of Tryon's works on the very day they were to have been shipped to New York—an episode Tryon thought might be called the Romance of the Poor Young Painter. De-

Fig. 32 *The Thames,* 1882. Pen and ink on paper, 5¼ × 8 in. (13.3 × 20.4 cm). Smith College Museum of Art (1915:13–3); Gift of Dwight W. Tryon.

spite the happy ending, the Tryons were ready to return to America after nearly five years abroad, and in the spring they departed Paris forever, stopping in London on the way home. Tryon's drawings of shipping scenes on the river Thames (see fig. 32) are not particularly distinguished; for all his academic experience, Tryon would never be comfortable with line. In their apparent spontaneity of execution, however, the English drawings suggest some familiarity with the works of Whistler. One sketch in the Smith College Museum of Art, titled *Moonlight on the Thames,* makes explicit Tryon's debt to the painter of Nocturnes.

But unlike Whistler, Tryon seems never to have entertained the notion of expatriatism. His reflections in later years make it seem as though he left New England only for the pleasure of coming home:

> It is good to travel and see what man has done in the past, to store the mind with the riches of bygone times and thereby formulate a standard by which we may gauge the work of the present. One may feel timidly that we have as good scenery, as good art, as good a government as others, but there is nothing like testing for oneself the exact measure of difference.

His friend the artist George Alfred Williams recalled that Tryon, "with all due appreciation of what his sojourn abroad meant to him," had declared that he was glad to be back in America.[66]

❧§❧

APPARENTLY, the Tryons did not consider resuming residence in Hartford. As Charles Lang Freer once explained to the father of an aspiring artist, New York was really the only place for an artist to live:

> I can state that the general impression in artistic circles as well as among prominent American artists seems to be that the best place for a young man of artistic talent to locate is in the largest place he can find, and that would mean in this country New York City. . . . I know that in Detroit there are at least twenty-five struggling artists, and I doubt if a single one of them has an income from his work sufficient to provide the usual comforts of life. As a rule, the results of their easels go at extremely low prices and even then are disposed of with the greatest difficulty. In New York it is different because all America goes to New York for luxuries, and unfortunately as yet the many consider art a luxury, that is, they are blind to the fact that in its highest form it is really a necessity.[67]

But even in New York the luxuries collectors sought were likely to be imported, and

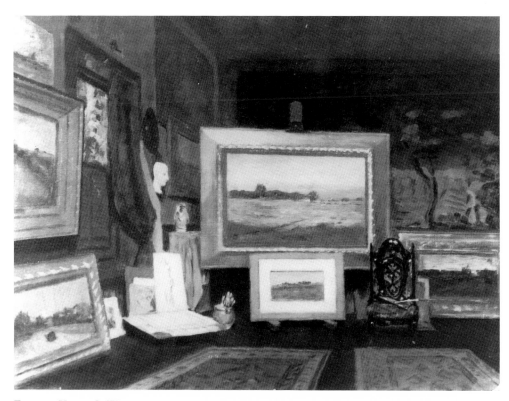

Fig. 33 Henry C. White (1861–1952), *Study of Interior of Tryon's Studio in Rembrandt Building, New York,* 1886. Oil on canvas. Photograph in Henry White Papers/AAA. Painting at center is Tryon's *Dartmouth Moorlands* (Smith College Museum of Art 1900:9–1), 1885.

few American artists in the last decades of the nineteenth century could count on making a living from their art. Tryon remained eminently practical in that respect throughout his life. "Personally, I have never looked upon my painting as a means of livelihood and am always surprised when my work sells," he said at a time when he could well have afforded to rest at ease. "Painting is in the same class as poetry and while there are doubtless poets who make a living it seems a doubtful staff to trust."[68] With characteristic prudence, then, Tryon decided to depend on the teaching rather than the practice of his art until he could establish a reputation in New York. With Hartford teaching experience and French academic credentials, he was well qualified to accept students for instruction, and by the autumn of 1881 had secured a studio on West Fifty-Seventh Street, where for several years he would paint and teach.

Among his neighbors in the auspiciously named Rembrandt Building were a number of artists, including William Bailey Faxon, R. Swain Gifford, Will H. Low, and

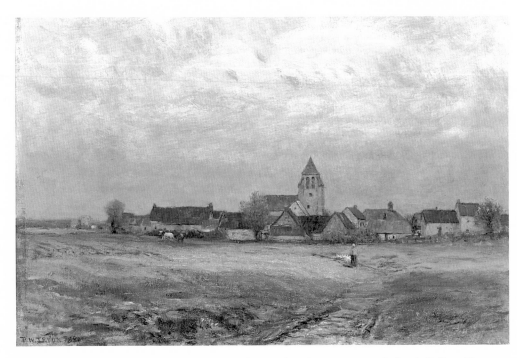

Fig. 34 *Cernay la Ville*, 1881. Oil on canvas, 20½ × 30½ in. (52.1 × 77.5 cm). Smith College Museum of Art (1881:1).

Maria Oakey Dewing, who had studied abroad and returned to become members of the Society of American Artists.[69] Formed in 1877 in reaction to the conservative juries of the National Academy of Design, the Society was exhibiting when the Tryons, having recently attended shows at the Paris Salon and the Royal Academy in London, arrived in New York in the spring of 1881.[70] Though under the impression that art did not exist outside Paris, Tryon was obliged to admit that nothing could compare with the works on display at the Society of American Artists, and eighteen years later could still recall "a fine Dewing and a Thayer [that] more than held their own" with the best modern work he had seen abroad.[71] "It was evident that the many artists who had been studying in Europe had made full use of their talents and opportunities," Tryon wrote in his recollections, "for here was a renaissance in art showing both genius and culture." By the time the next exhibition was installed, Tryon himself had become a contributor and later that year was made a member.[72] As Charles Caffin observed, election to the Society of American Artists at that time was "practically the final graduation of the studentship abroad."[73]

The paintings Tryon submitted to the exhibitions of the Society of American

Artists and the National Academy of Design during the first years after his return from France were as often European as American in subject. *Cernay la Ville* (fig. 34), painted in 1881, is one example. With titles recalling scenic spots in France and Holland (*Moonrise off Dieppe, Harvest Time in Normandy, River Maas at Dordrecht*), they were concessions to the taste for things transatlantic that had been prevalent ever since the Centennial Exposition. In the 1880s, Barbizon paintings were more eagerly sought after than ever, and Tryon's works, constructed in the studio from sketches made in Europe, must have seemed to some collectors less expensive versions of the real thing.

At the same time that he was producing souvenirs of Europe, however, Tryon was reacquainting himself with the American landscape. During his first summer back Tryon would doubtless have visited his friends and relations in Hartford, and the titles of two paintings from that period, *A Connecticut Cornfield* and *Glastonbury Meadows,* indicate that he took a sentimental journey to his ancestral home at Tryontown as well.[74] He may have been hoping to find a lifelong inspiration in the landscape of his childhood, as Daubigny had done at Auvers, but the Connecticut countryside proved disappointing. "It would be difficult to imagine a less interesting country," Tryon said, "flat, sandy and mostly given to the raising of tobacco."

In search of a domesticated wilderness like the Forest of Fontainebleau, Tryon spent two summers in East Chester (present-day Eastchester), New York, a village that offered a few of the elements he associated with Barbizon. The subjects of his paintings became American at last, though Tryon commanded his French sensibility to render the native scene more appealing to the picture-buying public. *Landscape* (fig. 35), for instance, pictures a pleasant agrarian life very much in the French manner;[75] and a comparison of another painting from the same period, *Sunshine and Shadow* (fig. 36), with Daubigny's *Farm* (fig. 37) shows that Tryon remained unequivocally in the "Barbizon mood," to borrow Peter Bermingham's phrase. Indeed, the similarity of his American pictures to genuinely French ones may explain the frequent confusion on exhibition lists of Tryon's name with the Barbizon painter Constant Troyon's.

Tryon not only painted like a Barbizon artist after his return from France but also managed to live like one. Just as the French landscape painters had depended upon the Paris Salon, Tryon relied on the New York art world for the sale of his pictures, even as he distanced himself from the artificiality of urban life to remain (as he would say of Daubigny) "constantly near the scenes with which he was in sympathy."[76] Tryon was attempting to settle down, to terminate the restless travels of his youth in which he had sought spectacular, sublime, and marketable subjects for art—the White Mountains and Mount Desert, Venice and Dordrecht—because, he said, the "painters who go for a few weeks or a month to a strange country fail to render that subtile charm which is

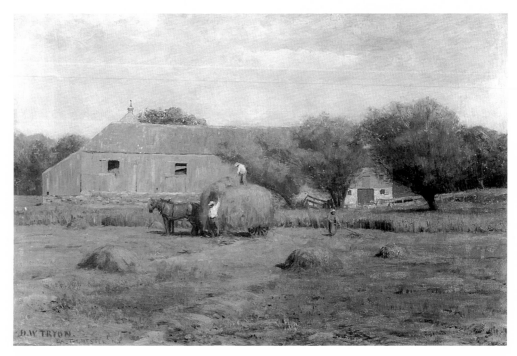

Fig. 35 *Landscape,* ca. 1882. Oil on canvas, 24 × 36 in. (61.0 × 91.4 cm). National Academy of Design, New York.

Fig. 36 *Sunshine and Shadow,* ca. 1882–83. Oil on canvas, 20 × 30 in. (50.8 × 76.2 cm). Bridges Collection.

Fig. 37 Charles-François Daubigny (1817–1878), *The Farm,* 1855. Oil on canvas, 20¼ × 32 in. (51.4 × 81.2 cm). National Gallery of Art, Washington, D.C.; Chester Dale Collection.

the essence and soul of every landscape." For Tryon, the most important legacy of the Barbizon school may have been a determination to commit himself to the character of a landscape he loved rather than capture fleeting impressions of one he hardly knew. "Only to the persistent lover and close companion does nature reveal her beauty," he said, "only to one who no longer looks upon her as a stranger does she yield the secret of her charm."[77]

East Chester, however, proved no more emotionally satisfying than Glastonbury. The artist R. Swain Gifford, a neighbor in New York, suggested that Tryon try Dartmouth, Massachusetts, a few miles from New Bedford; Gifford spent his summers at Nonquitt in the same vicinity, and assured his friend that it was equal to any place one could find in France. Accordingly, in 1883 the Tryons rented a house in South Dartmouth (sometimes called Padanaram),[78] and found that "its continual breeze, its freedom from mosquitoes, and its quaint and beautiful scenery" made it an ideal location. For the next few years the Tryons returned each season to become the town's first "summer people," and in 1887 confirmed their commitment to South Dartmouth by building a modest house on Water Street that they would call "The Cottage."[79]

Fig. 38 "Tryon's Padanaram." Photographic postcard. New Bedford Whaling Museum, Massachusetts.

Padanaram probably did remind the artist of Europe. The flat land and windmills of the salt-making industry would have made the countryside appear vaguely Dutch, and the town itself, with its seventeenth-century cottages and shingled fish houses, must have looked rather like a French fishing village.[80] During his first summers there Tryon depicted groves of oaks (see fig. 39) that might have occupied the Forest of Fontainebleau, and scenes of a village that could be mistaken for Monchaux.[81] Indeed, a painting presented to the Smith College Museum of Art as a "village scene in France" (fig. 40) can be identified as a view of Middle Street, South Dartmouth.[82]

The chief attraction of the village, however, seems to have been its proximity to the water. Tryon never lost his love of ships and the sea, and from the front porch of the Cottage or the windows of his bedroom, he could see the Apponagansett River opening onto Buzzard's Bay. Although the industry was in decline, a fleet of whale ships was still in active service in New Bedford, and boats were built in South Dartmouth, where sailors and sea captains constituted a large portion of the population.[83] Tryon himself could afford at first no more than a sixteen-foot sailing canoe, which he bought in the city and sailed alone out the Harlem River, through Long Island Sound, and on to Dartmouth in five days.[84]

Tryon's seafaring spirit was not entirely unrelated to his occupation, for he had learned from Daubigny the virtues of studying land from the water. "The dweller

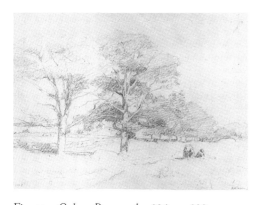

Fig. 39 *Oaks—Dartmouth*, 1886 or 1888. Graphite on paper, 7⅜ × 10 in. (18.6 × 25.4 cm). Smith College Museum of Art (1930:3–144).

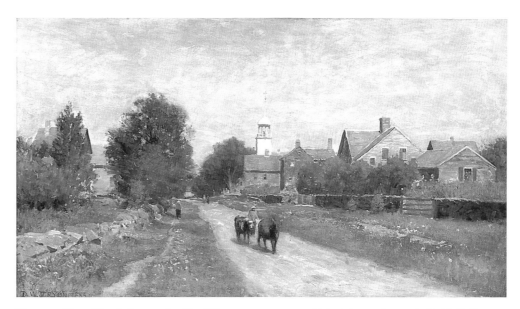

Fig. 40 *View of South Dartmouth*, 1883. Oil on canvas, 19 × 34⅜ in. (48.2 × 87.4 cm). Smith College Museum of Art (1986:28); Gift of Rose K. Coen.

ashore is usually up too late to see the rising mist which the sun so quickly dissipates," Tryon wrote, "but from the *Botin* the last of the evening glow and the earliest flush of dawn were watched and recorded."[85] In the days before he had a boat of his own, Tryon occasionally accompanied a local fisherman on his trips round the bay and once witnessed a particularly inspired sunrise from the water at Fairhaven, where they had anchored for the night.[86] Recollecting that impression a day or two later in his studio, Tryon painted *Daybreak* (fig. 42).

Although Tryon's impression of a sunrise may bring to mind a painting by Claude Monet, Tryon would argue that, like Daubigny, he was what he called a "true Impressionist," defined as "one who possessed a sufficient knowledge of nature and a sufficient strength of memory, to record the most fleeting effects with great force and veracity."[87] In contrast to most French impressionist paintings, Tryon's were produced in his studio either entirely from memory (*Daybreak* is one example) or from studies made from nature. Disliking the artist's impedimenta, Tryon never painted out-of-doors,[88] and the impressionist practice of completing pictures from boats on the Seine would have seemed to him intolerably inconvenient. On the few occasions when he

Fig. 41 Dwight and Alice Tryon in Padanaram, 30 August 1888. Albumen photograph. Tryon Papers/ FGA.

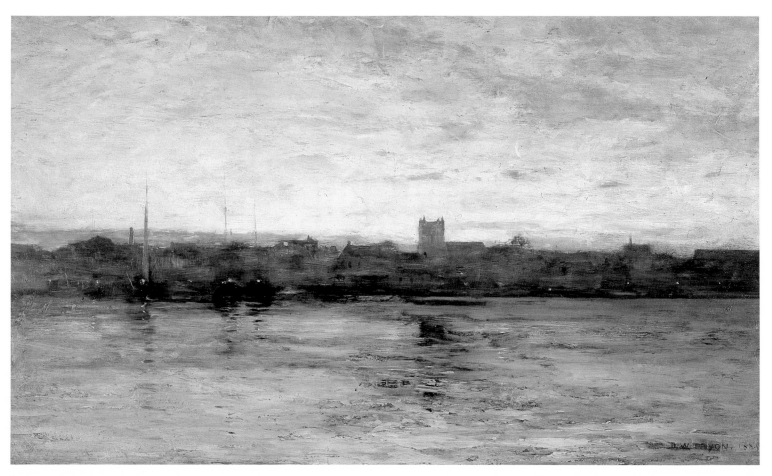

Fig. 42 *Daybreak,* 1885. Oil on panel, 17¾ × 30 in. (45.1 × 76.2 cm). Museum of Art, Rhode Island School of Design, Providence; Jesse Metcalf Fund.

did decide to make a drawing, he seems to have been caught unprepared. His "sketchbooks" contain tiny drawings made with lead or charcoal on scraps of paper he happened to have in his pocket—bank checks, invitations, shopping lists—with suggestions of color recorded in black and white, keyed to the alphabet and elaborated in longhand. "Delicate blue at A passing into yellow grey at B," Tryon scrawled across the bottom of a landscape drawing showing capital letters suspended in the sky, "grey in clouds, bluish at C, getting warmer at D."[89] His sketches are less studies than mnemonic devices: Tryon was learning the landscape's features by heart.

Royal Cortissoz remarked in 1919 that the paintings Tryon produced during the early 1880s, though plainly acknowledging a debt to certain "Parisian masters," suggest that the artist "was developing a quality of his own, a quality both of color and of

atmosphere, and especially he was finding out and interpreting with great truth the special note of the American countryside."[90] In fact, Tryon was simply discovering South Dartmouth. "There is no country I take it but has a mission for some one," he said. "It all depends on what one takes to nature."[91] Not until the latter half of the decade, when he had become "sympathetic" with the landscape, could he reformulate the Barbizon style to make it express the character of a different country. It was a timely revision. If French paintings of the School of 1830 had enjoyed unprecedented popularity in the early 1880s, by the end of the decade they were finally beginning to look old-fashioned, partly because Americans had come to appreciate the works of Whistler. Like Tryon, Whistler had adopted a fashionable style in his youth (first realism, in the manner of Gustave Courbet; then a sort of Rossettian pre-Raphaelitism, followed by the classicism of Albert Moore) only to find his mature style once he detected the aesthetic possibilities of a familiar theme, the river Thames. Just as Whistler transformed an urban, industrial scene into a vision of beauty in his Nocturnes, Tryon would turn a homely rural landscape into an ideal country.

In the late 1880s, Tryon, like many other American artists of his generation, produced a series of paintings of "black nights with troubled skies," as the collector Duncan Phillips described them.[92] Tryon's night pictures, such as *Moonlight* of 1887 (fig. 43), exhibit something of the Barbizon mood, and the series of "haystacks" he produced from 1887 to 1889 (see cat. nos. 2 and 3) particularly recall French-inspired farmyard scenes. More emphatically, these somber, muted paintings announce an awareness of Whistler, whose Nocturnes were inspired by evening, when mists clothed the world with beauty, and Nature, the artist said, sang her song in tune. Tryon used the word *moonlight* as a sort of synonym for *nocturne:* both were general terms that served to deflect interest from the subject of the picture to the aesthetic merits of the art object itself. Because Tryon's intention was to "depict some mood or special phase of nature" rather than any particular place, he was never interested in titles, since "good art is like good music or a beautiful flower—its name is only secondary." Echoing Whistler's sentiments, Tryon said: "Its beauty should be all sufficient. Its appeal direct to the mind."[93]

Although these paintings retain the spirit of Barbizon, Tryon seems to have been trying to shed the association. As the popularity of French landscapes subsided in America, Tryon apparently lost his taste for them as well. Some years later he repudiated the influence altogether, telling Charles Caffin in 1909 that Daubigny had offered little but the "inspiration of his genial company." Moreover, in the autobiographical notes he prepared for Henry White, Tryon dismissed both Daubigny and Harpignies with the remark that he had "found little help from them."[94] As early as

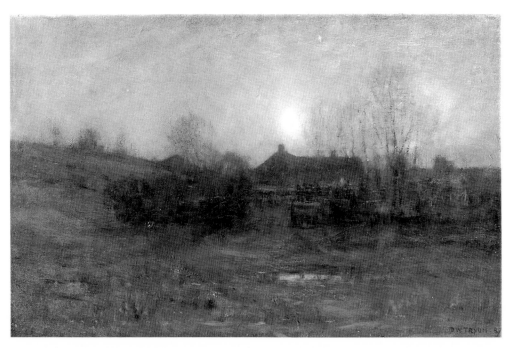

Fig. 43 *Moonlight*, 1887. Oil on wood, 14 × 22 in. (35.6 × 55.9 cm). The Metropolitan Museum of Art, New York (06.1299); Gift of George A. Hearn, 1906.

1896, Tryon had gently reproached his teacher by pointing out that Daubigny lacked a "strongly developed critical faculty," a deficiency that made him an amiable instructor but too easily satisfied with his own work. In Tryon's opinion the mere "impressions" that had so decisive an influence on Monet should never have left Daubigny's hands. Outlining the error of the artist's ways, Tryon wrote:

> I have frequently seen him transpose a morning sketch made in full grey light, into a sunset or twilight by adding a note or two of vivid color at the horizon, paying little or no attention to the many notes of color necessary to unite and harmonize two such differing effects.[95]

The statement defines by opposition Tryon's own technique as it would develop in the years after 1886, when his attention to subtleties of tone would have made the art of the Barbizon school appear altogether undiscriminating.

Tryon's distinctive landscape style, an affectionate presentation of a simple, local setting, appeared at the end of the eighties, when the artist was not yet forty: *The First Leaves* (fig. 44) signals an artistic rebirth.[96] Although Tryon had depicted trees before,

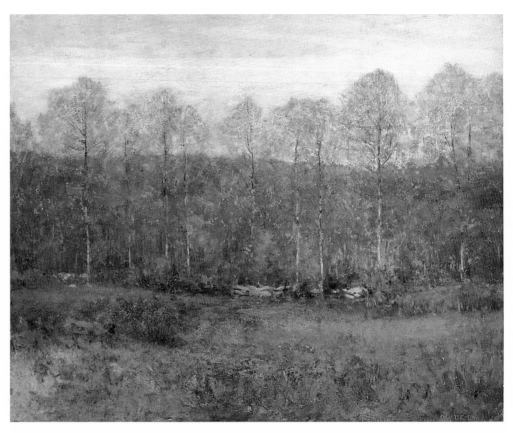

Fig. 44 *The First Leaves,* 1889. Oil on panel, 32 × 40 in. (81.2 × 101.6 cm). Smith College Museum of Art (1889:6–1); Museum purchase.

the carefully finished Barbizon-style drawings in the Smith College Museum of Art (such as *Oaks—Dartmouth,* fig. 39), were evidently intended as studies, not as preparatory sketches for paintings; not until *The First Leaves* did Tryon realize the aesthetic possibilities of the subject. Inspired by a "walk among the trees in early May," the painting is the earliest manifestation of Tryon's preference for "tall trimmed trees in groups."[97] *The First Leaves* pictures a graceful line of white birches stretching across a clearing marked by an old stone wall and studded with boulders and huckleberry bushes. In the meadows of Dartmouth, Tryon discovered an uncomplicated scheme that impressed itself indelibly upon his inner eye. The row of trees in the middle distance silhouetted against the sky appears in most of his future compositions.

As a sign of its success, *The First Leaves* received the Webb Prize in 1889, an honor Tryon particularly prized as it came from the organization of painters he most admired,

Fig. 45 Dwight W. Tryon, ca. 1890. Albumen cabinet card. Tryon Papers/FGA.

Fig. 46 Charles Lang Freer, 1880s. Platinum print. Freer Papers/FGA.

the Society of American Artists.[98] Awarded to the best landscape painting in the annual exhibition by a young American artist (at thirty-nine, Tryon qualified for the last time), the prize confirmed Tryon's position in the New York art world and predicted his future achievement. "If an artist hasn't 'arrived' before he is forty," Tryon later told Walter Copeland Bryant, "as a general rule he will never get there."[99]

Considering his five-year absence from the United States, Tryon had secured a reputation with astonishing speed. Within one year of his return from Europe he had obtained membership in the Society of American Artists, the American Water Color Society, and the National Institute of Arts and Letters. By the mid–1880s he had become a regular contributor to exhibitions at the National Academy of Design, the Brooklyn Art Association, and Gill's Art Galleries in Springfield, Massachusetts, which exhibited "The Best Work of Eminent American Artists Resident in America and Europe." In New York his works were frequently included in the select array of American paintings shown at N. E. Montross's art supply store at 1380 Broadway, later to become the Montross Art Gallery.[100] In addition to the Webb Prize, Tryon had been awarded a bronze medal at the Boston Mechanic's Fair (1882), two American Art Association gold medals (1886 and 1887), and the distinguished Hallgarten Prize at the National Academy (1887).[101] By the end of the decade, therefore, he found himself in a position to appeal to gentlemen of means. Thomas B. Clarke, the first major collector to turn away from fashionable European paintings and champion contemporary American art, began buying Tryon's works in the mid–1880s;[102] and in the spring of 1889, Tryon sold a painting, the first of many, to an industrialist from Detroit, Charles Lang Freer.

❦

CHARLES FREER was an avid collector of prints who had been appointed chairman of the Detroit Club's art committee in 1888. That position may have aroused his interest in exhibitions of contemporary art and lured him to the Society of American Artists show, on view at the Fifth Avenue Art Galleries from May 13 until June 15, 1889. The prize-winning *First Leaves* or another painting on display called *Evening* may have attracted his attention to Tryon, whose address was noted in the catalogue.[103] The architect Stanford White and the artist Frederick Stuart Church have been suggested as abettors to Freer's visit to the artist's studio, but the existing evidence supports neither Freer's acquaintance with White nor Tryon's with Church at that date, making both possibilities conjectural at best.[104] We know, however, that Freer had recently ventured into the acquisition of oil paintings, and can surmise that the abundance of art in New York put him in the mood to begin a collection of his own.[105] Apparently, he called on

Tryon without introduction and bought *The Rising Moon: Autumn* (cat. no. 3) off the easel for eleven hundred dollars.

That particular "moonrise" had also appealed to the Chicago businessman Potter Palmer and his wife, who intended to purchase the painting upon their return from Europe if they found nothing there they admired more.[106] In Paris the Palmers (who already owned a number of Barbizon paintings) purchased their first impressionist works—a pastel by Edgar Degas and *Madame Renoir in the Garden* by Pierre-Auguste Renoir—but stopped back by Tryon's studio all the same, only to discover they had lost *The Rising Moon* to a competing midwestern connoisseur. In light of their recent exposure to French impressionist painting, the Palmers' abiding affection for *The Rising Moon* is especially revealing. Though clearly related to his other haystack pictures, the palette of *The Rising Moon* is significantly lighter, and compared to *Moonlight* (cat. no. 2) painted two years earlier appears distinctly impressionist, as if Tryon had traveled the distance from Fontainebleau to Giverny.

In fact, Tryon was heading in quite another direction. His movement away from Barbizon style and subject matter, which were sure to be accepted by the ordinary picture-buyer, suggests that Tryon's philosophy had been affected less by French impressionism than by the ideas of English aestheticism, which were just becoming current in America. By the end of the decade Tryon had fully adopted Whistler's belief that appreciation of fine art was necessarily limited to the discriminating few. Freer, who would appear to be among the elect, might have inferred from his first letter from the artist that in purchasing *The Rising Moon* he had acquired a token of culture: even as Tryon applauded his patron's good judgment, he implied that continued appreciation was the only protection against philistinism. "At the last moment I regret parting with this picture, which I am sure is my best work," Tryon wrote.

> I am consoled by the feeling that it is going where it will be appreciated. You must not look for a general appreciation of it by many. It will be a picture which the average person will see nothing in and at first sight will not reveal itself to even more cultured ones. If as I feel sure it continues to give you pleasure it will be all I ask.[107]

Tryon may have suspected that this self-made businessman from the Middle West was no more than a parvenu shopping for a "passport to gentility," to use Caffin's felicitous phrase, for when he wrote Freer again a few months later he said, "I shall be pleased to learn if it continues to give you pleasure." [108]

With his purchase of *The Sea: Sunset* (cat. no. 4) the following February, Freer seems to have passed Tryon's test of taste. "I would like you to have it better than any

one I know," Tryon wrote, offering the painting at the "special price" of eight hundred dollars, frame included, even though he customarily received almost twice that amount.[109] Indeed, the price of Tryon's paintings had risen from five hundred dollars for a work exhibited at the National Academy of Design in 1882 to one thousand dollars for *A Pasture, October* in 1888. The elevated prices of the paintings reflected a change in their character, which demanded a different public from the one that had supported his earlier efforts. Tryon confided to Freer that most buyers would have a "preconceived idea" of his work that this painting was unlikely to fulfill; for even more than *The Rising Moon,* which Tryon had defined as "quiet and reserved in quality,"[110] *The Sea: Sunset* challenged the conventions of European-inspired pictures in subject and style and would not have appealed to purchasers who had admired paintings like *Harvest Time in Normandy,* or even *Moonlight* of 1887. Clearly, Tryon saw the advantage of securing a patron for these expensive and intentionally inaccessible pictures. "Any subject like this which departs so widely from my usual subject," Tryon wrote Freer, "does not immediately find appreciation except from a rare individual."[111]

As it turned out, Tryon would say that Charles Lang Freer was the best judge of pictures he had ever known, "better than any painter."[112] He would also find him to be an exceptionally accommodating patron, for Freer saw himself as "simply a guardian" of the works of art he acquired; as he explained to Thomas Dewing, "you should always consider that your wishes must control your own work, in which you and I have a joint ownership."[113] Indeed, one of the reasons Tryon had hesitated to part with *The Rising Moon* was that he wanted to include it in the 1889 Inter-State Industrial Exposition in Chicago (Sara Tyson Hallowell, secretary of the art committee, felt sure that it would take first prize), and even after Freer granted permission to exhibit the painting, Tryon continued to worry that he might be "too much inconvenienced by loaning it."[114] Before long Freer had generously agreed to send *The Sea: Sunset* to Chicago for the 1890 Exposition; it was a condition of the discount sale, but Freer would surely have consented in any case,[115] and Tryon at last began to understand Freer's concept of patronage. Both works were greatly admired there, and as predicted, *The Rising Moon* was awarded the Potter Palmer Prize. Tryon professed surprise, nevertheless. "Painting as I do without reference to public exhibition," he said, "I expect little in this line."[116]

Although the paintings' exhibition meant that Freer did not receive them in Detroit until the autumn of 1890, he would have had no place to put them even then in the rooms he was renting in a small house on Alfred Street.[117] Plans for a new home were already under way when Freer and Tryon met, however, and Freer's indication that he meant to hang *The Rising Moon* and *The Sea: Sunset* as pendants suggests that

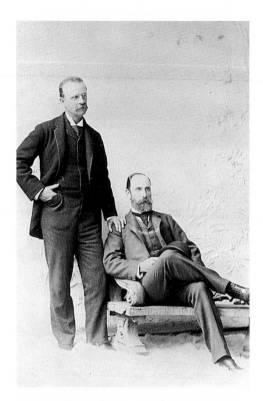

Fig. 47 Frank J. Hecker and Charles Lang Freer, 1880s. Albumen cabinet card. Freer Papers/FGA.

the impending need for interior decoration may have motivated his purchases.[118] In 1884, Freer and Frank J. Hecker bought out their partners in the Peninsular Car Works and founded the Peninsular Car Company; their fortunes rose precipitously as the company erected a new plant and acquired two railroads, the Lake Shore and Michigan Southern and the Grand Trunk. Prosperity assured, Hecker and Freer each purchased—in cash—two lots on the north side of Ferry Avenue, a fashionable new residential street that was expected to become the handsomest in town.[119]

The houses Hecker and Freer built on adjacent acres reveal differences not only in matters of taste but in manners of life. Hecker's flamboyant mansion, designed by Louis Kamper and modeled on the Château de Chenonceaux near Tours as an allusion to Detroit's French heritage, was constructed with entertaining in mind: the doors separating the colonnaded reception hall from the parlor, music room, and dining room on the first floor could be rolled back to create an enormous ballroom. Freer's home, on the other hand, was a somber, shingle-style house constructed of stone from a quarry near Kingston, New York, and plainly intended for a quiet, mostly solitary life: on the first floor the comparatively modest library, parlor, and dining room were grouped around a foyer, and on the second a single spare room suggested that Freer did not expect to accommodate more than one or two guests at a time. The interior of the house, oriented toward the gardens with enclosed porches, balconies, window seats, and skylights, reflected Freer's taste for light and space; and its many conveniences (total electric wiring, house telephones, built-in bookshelves, cupboards, commodious closets and cabinets with cedar-lined drawers, twelve fireplaces, and a wood-carrying elevator from the basement) expressed his intention to live a comfortable and gracious life.

The architect was Wilson Eyre, whose houses in the Germantown section of Philadelphia Freer had admired.[120] Eyre submitted plans for Freer's approval on the tenth of April 1890, and that same afternoon, Freer visited Tryon's studio to see *The Sea: Sunset* framed and ready to send to Detroit. Apparently, he brought the blueprints with him to ask for the artist's opinion.[121] "The plans for your new house I have studied with much pleasure," Tryon responded two weeks later, objecting only to "two diamond shaped windows" that were, he thought, "out of harmony" with the rest of the plan: "The whole character of the house is so large and ample that any tendency to pettiness of detail must injure it."[122] What Tryon read as "windows" were in fact decorative motifs in the shingling, but Freer accepted his judgment all the same and seems to have abided by Tryon's advice in other respects as well, since much of the interior detail in Eyre's plan was subsequently simplified.[123]

From his cottage at South Dartmouth that summer, Tryon inquired how Freer's

Fig. 48 View of East Ferry Avenue from Woodward Avenue, Detroit, ca. 1893, showing Frank J. Hecker's home in the foreground and Freer's beyond. Burton Historical Collection, Detroit Public Library, Michigan.

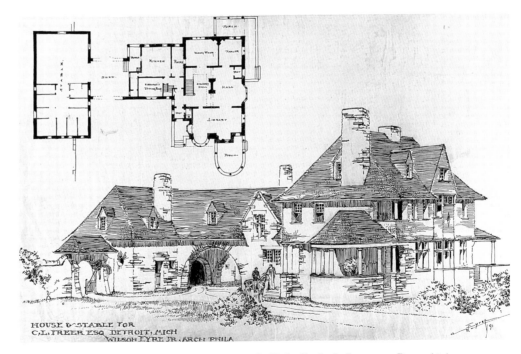

Fig. 49 Wilson Eyre, Jr. (1858–1944), *House and Stable for Charles L. Freer,* 1891. Pen and ink on paper, 16¼ × 24¼ in. (41.3 × 61.6 cm). The Detroit Institute of Arts, Michigan; Gift of Miss Louisa Eyre.

new home was coming along,[124] but not until March 1891, nearly a year after he had offered his opinion on its design, did Tryon express professional interest in the project. "I want to see you some time before your house is completed as I desire to do some work of a special kind for it," he said, "or at least to make you a proposition which you can follow or not as you feel inclined." Although Freer's letter in reply has not survived, it appears that he agreed enthusiastically to Tryon's offer.[125] One month later Freer received the artist's sketch of a landscape painting hanging in place above a mantel (fig. 50).

At that time the painting itself seems to have been almost incidental to his plan. Tryon's drawing is less a preparatory sketch for a work of art than an indication of the environment he hoped it would occupy—the hearth of Freer's home. Two options were presented for Freer's approval: an arch on one side of a fireplace, which Tryon thought "rather too cold," and a portiere on the other, which looked "more homelike" and was, Tryon said, "finer in every way, more in harmony with other forms and giving a chance for color which is invaluable in its effect on the room." In volunteering to paint a picture or two for Freer's house, Tryon seems to have assumed responsibility for all the details of their setting. He began searching for suitable fabrics to cover the side walls, calculating the most agreeable size for the picture frames, and considering the design and finish of the other woodwork so that everything would be in keeping architecturally and "in harmony" with the pictures.[126]

Fig. 50 Sketch of a fireplace, 1891. Graphite on paper, 5 × 8⅛ in. (12.5 × 20.5 cm). Included in a letter from Dwight W. Tryon to Charles L. Freer, 5 April 1891. Freer Papers/FGA (10A).

Tryon's participation in the decoration of Freer's house was not, therefore, confined to canvas. His interest in creating a complete and harmonious setting for works of art recalls the celebrated interior decorations of Whistler and other exponents of the English Aesthetic movement, such as E. W. Godwin and William Morris; the concept of the House Beautiful became current in America during the decades following the Centennial Exposition. Working closely with Eyre, Tryon proved an exemplary aesthete. The artist and architect discussed everything they could think of in connection with the project—"even the colors of all rooms leading out of hall so a perfect harmony may be felt between them"—and in their efforts to perfect an artistic environment remained considerate of their patron's pleasure. They decided, for example, to panel the spaces behind Tryon's paintings in oak so that the room would appear aesthetically complete even when the paintings were away on exhibition.[127] Freer also commissioned Thomas Dewing to oversee the decoration of the parlor and Frederick S. Church to execute a painting for the dining room. Confident in their talents, Freer gave them liberty to do whatever they pleased.[128]

This record of extraordinary cooperation stands in contrast to the history of the era's most famous interior decoration project, the Peacock Room. Whistler's magnificent *Harmony in Blue and Gold* had almost entirely obscured the achievements of the designer, Thomas Jeckyll, and his presumptuous behavior and arrogant demands had alienated his patron, Frederick R. Leyland. Tryon may have been aware of the precedent of the Peacock Room, for he carefully communicated every intention to his patron. The drawing Tryon sent Freer early in April (fig. 50) could be taken to mean that the decoration he originally envisioned would not have extended beyond the two overmantels; indeed, Tryon maintained that when he first made his "proposition" he had no idea the room would require so many paintings.[129] But Tryon enclosed in his next letter to Freer a plan showing seven spaces in the hall for pictures (fig. 51), and by the end of the month had provided an estimate of his fee. Because at least four of the works would be large (no less than six feet wide) and he wanted the paintings to reflect credit on them both, Tryon advised Freer that the preparation and execution of the project would be sure to occupy his time for the "best part of two years," so that the cost of the commission would be five thousand dollars—less if the paintings took less time than predicted. "I wish above all things to have you know the extreme limit first," Tryon said, "as I dread misunderstandings of all kinds."[130] Freer agreed without hesitation to Tryon's terms, relieving the artist of his fear that their conceptions of the work's importance might not agree. There were few people in the world for whom he would undertake so formidable a project, Tryon said, but he felt sure in this case he had only to follow his instincts—"I know that if I can robustly satisfy myself in the

Fig. 51 Sketch of spaces for paintings in the hall, 1891. Ink on paper, 8¼ × 5½ in. (21.0 × 14.0 cm). Included in an undated letter from Dwight W. Tryon to Charles L. Freer (after 5 April 1891). Freer Papers/FGA.

work you will with your usual sympathy appreciate it."[131]

Although Tryon still had not mentioned the program of the pictures, it may have been a subject for discussion when Freer paid the first of many visits to the Tryons in South Dartmouth that summer.[132] When Tryon returned to New York in November, however, his mind was mostly on the frames he wanted Eyre to design, which should be "appropriate for landscape (leaf pattern or something of that kind) and at the same time suggest an affinity to the wood work of the room."[133] By Christmas 1891, Tryon had secured accurate measurements of the spaces in which the pictures would hang but had not yet ordered the canvas.[134] In fact, Tryon did not mention working on the paintings themselves until mid-February, when he suddenly announced that the pictures were in progress. One week later he wrote Freer that because he had spent adequate time preparing for the project, the actual work was going faster than he had dared to hope; two of the panels, *Springtime* and *Summer* (cat. nos. 8 and 9), were "advanced enough" for Freer to see when he visited New York.[135]

Over the course of two years, then, Tryon produced a cycle of four seasons, a dawn landscape, and two marine paintings for Freer's main hall. The landscape theme was particularly appropriate to Freer's house, in which the interior was architecturally related to the gardens; and the two seascapes, *The Sea: Night* and *The Sea: Morning* (cat. nos. 6 and 7), though less successful on their own, probably created a pleasing effect in place, catching and containing morning and afternoon sun from their positions on either side of the front bay window. Each of the paintings would be exhibited independently on occasion, but Tryon and Freer always regarded them as an "ensemble,"[136] orchestrated to be an "integral part of the room," the artist later explained,

> and [to] carry out, as far as possible, the classic purity of the design. For this reason I kept the flat horizon lines in the four panels of the same height. The horizontal lines of the ground, supplemented and offset by the verticals in the trees, seemed to make them a part of the architecture of the room.

Tryon said that everyone who saw the hall "felt that, in a mysterious way, the pictures fitted and completed the whole thing."[137] Indeed, when Royal Cortissoz referred to this group of paintings as Tryon's most important work, he observed that the artist had preserved the "intrinsic symmetry of landscape—the symmetry that falls instantly into line with the poise of architectural things."[138]

But the execution of the panels was only the beginning of the project. Freer himself prepared a stain for the oak paneling, rubbing the wood with solutions of iron rust and water until Tryon assured him that he was "on the right track."[139] The side

walls presented a greater challenge. Tryon initially intended to have them covered with fabric, suggesting to Freer that he order specially designed silks from Cheney Brothers, tinted Japanese burlap, or East Indian grass cloth.[140] But because Freer did not care for "stuff on the walls,"[141] Tryon had to devise some other solution. Convinced that "paint on walls is at best cold and formal, and no tint can be mixed flat which is satisfying," he began to imagine a "warm quiet harmony" for the room, and finally envisioned a "gradual introduction of blue—say over silver or gold." W. C. LeBrocq, a New York decorator Freer had engaged to assist in "deciding arrangements of color," was instructed to carry out the elaborate decoration under Tryon's instruction.[142] He arrived in June to deck the walls and ceiling with sheets of dutch-metal foil and layers of lacquer and semiopaque glazes, a process Freer would later describe in meticulous detail.[143]

Although Tryon and Freer may have discussed the possibility of Tryon's traveling to Detroit as early as March 1892, the trip had to be postponed until the following fall because Mrs. Tryon was troubled with fainting spells and Tryon himself hated to miss even a day of the summer season.[144] Fearing that Freer's decorator had a "tendency to too crude color," Tryon selected samples for other rooms in the house but could make no final decisions, he said, until the carpets and "other color masses" were fitted.[145] Throughout the summer Freer attended to a number of pressing details (light fixtures, wood carvings, furniture orders),[146] and when he visited the Tryons in South Dartmouth and the Dewings at their home in Cornish, New Hampshire, took along the architect's photographs of the house for them to admire.[147]

Late in November, Freer moved into his still-undecorated house, and the Sunday after Thanksgiving the artists finally arrived.[148] After LeBrocq's summer work the hall looked like the inside of a copper kettle, but Tryon had warned Freer that it might be a "trifle gorgeous for a time."[149] He went to work immediately, applying irregular patches of vandyke brown and antwerp blue to the surface of the walls, blending the paint into the dutch-metal leaf with a large brush, then treating the ceiling the same way, using strokes of cobalt blue.[150] (One of Freer's contemporaries insisted that the "curiously mottled, thrush-egg effect" of the ceiling had been achieved by workmen lying on their backs, throwing into the air sponges "soaked in some queer kind of Dutch oils."[151]) Unfortunately, the decoration has not survived—though the house still stands on East Ferry Avenue—but according to Henry White, the walls were "ideal as backgrounds, keeping their place, subordinate to the decorations, and yet glowing with a quiet richness, handsome in color themselves."[152]

The final touch to the hall was a dark blue trim, the conception of Maria Oakey Dewing, an accomplished artist and acknowledged expert on interior design. Tryon

objected to the idea from the start,[153] and Eyre agreed that the border would detract from other beauties of the hall; but on this issue Freer held firm. "At first sight it does seem conspicuous," he conceded,

> that is, it differentiates so much from other things in the hall that it almost suggests lack of harmony, but without it the hall would be much less attractive. We tried very many effects—dozens of them in fact—but finally decided that Mrs. Dewing was right in [her] original suggestion.

After living with it for a week or two, both Tryon and Thomas Dewing "decided it was very 'swell.' I myself," Freer wrote Eyre, "am very much in love with it."[154]

The artists were home again by Christmas, and LeBrocq had nearly completed his work before the year was over.[155] By spring the light fixtures for the hall were in place, the blue-and-gold fabric Tryon selected for the portiere had been approved, and the bench he designed had been ordered from A. H. Davenport and Company of Boston.[156] With the shipment of *Winter* (cat. no. 11) in April, Tryon's responsibility for the Freer house appeared to be over. He felt relieved to be through with the project even though it had been the most delightful experience of his life, he said, "and in some ways the most instructive."[157] But in 1897, Freer asked Tryon to execute one more painting for the house—a large work to hang in the gallery of the upper hall, which Tryon decided to undertake as soon as he was assured that he was not "claiming too large a share in the 'House that Freer built.'"[158] When *Early Spring in New England* (cat. no. 20) was delivered to Detroit, it took its place, Freer said, as the "guardian-like leader" of the ensemble.[159]

In the end Freer was so well satisfied with his "little house in Detroit" that he wrote Tryon from a ship en route to Ceylon that in all his foreign travels he had found nothing to compare. "Its quiet, modest air contrasts strongly with the pomp and show of the Continent," he said. "As for its contents; the paintings, well, I have found nothing for which I would exchange them, and there is nothing against which one need hesitate to exhibit them before an intelligent and fair minded jury."[160]

FREER became so devoted to Tryon's art during the decoration of his house that he wrote Wilson Eyre in 1893, "I know it will do your soul good to appreciate Tryon. Poor Inness is sure to be forgotten while Tryon will live forever."[161] At the end of the nineteenth century, when George Inness was generally considered the greatest landscape painter in America, perhaps the world, Freer's prophecy would have sounded

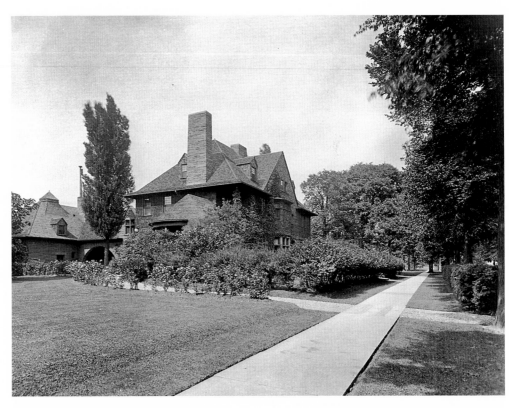

Fig. 52 Freer's house at 33 East Ferry Avenue, Detroit, 1904. Platinum print. Freer Papers/FGA.

even more extravagant than it does today. The comparison itself, however, was not uncommon: contemporary critics often remarked the resemblance of Inness's amorphous effects to Tryon's ethereal ones.[162] Freer would have had the opportunity to judge their work side by side. In 1891 he had purchased from Thomas B. Clarke a painting he considered "one of the dozen masterpieces" by Inness, *The Home of the Heron* (fig. 53). Within a few months of communicating his conclusion to Eyre, Freer was attempting to dispose of it. To William Macbeth, Freer explained that he lacked a suitable space for the painting in his new house; to his friend William Bixby, Freer confided that he had "tired completely of the picture."[163] It was the "greater refinement" of Tryon's art that held his attention, Freer told Eyre—"and I have always known that the truth would sooner or later be yours. Now that you have re-discovered Tryon, I am happy."[164]

So convinced of Tryon's talents was Freer that he allowed *The Rising Moon* to travel to the International Art Exposition in Munich in 1892 ("It is a fine idea to let the

Europeans see the good work now being done by our home artists"[165]) and generously lent works to the World's Columbian Exposition the following year. Among the fourteen paintings by Tryon on view in the Fine Arts Building were two pairs from Detroit: *The Rising Moon* and *The Sea: Sunset* (cat. nos. 3 and 4), and the decorative panels *Springtime* and *Autumn* (cat. nos. 8 and 10).[166] Freer was so taken by the display that he wrote Thomas Dewing,

> After careful study at the Fair, I am more thoroughly impressed than ever that the art of yourself, Tryon, Thayer and Whistler is the most refined in spirit, poetical in design and deepest in artistic truth of this century.[167]

His conviction that contemporary American art could hold its own with the finest paintings in Europe confirmed the opinion Tryon had formed upon seeing the Society of American Artists exhibition after his sojourn abroad. By 1893 and the crowning event of the American Renaissance, Tryon had joined the exalted company.

Indeed, during the years of the Freer commission, Tryon was moving ever closer in style to Thomas Dewing, whose work he had particularly admired in 1881. Were it not for a difference in size, Tryon's *Midsummer Moonrise* (fig. 54) of 1892 could be the pendant of a painting Dewing produced the same year, *After Sunset* (fig. 55), a portrayal of two women in a landscape not unlike Tryon's verdant glade. Both of these dreamlike scenes, vaguely illumined by a moon rising just above the trees, display the artists' sensitivity to tone (their opalescent colors are modulated like the wall surfaces of Freer's house) and appear to represent that "poetic and imaginative world," as Dewing was to describe his decorations, "where a few choice spirits live."[168]

The artists' aesthetic coincidence was turned to collaboration in 1893 for the purpose of painting a triptych (figs. 56–58) for Freer's neighbor, Frank J. Hecker. Freer sent Tryon a sample of the wall covering of the room in which the triptych would hang so that the panels could be harmonized with the intended surroundings, and Tryon painted his part of the project in sight of Dewing's panel.[169] The triptych was installed as a surprise for the Heckers, who were vacationing in the Sandwich Islands, and when Freer saw the finished work in place in the parlor he was impressed by the "general harmony of the effect."[170] Painted thinly and loosely over coarsely woven canvas, Tryon's cool, pale *Spring* and *Autumn* limit the exultant emotion released in Dewing's *Summer,* a larger and more elaborately framed picture that is clearly the centerpiece of the composition. Tryon's strictly architectonic seasons have little personality of their own. As Kathleen Pyne has pointed out, "Tryon's vision is impersonal, 'scientific,' and Oriental, in that the painter's own mood does not color or interpret the scene."[171]

Fig. 53 George Inness (1825–1894), *The Home of the Heron,* 1891. Oil on canvas, 42 × 37 in. (106.5 × 93.5 cm). The Art Museum, Princeton University, New Jersey; Gift of Stephen Harris and David Harris, in memory of their father, Victor Harris.

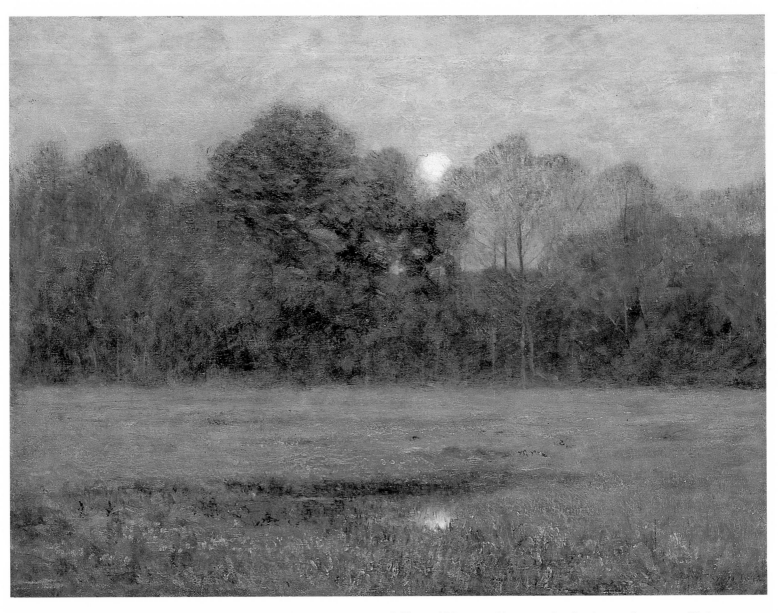

Fig. 54 *Midsummer Moonrise*, 1892. Oil on wood, 19 × 24⅝ in. (48.7 × 65.1 cm). National Museum of American Art, Smithsonian Institution, Washington, D.C.; Gift of the International Business Machines Corporation.

This distinctly decorative phase of Tryon's development was limited, however, to a few years and a handful of canvases. Tryon himself would say in reference to the paintings of that period that they could neither sustain extended examination nor "stir the emotions as deeply" as his later and, to his own thinking, greater works of art.[172]

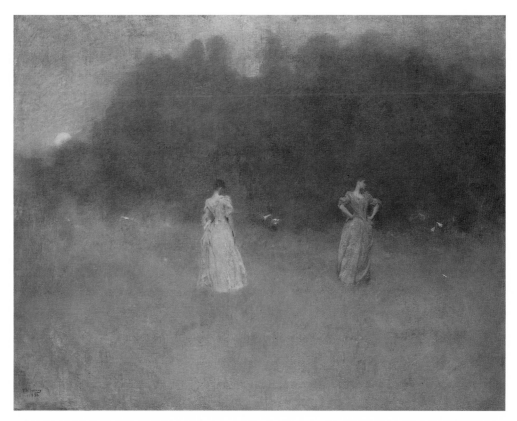

Fig. 55 Thomas Wilmer Dewing (1851–1938), *After Sunset,* 1892. Oil on canvas, 42⅛ × 54⅛ in. (107 × 137.4 cm). FGA (06.68).

Indeed, Tryon's inclination toward art for art's sake was balanced and finally overcome by an intention altogether different, arising from his "affectionate intimacy," as Charles Caffin phrased it, with the countryside surrounding his summer home. "It seems to me every country has a soul as well as a body," Tryon said, "and this soul is what is really worth giving expression to in Art." [173]

As an important premise to that point of view, Tryon stated that the "spirit of art reveals itself to the ardent lover only." [174] By the mid-nineties he was involved in a relationship with the Dartmouth countryside that can only be called romantic: "A painter ought to be like an enraptured swain—who sees more in his girl than is visible to any one else." [175] Certainly the object of his affection (a "dreary waste of upland or meadow," as one critic described the landscape) would not appear to inspire devotion; but "entire familiarity with all the physical facts must precede an understanding of the

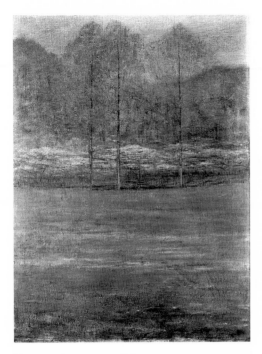

Fig. 56 *Spring,* 1893. Oil on canvas, 40½ × 31½ in. (102.87 × 80.01 cm). The Detroit Institute of Arts, Michigan; Bequest of Frank J. Hecker.

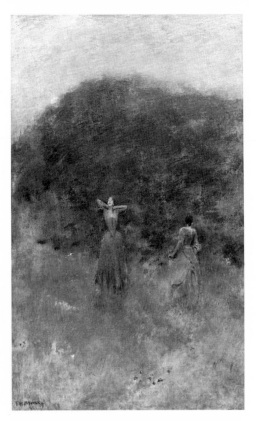

Fig. 57 Thomas Wilmer Dewing (1851–1938), *Summer,* 1893. Oil on canvas, 50½ × 32½ in. (128.27 × 82.55 cm). The Detroit Institute of Arts, Michigan; Bequest of Frank J. Hecker.

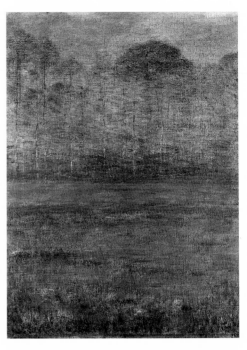

Fig. 58 *Autumn,* 1893. Oil on canvas, 40½ × 31½ in. (102.87 × 80.01 cm). The Detroit Institute of Arts, Michigan; Bequest of Frank J. Hecker.

higher truths," Tryon maintained. Art he defined as "love and sympathy with some near and homely thing."[176]

Having found the love of his life, Tryon never looked at another landscape. His fidelity was so unyielding that his friend Elbridge Kingsley despaired of persuading him even to paint the countryside around Hadley, Massachusetts, one hundred miles away.[177] Condemning those landscapists who would promiscuously "flit from country to country or, at least, from place to place, noting only the superficial features,"[178] Tryon rarely ventured outside the orbit of New England from the time he took up residence there, and never expressed the slightest desire to see more of the world than he already had. "One may travel long and never find the same or as fine a country as New England," he wrote Henry White in 1897. "And this is right; to the properly balanced mind the charm of one's native soil speaks a deeper language than any other."[179]

Freer, who lived for "glimpses of faraway coasts and strange horizons," conceded that Tryon was right not to travel, since the "interesting scenes met with on an ex-

tended foreign trip would unbalance results." [180] So finely attuned to his native soil that passing from New England to New Jersey felt like entering another world, [181] Tryon recognized nature as the symbol of his soul. "I doubt if by any but the landscape painter can this be understood," he said in words redolent of romanticism,

> the effect of the subtle under-charm, the faint reminiscences of childhood days, the memories of many a day afield, and who shall not say that even pre-natal memories come in the form of intuitions too subtle to define and, often unconsciously transferred to the picture. [182]

Tryon's landscape paintings represent a late flowering of American transcendentalism.

It has not gone unnoticed that Tryon's spirituality owes much to the philosophy of Ralph Waldo Emerson, whose works he might have known from the bookstore in Hartford. [183] He owned two volumes of Emerson's *Essays* and on at least one occasion advised a friend to read the "Essay on Art." [184] Beyond those facts, however, the connection is purely conjectural. Emerson's influence may be assigned to the early stages of Tryon's artistic development, when he was producing pictures of a universe in which the "light of higher laws than its own" appeared to shine through: the famous "transparent eyeball" image evokes the supernatural clarity of luminist landscapes and marines. [185] Yet the tenets of transcendentalism seem to have had a more profound impact on Tryon's art later in his career, when he had earned the leisure that allowed him to experience the "perfect exhilaration" in nature that Emerson enjoyed.

If Tryon's knowledge of Emerson remains largely undocumented, his dedication to Henry David Thoreau is a matter of record. Among the books in Tryon's library were the ten-volume *Writings,* published in 1894–95, and *Familiar Letters* of 1895; even if he had known the works of Thoreau for years, Tryon evidently continued to collect them throughout or even beyond the 1890s. In a letter of 1918, Tryon instructed George Alfred Williams to read *Cape Cod* and *Walden* and quoted from memory a passage he had read years before. He urged Walter Copeland Bryant to study Thoreau, declaring that reading his essays was "like seeing nature itself": Thoreau, Tryon wrote, was the "best landscape '*word*' painter." [186]

The attraction of *Walden* (which Henry White termed "Tryon's Bible" [187]) is not difficult to discern. In Thoreau's essay about life on Walden Pond, Tryon would have caught glimpses of his life on Buzzard's Bay. The scenery of Walden, like the landscape of Dartmouth, was "on a humble scale, and though very beautiful, does not approach to grandeur, nor can it much concern one who has not long frequented it or lived by [the pond's] shore." Furthermore, Thoreau, like Tryon, had cause to complain that the

vision of his contemporaries did not "penetrate the surface of things"—and it was the surface of Dartmouth, Tryon believed, that belied its exquisite soul. Perhaps more attractive to Tryon was Thoreau's belief that philosophers and poets were at a disadvantage in nature, while "those who spend their lives in the fields and woods, in a peculiar sense a part of Nature themselves, are often in a more favorable mood for observing her."[188] Every summer for the rest of his life Tryon, a "nature lover and fisherman,"[189] would journey to South Dartmouth to live deliberately.

❧ ❧

THE PATTERN of Tryon's existence was set from the time he built his house in South Dartmouth, and for the remaining forty years of his life its course was rarely disrupted. His landscapes reflect that regularity. Charles Caffin admitted that Tryon's works, while exhibiting over the years "increased acquisition of facility and the power to render more penetratingly the mood of nature," displayed little "evolution of motive."[190] Indeed, the theme is almost always the same; modern eyes may find it monotonous. But Tryon never tired of the pastures near Padanaram. Every spring, year after year, he returned after a winter's absence to a landscape so familiar he could paint it from memory, finding it essentially unaltered yet never quite the same. By concentrating his attention on a single subject, a stand of trees spanning a vacant meadow, Tryon was able to explore through his art the nuances of change that appealed to him in nature.

Tryon left the city every year in April, arriving in the country before winter had quite departed, in order, he said, to catch the spring.[191] Tryon's letters indicate that the weather was usually cold, wet, and bleak at first: "We arrived here yesterday and find as yet no vestige of leaf or bud and as the wind howls over our heads it seems more like winter than summer. Nevertheless," he wrote one April, "it is fine and free and I love it all."[192] In fact, Tryon considered the cold sea air one of the advantages of South Dartmouth, since it held back the foliage and left nature "trembling on the verge of a resurrection."[193] The delicate color tones of the countryside during the last weeks of April appealed to Tryon's preference for a limited palette, and he appreciated the contours of the trees that showed through the budding branches, as in *Early Dawn* (fig. 59). But the coming of May, and the advent of a more effusive stage of the season, never failed to fire Tryon's enthusiasm. "We are now in all the glory of a New England spring," he wrote Freer, "budding, leafing and blossoming things in every direction— a veritable resurrection!!"[194] Although he wished for materials of a "finer nature than paint" to translate springtime into art, Tryon represented more scenes of spring than any other time of the year.[195]

As spring slipped into summer, Tryon painted less and less. "I do some sailing

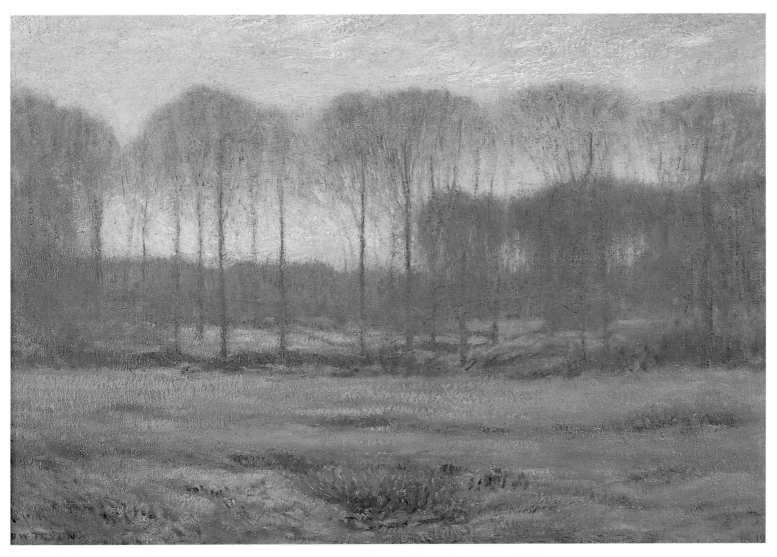

Fig. 59 *Early Dawn,* 1900. Oil on panel, 20 × 30 in. (50.8 × 76.2 cm). Collection of Mr. and Mrs. Willard G. Clark.

and fishing and have completed two small pictures," he said in one August letter, "but as the dark greens of summer do not very strongly appeal to me, I am taking it rather easy during the warm weather."[196] In 1894 he built a studio south of his house, but because only a succession of rainy days could drive him indoors, it soon became a storehouse for fishing tackle and sailing gear.[197] Tryon maintained, however, that he was "absorbing material for art" even as he worked in his garden or painted his boat, and when he went fishing he did not neglect his profession: "Subconsciously I study

Fig. 60 "D. W. Tryon. A Critical Moment," ca. 1910. Photographic postcard. Tryon Papers/FGA.

the sky, the water, the trees, storing up in my mind impressions for future use."[198]

Tryon was famous as a fisherman. Padanaram natives used to say that he could catch fish even when there weren't any.[199] He went out every day, frequently fishing off the pier in front of his house, and tried for night-feeding frost fish when the weather got cold.[200] He devised a leopard-wood fishing rod said to be the "best ever invented," and tied flies to send professionals into despair.[201] (Indeed, Tryon asked that the journal in which he specified flies for every day of the year be destroyed upon his death so that its secrets could not become common knowledge.[202]) He boasted to his friend William Bixby in 1904 that he had caught in a single month more than two hundred sea trout ranging from three to ten pounds apiece, and told Walter Copeland Bryant that in 1905 alone he had brought in about one and a half tons of fish.[203] His neighbors would line up at the wharf each evening for a share of fresh fish; a particularly voluminous catch could depress the local market. In search of still-richer waters Tryon sometimes made brief trips away from home. For many years after 1907 he traveled to Ogunquit, Maine, each September to fish for the pollack that returned to the river from the sea.[204]

Tryon also gained local renown as the "most consummate boatman" in Dartmouth, a measure of respect that pleased him more than all the professional honors he

Fig. 61 Tryon camping in Canada, 1898. Nelson White Papers/AAA.

Fig. 62 Dwight W. Tryon in *Alice*, ca. 1910. Photographic postcard. Tryon Papers/FGA.

ever received.[205] His first cruising sailboat (fig. 62) was built to his specifications at Fairhaven in 1885 and christened *Alice;* according to Henry White, Tryon's boat was the first and for a while the only pleasure craft in the waters of Padanaram.[206] A few years later Tryon designed a catboat named *Vera* that sailed, he said, like a bird. In a race on Decoration Day in 1894, his boat beat all the others in its class and the three classes lighter, and Tryon crowed in triumph that "no boat in this vicinity ever stirred the bogs up so much."[207] Clearly, Tryon made the most of the golden days of summer, spending as much of his time as possible "on the water and in the fields" and rising each day at four to "enjoy the moods of nature denied to those who sleep late."[208] There was so much to do during his vacation that he kept busy from morning till night, trying for "continuous out of doors."[209] But when the first frost fell, Tryon laid up his boat and, if the weather remained constant, began to make studies directly from nature.[210]

In the early decades of his career Tryon rarely painted autumn scenes because, he said, they made him think of death.[211] But as time went on he began to observe the aesthetic advantages of the season that would become, after early spring, his favorite. When the leaves began to fall, the "wonderful anatomy of the trees" that Tryon loved to paint—as in *Autumn Day* (fig. 63)—became apparent once again.[212] As Peter Bermingham has noted, many American landscapists of the late nineteenth century "replaced the joyous cacophony of Jasper Cropsey's Hudson Valley autumns with a mellowness that metaphorically approximates the muted tones of the 'Brown Decades.'"[213] Tryon in particular preferred the somber shades of late October and November to the flaming foliage of a high New England autumn. "The country is a perfect egg of color just now," he wrote to Freer one October, "and when it sobers down a trifle I hope to get some studies of interest."[214]

Tryon was always impatient for the leaves to turn because of his unavoidable departure late each November. The Cottage was heated only with open fireplaces, and the Tryons were always uncomfortable in cold weather.[215] "I wish the winter were less rigorous so that we might remain a longer time in the country," Tryon wrote Freer, "but alas! the New England climate is a hard one, and the city is at least a refuge."[216] Moreover, as he confided to Walter Copeland Bryant, he knew that if he lived permanently in the country he would get lazy and paint very little.[217] Indeed, his autumn letters reflect the lassitude of South Dartmouth. "I would have answered earlier but had nothing special to say as one day is so like another here that it seems as if time was of no account," he wrote one November. "With us there is little new," he said another year, "the tide ebbs and flows through the same old bridge."[218]

The languorous life of the country, like the Lotus Land, gradually subdued

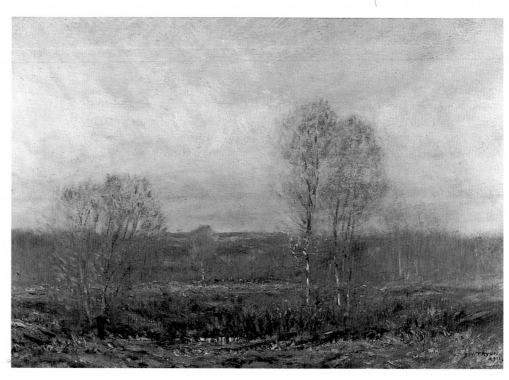

Fig. 63 *Autumn Day,* 1911. Oil on board, 10½ × 15½ in. (26.7 × 39.4 cm). The New Britain Museum of American Art, Connecticut; Gift of Howard Bristol.

Tryon's spirit and diminished his ambition; inevitably, he would begin to look forward to winter in the city. "Don't hurry back," Freer admonished Tryon in 1901,

> New York is more deadly than ever. The streets are so crowded one can scarcely prevent being crushed, and the construction of the underground railway is causing lots of confusion. Gas-pipes, water-mains, and sewers are being torn right and left, and the odor of escaping gas, etc., fills the city with the deadliest of stenches. You had better stay in the "land of rest" until the frost shall have killed off some of the city microbes.[219]

Freer recognized that after the peace of Padanaram, the city was bound to feel especially oppressive; and year after year Tryon found that New York, in comparison, seemed like Hades.[220]

The Tryons' winter home at Central Park West and Sixty-Fourth Street distanced them from the atrocities of the streets. Chairs were drawn up before the east window of the Harperley Hall apartment so that Dwight and Alice could enjoy a commanding

Fig. 64 Tryon's Harperley Hall apartment, New York, after 1910. Tryon Papers/FGA. The painting on the wall is *The Wave* (see fig. 80).

Fig. 65 Tryon in his studio, Harperley Hall, New York, ca. 1920. Nelson White Papers/AAA.

view of the park. "If we must submit to city life," Tryon wrote Freer, "we are as pleasantly situated as it is possible to be." [221] In the parlor a painting by Thomas Dewing called *The Garland* hung over the mantel,[222] and several of Tryon's own works lined the walls; at one end of the room pieces of pottery were tastefully arranged above shelves holding Tryon's collection of rare and beautifully bound books.[223] The centerpiece of the dining room was a sixteenth-century Madonna (which Tryon declared the finest in the country), together with the painting *Indian Encampment* by Ralph Blakelock, one by Wyant, and two Venetian works attributed to Canaletto.[224]

But most of the artist's winter hours were spent in the sky-lit studio (fig. 65) adjoining the living room. Its walls were covered with Japanese grass cloth (presumably the material Tryon had suggested for Freer's house),[225] and on one of them hung a large Flemish tapestry that Tryon used as a background for his paintings because, he said, "it harmonized with everything." Henry White recalls that in Tryon's studio there was no "confusion of painting materials or unfinished pictures," only a small stand with Tryon's palette and a Japanese vase filled with brushes. One or two easels supported works in progress; finished pictures could be viewed beneath a canopy designed to shade the eyes from the glare of daylight. Propped upon the mantel was a Japanese print that Tryon admired "from a colorist's point of view," and beside it sat some Japanese ceramic pots he gazed upon to refresh his vision whenever his pictures began to look dull.[226]

Except for occasional studies of Central Park in snow, Tryon's oeuvre almost entirely omits winter from the cycle of seasons. He disliked it pictorially—"especially snow scenes"—and harbored indignation against the cold and its concomitant ills. "I am just recovering from an attack of the grippe," he wrote a friend one January. "People ask me why I no longer paint winter, bah! The good summer time for me." [227] Tryon spent his months in New York, therefore, committing fond memories of warmer days to canvas. Empowered by a summer of physical activity, he would be caught up "in the whirl of work" with several pictures under way during the first month or two following his return to the city. He painted every day "until dazed or drunk," he said, "with the excitement of work." [228] The city was a stimulant that released him from the lethargic spell cast by the country: "No sooner do I strike New York than I begin to work like mad," Tryon told Freer. "There seems to be a vital force which goads one on here to work to the limit." [229] Tryon painted so feverishly at first that he hardly knew when to stop—"As my mind keeps ahead of my hand I find it a constant delight and a temptation to work rather too hard"—and the strain would become eventually more than he could stand; nearly every winter he suffered a temporary collapse before he could finish the season's work.[230] When his mind had worn thin from painting, Tryon

took up his "knitting work" (his phrase for tying flies) and constructed fishing rods in preparation for the summer season.[231]

As early as February, Tryon began looking forward to spring, and sometime during the next month he usually came down with "fishing fever."[232] He wrote Henry White one March:

> Especially now that the birds have come and an occasional thunderstorm, I find it hard to content myself in the city and my thoughts turn naturally to fish and fishing. Painting is a back number and it requires moral courage at this season of the year to face a panel and try to depict the charms of nature with memories dimmed by distance.[233]

The last days of winter he spent reading books and studying works by other artists, counting the days until he could return to the "fountainhead" of inspiration. "We are anxious to shake the dust of the city from our feet," Tryon once wrote Freer a few days before departure, "and get among the birds and fishes."[234]

❧ ❧

THE PSYCHOLOGICAL advantages of the artist's way of life become apparent in the equilibrium of his art. Duncan Phillips observed that the salient characteristic of Tryon's style was the perfect balance he achieved between observed facts and genuine emotions; Charles Caffin, for lack of a better term, named the artist a "Realist-Idealist."[235] Tryon's annual sojourn in South Dartmouth provided raw material for landscapes, but it was in New York that visual facts were transmuted into art. The urban environment caused him to recreate his "country joys": had he lived permanently in South Dartmouth, Tryon said, he would not have needed to create an "ideal country."[236]

Through exile from the subject of his paintings, Tryon discovered that the mind was not only a mechanism of memory but also an instrument of selection. In his volume of *W. M. Hunt's Talks on Art,* Tryon marked the passage: "Keep yourself in the habit of drawing from memory. The value of memory-sketches lies in the fact that so much is forgotten." He inscribed in the margin: "The less imitation the more suggestion and hence more poetry."[237] Working from recollection, Tryon subdued the colors of the landscape and eliminated detail; his paintings show a beloved scene made indistinct by distance. Images stored so long in the mind's eye could hardly have evaded the glamour of nostalgia.

If conjuring visions of South Dartmouth came easily, finding the means to translate his sensations was fraught with difficulty.[238] Every painting was a problem, he said,

with a different "dominating idea" to preoccupy him. Freer maintained that the better Tryon painted, the better he wanted to, but the artist himself despaired of ever feeling that improvement was certain.[239] Convinced that art should exhibit a "clear and sane method of procedure," Tryon labored all his life to relate the conception of a work of art—"art thought"—to its "technical expression."[240]

In his search for ways to convey his impression of the landscape, Tryon experimented with various materials. He attempted watercolor painting but did not care for the results,[241] and the few works he did produce in opaque watercolor, or gouache, tend to assume the appearance of pastel. Tryon initially considered powdered chalks on paper too fragile a form to merit much attention, but after years of experimentation he began to layer applications of pastel and fixative—to fix the paintings "from the foundation up" as he phrased it, making them more permanent; and he came to appreciate the corresponding changes in color that allowed him to achieve "more perfect atmospheric relations."[242] Pastel paintings, however, were too fragile for repeated reworking, and Tryon liked to revisit his landscapes a number of times. Because it could sustain repeated manipulation, oil painting was the medium Tryon found most satisfying and efficient.

During the early years of his career Tryon often worked on canvas, and his thinly painted decorative panels depend upon the texture of the weave. But his customary support was a wood panel, mahogany-faced plywood one-eighth-inch thick, prepared with a ground of pure white.[243] Beginning with brilliant colors, Tryon would structure a vigorous composition, then paint over the pattern a more detailed picture modeled "in a violent key of color, forced to the extremity of crudity and brutality."[244] A photograph of the artist before a work in progress (fig. 66) exhibits one of those embryonic landscapes. The painting on the easel shows bold, expressionistic shapes suggestive of trees and a foreground pond, but bears only a formal resemblance to Tryon's finished works. Having realized the clarity of midday in his preparatory painting, Tryon would turn his work to the wall and allow it to dry for weeks, even months, until he felt in the mood to face it again.

It was at the point of bringing forth the panel after a period of gestation that the artist would envision a finished work: suddenly he knew what he wanted and then, Tryon said, "one beautiful tone suggests another still more beautiful . . . and so on until it is all beautiful."[245] Once the "mood was upon him" (as White described Tryon's creative urge), Tryon would paint "another complete though more refined picture upon the first," covering the surface with delicate colors or enveloping the forms with glazes, transparent veils of pigment he called atmosphere. The desired surface quality required "tone after tone and color over color," a layering of impressions embodied in

Fig. 66 Dwight W. Tryon, ca. 1923. Smith College Archives.

multiple mantles of oil paint and varnish. As a result, the daylight of the preparatory painting diminished to the somber tones of twilight or dawn, depending upon the painting's conceit.[246]

At this stage, the composition would be set aside to be varnished, scraped, scumbled, and further refined at some later date. Months might go by before Tryon would rework a painting, and sometimes a year or two would pass before he could call it complete.[247] He worked on several paintings at once, therefore; he wrote George Alfred Williams one winter that he had about a dozen "in various states of torment."[248] Indeed, the surfaces of Tryon's paintings sometimes contradict their apparent composure. The textures of the landscapes are varied and complex, showing irregularly painted patches that have been repeatedly rubbed and retouched. Except in luminous skies, where strokes of the artist's brush are clearly defined, their surfaces appear under close examination agitated and occasionally overwrought. "Some things may be easily and directly expressed in paint," Tryon wrote in 1922, "but the rare qualities which stand continual study are the result of much work which . . . must be concealed and made to appear spontaneous."[249] The finishing touches effaced the traces of Tryon's labor and consolidated the elements of a painting's composition, he said, as keystones bind an arch.[250]

Despite the duration of the creative process, Tryon's production was prodigious. The best of his work went to Freer, who attributed the artist's accomplishment to sheer intelligence. "It's not energy, nothing of the kind—simply brains to know what to do, how to do it, and when to do it!"[251] Tryon painted hundreds of pictures, and many of them, particularly those produced after about 1913, show signs of the system the artist devised to allow him to paint with direct and orderly methods.[252] But even the more mechanical paintings found buyers. Tryon preferred to sell works directly from his studio (he distrusted dealers, with the exception of N. E. Montross), and Freer noticed that they were usually "grabbed up before the paint was dry."[253]

One of Tryon's principal patrons was William K. Bixby, the president of the Missouri Car and Foundry Company, who relied on Freer's counsel in matters of taste. The first painting by Tryon that Bixby purchased, *Clearing after Showers,* came with Freer's endorsement: "It is low in tone, extremely mysterious, and still contains that remarkable force and character which is always found in his very best work."[254] Nevertheless, Bixby was impressed "somewhat unfavorably" by the first sight of his new acquisition, and Freer—though he named the picture "one of the great landscapes of the world"—expressed no surprise. Apparently, he had learned through experience that Tryon's paintings were too subtle to appeal to many people, and that in any case a long acquaintance was required to fully understand them. Freer advised his friend that

"truly great paintings are interesting in all kinds of light," and that this one could show to advantage even from a distance—though he himself enjoyed looking at it with his nose against the frame. Tryon himself explained that an appreciation of his work depended upon the "alert intelligence and sympathy of the beholder." Two weeks later Bixby had begun to develop a taste for *Clearing after Showers,* and Freer assured him that he would find it more attractive every day. "Within a year," Freer said, "I am sure it will bowl you completely over."[255] Indeed, if appreciation came only after time, it was tenacious once acquired. With the purchase in 1904 of ten of Tryon's paintings, Bixby's collection became, Freer said, one of the "very finest in existence."[256]

In 1905, Bixby told Tryon that his collection of paintings had opened his eyes to "certain beauties of nature and especially to the charm of early spring," the greatest compliment he could have conferred. "How much one adds to the charm of life by the appreciation of nature's beauties," Tryon replied. "When I find one beginning to enjoy intensely natural sights and sounds I feel they are beginning to really live."[257] The artist's success in conveying the moods of nature was confirmed in other instances as well. Freer met an American in Kyoto who told him Tryon's paintings "had taught him new truths of nature and made brighter his life," and Lorinda Munson Bryant, in *What Pictures to See in America* (1915), observed that Tryon had for many years "been gently and persistently leading the American people into an appreciation of the beautiful in nature."[258] Believing that paintings could give notice of the natural world, which could in turn draw attention to higher truths, Tryon declared an appreciation of art to be a "necessity of general culture." Considering all the ways in which the wealth of the Gilded Age could be squandered, Tryon recognized the critical need for "education in taste."[259]

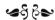

TRYON's faith in the virtues of art appreciation informed his forty years of teaching at Smith College. According to Alice Tryon, William Washburn, the governor of Massachusetts and a trustee of the college appointed by its founder, had approached Tryon about taking charge of the fledgling art department when the Tryons were living in Paris. Tryon, however, did not accept the position until 1886, when he was "well started" in New York. Indeed, Mrs. Tryon maintained, her husband had "established himself as a well known artist before he ever heard of Smith."[260] The college may not have been the first or the only institution of higher learning to attempt to engage Tryon as a teacher,[261] but Smith was successful where others failed, Mrs. Tryon implied, because it agreed to honor an unusual stipulation: an assistant would be hired to teach drawing and painting, and Tryon would make periodic visits to the college, "when it

was convenient," to criticize the students' work. He traveled to Northampton no more than once a week, except during a month of the autumn term and one or two weeks of the summer, when he insisted on having "entire freedom to carry on his private sketching."[262] In later years Tryon came to campus so infrequently that some members of the department believed the famous artist to be a myth.[263]

The president of the college, L. Clark Seelye, was convinced that Tryon's association with Smith, however tenuous, would help "to make the study of art an integral and honored part of the higher education of women." From the college's beginning in 1877, "aesthetic culture" had played a part in the curriculum. Although the schools of art and music were at first only affiliated with the college, Seelye eventually succeeded in making them regular departments of instruction; the arts were not to be regarded as "mere accomplishments, but as serious pursuits which demand strenuous intellectual work in order to prosecute them successfully." It became a mark of Smith's distinction that the college recognized proficiency in art among the qualifications for the baccalaureate degree.[264]

Though practical considerations may have motivated Tryon's decision to join the faculty of Smith College, President Seelye's commitment to the fine arts must account for the continuation of his tenure. As early as 1889 the president advised the trustees of the college that Tryon's increasing fame might cause him to stop teaching altogether. On Seelye's recommendation Tryon was appointed director of the art school, and it was under his authority that the school, and later the art department, began to emphasize the study of both the theory and history of art.[265] The artist continued to teach at the college, earning the salary of an assistant, until 1923. Upon Tryon's retirement, Seelye wrote that without his "encouragement and sympathy" the art department at Smith could not have achieved its exalted place in public esteem.[266]

Tryon's performance as professor of drawing and painting was said to have been from the first "inspiring and faithful, able and efficient." One of his pupils recalled that every third Friday was a red-letter day at Smith College—"he so imbued us with his own great enthusiasm that we were a-tiptoe with effort and desire for better things." Under Tryon's instruction, President Seelye reported to the trustees, the students' work became better than ever before.[267] The benefits appear to have been reciprocal. Mrs. Tryon said that her husband found teaching an agreeable respite from his winter work, and in his copy of *W. M. Hunt's Talks on Art,* Tryon underscored the lines: "Teaching helps the teacher. I come in here and put into words the very thing that I've been trying to do in my own room.... I do a thing four times as easy since I've been teaching."[268] Tryon passed on principles of art he had learned in Jacquesson's atelier, tempering the rules with the liberality he had found wanting in the French academic

Fig. 67 Life drawing class in the Hillyer Gallery, Smith College, ca. 1896. Smith College Archives.

system. There was no single way to paint, he said, and "if there had been it would have been patented long ago." His students were free to do whatever they pleased, as long as they observed the "fundamental truths of nature" and the "principles of aesthetics." [269]

Tryon maintained that he could teach anyone to draw in a matter of months, but Smith students, he found, were more comfortable with color than line. He ascribed the phenomenon to their sex: women were "creatures of emotion rather than logic." [270] (Although Tryon's view was not uncommon, it is curious considering his own preference for color over line.) But if few women were "fitted by nature" to produce fine art, all could be enriched by art appreciation. Indeed, because feminine minds were thought to be especially "alive to beauty," [271] Tryon directed his attention to what he called "art as a humanizer." Women in possession of cultivated tastes could exercise a refining influence, Henry White explained, "by association, upon the men they married." [272] A painting of 1889 called *Knowledge Is Power* (fig. 68) appears to illustrate the theory: a female scholar tames tigers with roses. Freer, who owned *Knowledge Is Power* and had presented reproductions to each of the Seven Sister colleges, wrote Alfred Vance

Fig. 68 Frederick S. Church (1826–1900), *Knowledge Is Power*, 1889. Oil on canvas, 20⅛ × 36 in. (51.1 × 91.4 cm). Grand Rapids Public Library, Michigan; Bequest of Charles L. Freer.

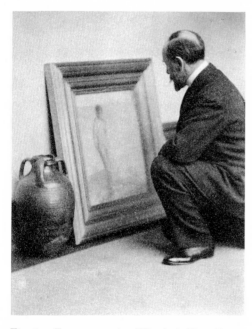

Fig. 69 Freer comparing Whistler's *Venus Rising from the Sea* to an Islamic glazed ceramic pot, 1909. Coated platinum print. Photograph by Alvin Langdon Coburn (1882–1966). Freer Papers/FGA.

Churchill, a member of the art faculty, that he considered the work of the art department at Smith College "one of the great movements in America, having as its aim real cultural refinement."[273]

Nothing did more "to refine and elevate popular taste," in President Seelye's mind, than familiarity with original works of art.[274] The first Smith prospectus promised that "more time would be devoted than in other colleges . . . to the examination of the great models of painting and statuary," and by the time Tryon arrived in 1886, Seelye had already acquired the nucleus of a museum collection. In addition to a large collection of plaster casts that would eventually be used as models for drawing classes, Seelye began to purchase modern paintings directly from artists' studios, with the intention of establishing a permanent exhibition of American art at Smith College.[275] It was at the time an enlightened, if eccentric, idea that inspired unstinting support from Tryon, the college's representative in the New York art world; the list of museum accessions during the years of Tryon's tenure reads like a roster of his friends and artistic relations.[276] In a letter written just before his retirement, Tryon said that for all his love of teaching, the focus of his years at Smith had been the "building of a fine collection of American paintings."[277] It was an interest the artist shared with his friend Charles Freer.

The scheme of Freer's collecting may have evolved from his revelation at the Chicago World's Fair that the art of Tryon, Thayer, Dewing, and Whistler was the best of the modern age. In the years after 1893 he assiduously acquired works by those four American artists even as he engaged his energy in the quest for Asian art. The burgeoning collections soon outgrew his residence in Detroit, and Freer proposed to bequeath them to the nation, together with funds for the construction of a "suitable building" for their care and exhibition.[278] In effect, the gallery was to be a memorial to Whistler, whose philosophy of universal beauty had determined the direction of Freer's aesthetic beliefs. It was probably Whistler's overarching concern for aesthetic arrangement that sustained Freer's controversial decision to permit nothing in the building other than the works of art included in his donation, "the idea being," he explained to Tryon in 1905, "to maintain the harmony of the collections to which I have given so much attention."[279] The Smithsonian Regents accepted the gift in 1906—though not without misgivings, delays, and the eventual intervention of President Theodore Roosevelt—and Freer devoted the rest of his life to uniting "modern work with masterpieces of certain periods of high civilization harmonious in spiritual suggestion," as he phrased his intention, "having the power to broaden esthetic culture and the grace to elevate the human mind."[280]

The apparently occult connection between the American and Asian components

of the collection was elucidated in an article by Leila Mechlin, produced with Freer's cooperation and published in *Century Magazine* in 1907: "As Whistler caught up the thread which, after being carried through successive generations in Babylonia, China, Korea, and Japan, had been dropped, so, after him, on still another continent, Tryon and Dewing and Thayer have equally independently and unintentionally become the continuers of the early Oriental idea."[281] That Whistler borrowed conventions from Japanese woodblock prints for his own works was beginning to be recognized by the turn of the century,[282] but Freer was less interested in direct lines of influence than in abstract aesthetic relationships. In common with the other American works in the Freer collection, Tryon's paintings appeared to achieve, as the critic Sadakichi Hartmann observed, the "calm perfection of Japanese art."[283]

It has been argued that Tryon derived elements of his artistic style from traditional Asian painting, and certainly Tryon, through his friendship with Freer, would have been able to see examples of Chinese and Japanese art that were not yet available to the American public.[284] But Tryon confessed to knowing little about Japanese art and culture,[285] and it appears that his understanding of Asia was not exceptional for his time. Like most American aesthetes, he owned an assortment of objects imported from Japan, including a collection of prints and a few silks, lacquers, and porcelains. (Freer gave him a Japanese bronze in which Tryon recognized a "rare subjection of nature to the needs of theme."[286]) He delighted in Lafcadio Hearn's *Glimpses of Unfamiliar Japan,* and conceived of Japan as an artist's utopia, a place where one's "appreciation of the beautiful would be fed in all directions."[287] Although he once remarked that his decorative panel *Springtime* (cat. no. 8) reminded him "in some ways . . . of some of the very old Japanese work in color and abstraction," the observation was not by any means an admission of influence.[288] To Tryon, the affinity demonstrated more an aesthetic coincidence than an artistic contrivance.

In making the connection, Tryon was participating in his patron's favorite occupation, for Freer delighted in aesthetic juxtapositions. He detected in Tryon's monumental *Sea: Evening* (cat. no. 33), for example, a similarity to the "work of the great Masters of the early Kāno school."[289] (The artist replied that "this kinship with former great minds really makes life interesting," but made no attempt to establish a line of descent.[290]) When he presented to his friend Bunkio Matsuki a wood engraving by Elbridge Kingsley (fig. 70) after a painting by Tryon, Freer wrote that its "quiet foreground, interestingly lighted middle ground, and poetic sky and distance" were reminiscent of early Japanese art: "It seems to me there is great harmony between it and the work of Sōami, for instance."[291]

Through such considered comparisons, a connoisseur could hope to obtain "keen

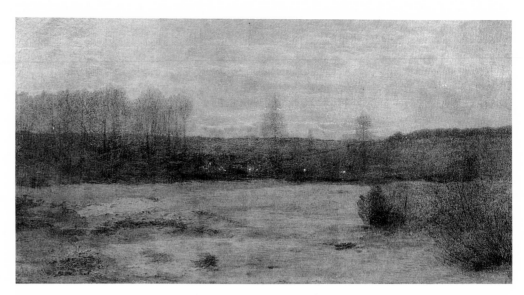

Fig. 70 Elbridge Kingsley (1842–1918), *Winter Evening*, ca. 1892, after Tryon. Wood engraving,
7¼ × 13⅞ in. (18.4 × 35.3 cm). Smith College Museum of Art (1915:3–1); Gift of Dwight W. Tryon.

sympathy with beauty," Tryon believed. "I cannot imagine a higher life than the rare moments when one is attuned to a really great art work," he wrote Freer in 1907. "It seems to me to contain the essence of all religions and comes the nearest to true spiritual manifestations that are known. Is it not this spiritual baring of the soul which some artists have the courage or the power to do that is true art?"[292] The artist's sympathy with the collector's ideals assured him a place of prominence in the future Freer Gallery of Art.

Tryon adopted, among other ideas, Freer's notion that some countries were more artistic than others. He wished that Japan would send missionaries to convert America's "heathen taste," and avowed in an interview that art had been "much more generally appreciated and practiced in China" than in the United States.[293] But after the turn of the century the artist became heartened by what Charles Caffin called the "demand for beautiful things," which created a need for the "rarer work" Tryon was qualified to supply.[294]

The nineteenth-century enthusiasm for European painting, encouraged by the Centennial Exposition in 1876, the year Tryon had providentially gone abroad, had produced a bias against American art that the Society of Art Collectors sought to

redress in the Comparative Exhibition of Native and Foreign Art. Held during the last months of 1904 at the Fine Art Gallery in New York, the exhibition displayed one hundred "foreign" (predominantly Barbizon) pictures side by side with one hundred "native" ones so that Americans could gauge for themselves the measure of the difference. Among the lenders to the exhibition were Andrew Carnegie, John Gellatly, Henry O. Havemeyer, George A. Hearn, and Charles Freer, who contributed Tryon's *Daybreak: May* and *New England Hills* (cat. nos. 22 and 24). William T. Evans was chairman of the Committee on American Art, an appointment Freer thought signified the collector's "advancement in the Fine Arts."[295] Indeed, the Comparative Exhibition resulted in a demonstration of progress. As the art historian William Gerdts has pointed out, the "European pictures necessarily represented an earlier artistic stage, one that had already been 'historicized.'"[296] Tryon's paintings (listed after Constant Troyon's in the exhibition catalogue) were among the examples that in comparison with the French school appeared avant-garde. Ten years later they would look hopelessly antique.

By 1900, when the new Montross Gallery opened on Fifth Avenue, Tryon had achieved sufficient status in the art world to merit a one-man show. "Although Dwight W. Tryon has for a number of years been regarded by his brother artists and by some of the wisest collectors on this side of the ocean as one of the landscape painters best calculated to uphold the dignity and achievement of American art," a critic for the *Mail Express* began a review of the Montross show, ". . . it has remained until this month of this year for art lovers to have opportunity to study anything like a large and comprehensive showing of his pictures, in a place by themselves, where their full appeal might exert itself."[297] The exhibition consisted of forty works (twelve from Freer's collection) produced within the previous decade of the artist's career. Tryon reported to Freer that the visitors had been plentiful ("and of an unusual class") and the critics "decent."[298] Indeed, one writer for the *New York Sun* placed Tryon "in the front rank of the native school" of landscape painters and declared that the exhibition confirmed his works "among those which do most to give it its high place in all modern art."[299]

Although Tryon intended to organize another show two years later,[300] the second Montross Gallery exhibition of his works, comprising only twenty-one paintings, was not held until January 1913. It was, Tryon said, "by far the best showing ever made" of his work. A critic for the *New York Times* agreed, concluding that it was an "exhibition to fortify an artist of sincere aims, as well as one to bring great pleasure to the discriminating public."[301] But two weeks after the retrospective closed, the International Exhibition of Modern Art opened at the Sixty-Ninth Infantry Regiment Armory

and the most prosperous period of Tryon's career came to an end. The Armory Show summarized recent achievements of American and European art in which Tryon had played no part. Indeed, the paintings of the New York realists in particular constituted a response to the escapist and elitist tendencies of contemporary American painting: selecting precisely the subjects Tryon disdained—scenes of the modern, urban world—the "ashcan" school represented a spirit of social reform entirely alien to the "ideal country" Tryon repeatedly recollected on canvas.

Although it seems unlikely that any artist living in New York could manage to miss the exhibition, no evidence of Tryon's attendance has come to light. In the years after 1913, however, Tryon frequently lamented what Abbott Thayer called the "present decadence" of American art,[302] and appears to have withdrawn from the New York art scene altogether. An opinion he first expressed to Freer in 1914, that the "trouble with most shows as well as most lives is lack of a high standard," became a familiar refrain in Tryon's correspondence. He wrote to George Alfred Williams that with few exceptions, contemporary art had declined so miserably that the "less one sees the better," and to T. W. Dunbar of the Milch Galleries in New York that much modern painting was bound to be discarded "because of its hasty consideration and careless workmanship."[303] Tryon's dissatisfaction deepened with the betrayal of N. E. Montross, the dealer who had championed his art in earlier days. "I gave Montross a piece of my mind lately about the stuff he is showing, but I think he is past cure," Tryon wrote Williams in 1915, alluding to exhibitions by artists such as Joseph Stella and Walt Kuhn mounted in the wake of the Armory Show. When Montross persisted in exhibiting modern American and European art the next year, Tryon declared that he had "lost about all faith in him and for that matter, all respect."[304]

Freer, too, deplored the twentieth-century devaluation of the art he treasured. "Think of a collection of American art in which there is not a single Abbott Thayer!" he exclaimed on the occasion of the 1915 Panama-Pacific International Exposition in San Francisco. "And what has [Frank] Duveneck done for American art that he should have so large a room, while there are only two Homer Martins, and Winslow Homer and George Inness, and Tryon, the greatest of American landscape painters, are so poorly represented?"[305] While Tryon could respond that he no longer concerned himself with such matters—"I find no solace in the idea of popularity and am willing to leave my work for the future to settle"[306]—Freer had assumed the responsibility of educating public taste. Possessing "absolute faith in the great majority of people to instinctively turn from bad art to real art if put in a position to compare the two,"[307] Freer intended his collections to promote "high ideals of beauty." His last will and testament provided for the purchase of "very fine examples of Oriental, Egyptian and

Fig. 71 Charles Lang Freer, 1916. Platinum print. Photograph by Edward Steichen (1879–1973). Freer Papers/FGA.

Fig. 72 Freer Gallery of Art, first-floor plan, 1916. Freer Papers/FGA.

Fig. 73 Freer Gallery of Art, main entrance on the National Mall, 1923.

Fig. 74 Tryon Gallery, Smith College. Smith College Archives.

Near Eastern fine arts," but prohibited additions to the American collection—not because he thought it less important but because he considered it already complete. The American section of the museum would remain exactly as Freer left it, his assistant Katharine Rhoades explained, a "permanent expression of his confidence in the works represented there."[308]

In 1923, when the Freer Gallery of Art opened to the public, eight of its eighteen galleries were apportioned to American art, and one of them was devoted exclusively to works by Tryon. Its position at the start of a visitor's circuit suggests that Tryon's native landscapes were meant to acclimate newcomers to unfamiliar surroundings.[309] At least one review of the initial installation corroborated Freer's notion that although the American paintings could not be compared to Asian art in terms of technique, "with the exception of Whistler, no painter in the gallery is more in harmony with the Eastern collections, especially of the later periods," than Tryon: "It was almost necessary to see Tryon in these surroundings to appreciate the quality of his devotion to the sensitive aspects of nature in his own part of the world."[310]

Freer did not live to see the inauguration of the museum, and Tryon, because of a disagreement with the director over the installation of his paintings, may never have seen them displayed in the Freer Gallery of Art.[311] Nevertheless, the opening of the Freer Gallery in 1923 seems to have quickened his resolve to present a museum in his own name to Smith College.[312] In October 1924, Tryon wrote his colleague Churchill that he was making a gift of one hundred thousand dollars for the construction of an art gallery. "My desire," he said, "is to see it materialize while I am alive."[313] By mid-December the site had been selected and the "practical and artistic" architect Frederick Ackerman was engaged to design the building.[314] Although Tryon originally envisaged a "severely classic style" for the gallery (perhaps not unlike the neo-Renaissance architecture of the Freer), he eventually decided that a Georgian or colonial brick building would "better harmonize" with other structures on the Smith College campus.[315] When ground was broken in June, Tryon conveyed to Churchill his ideas about the "purpose of the various rooms and the distribution of objects in the new Tryon Gallery," and was assured that his intentions would be honored. The artist died the following week.[316] The Tryon Gallery opened in September 1926, dedicated to the students of Smith College, that they might "know in their youth the solace and inspiration of art."[317]

Tryon lived almost until his seventy-sixth birthday, and felt thankful, he told Henry White, that he would not live to see another hundred years go by. "I am glad that I have lived my life when I did," he said. "My lines have been cast in pleasant places."[318] Tryon detested the "gas age—the age of speed and superficiality," in which,

Fig. 75 Old bridge at Padanaram, 1915. Photographic postcard. Tryon Papers/FGA.

he complained, the "auto and the radio take the place of an interest in art and the house is mortgaged that the occupants may attain forty miles an hour." Thanks to his "farmer boatman life," Tryon was able to avoid the irritants of the modern world for half of every year, at least; but by the second decade of the twentieth century even the peace of Padanaram was disrupted by the noise of automobiles crossing the bridge over the bay.[319] Worse still, summer people crowded the village and built "unpaintable" bungalows in the "choicest sketching fields" of Dartmouth.[320] "If I were a few years younger," Tryon wrote George Alfred Williams, "I would strike for a new home."[321] He had feared he would become quixotic with age, but modern society made him cynical. "There are too many people in the world," Tryon declared, "and, for the most part, they do not know what to do with it."[322]

The fall of 1924 was Tryon's last in South Dartmouth. "We are holding on until about the twentieth of November," he wrote, "as we hate to miss a day of this glorious New England autumn."[323] *November Evening* (fig. 76), a memoir of the season, closes Tryon's career. It shows the end of a day at the end of autumn, revealed through almost preternatural light and color. From the beginning of January 1925 the cancer that had slowly invaded his life made Tryon too ill to paint. "It takes so much nerve force to reach anything worthwhile in art that I had rather abandon all attempts at painting than do inferior work," he wrote in March.

> Well, I suppose the time comes to all when they must lay down their burdens and rest. I cannot complain. I have had a long life of art, nearly sixty years of painting, and I feel that I have quite fully expressed myself if I do nothing more.[324]

Remembering the motifs of his first years in Dartmouth, Tryon began a pastel drawing of a haystack, a farmhouse, and a stone wall; but the work remained unfinished when he died in Padanaram on the first of July, at sunset.[325] He was buried less than a mile away from his house at the edge of the cemetery nearest the sea, and his grave is marked by a boulder bearing a plaque inscribed with lines by Tennyson that Tryon must have selected himself.

> Sunset and evening star,
> And one clear call for me!
> And may there be no moaning of the bar,
> When I put out to sea.

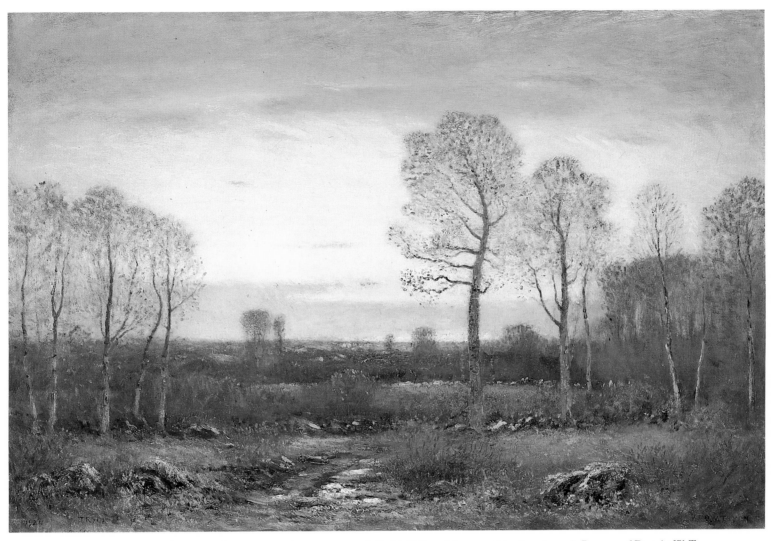

Fig. 76 *November Evening,* 1924. Oil on panel, 20 × 30 in. (50.8 × 76.2 cm). Smith College Museum of Art (1926:12–1); Bequest of Dwight W. Tryon.

Notes

1. White 1930, 15. Tryon was born in Hartford, Connecticut, on August 13, 1849.

2. Tryon to George Alfred Williams, 8 February 1923, Nelson White Papers/AAA.

3. Freer to Tryon, 17 June 1895, from Ama-no-hashidate, Japan, Tryon Papers/FGA.

4. Tryon Papers/AAA consists of autobiographical notes Tryon wrote for Henry C. White beginning 18 January 1925. Hereafter, all quotations by and biographical details about Tryon are from this source unless otherwise indicated.

5. Anson Tryon, whose occupation had been listed in the Hartford City Directory from 1842 through 1852 as "mason," died on 25 June 1853 at age thirty-three and was buried at Hockanum Cemetery, East Hartford.

6. In a letter to Freer (3 September 1896 [78]), Tryon tells of the "fine hunter types" who were guides on a trip through the Maine Woods: "They said I was one of the very few who when shown game preferred to watch it instead of killing. I had endless chances to kill deer but did not shoot at all."

7. "Death of a Hartford Lady in Waterbury," *Hartford Times,* 11 January 1866. Delia Roberts was born around 1820, married in 1843, and died in January 1886 in Waterbury, Connecticut.

8. By June 1860, when the Federal Census was taken, Delia and Dwight Tryon were living in the household of Jonathan Roberts, who listed his occupation as "farmer."

9. White 1930, 8.

10. H. W. French, *Art and Artists in Connecticut* (Boston: Lee and Shepherd, 1879), 160–61.

11. White 1930, 18.

12. Tryon to George Alfred Williams, 2 August 1923, Nelson White Papers/AAA. Smith College conferred the degree on Tryon in 1923.

13. White 1930, 27; Littmann 1923.

14. Wadsworth Atheneum, *Catalogue of Original Oil Paintings, Both Ancient and Modern, the Entire Collection of J. G. Batterson, Esq.,* exhib. cat. (Hartford: Case, Lockwood and Company, 1864).

15. Among the paintings that Tryon recalled may be Jan Kobell the Younger, *Landscape with Cattle;* William van de Velde, *Marine;* Jan Baptist Weenix, *Game Piece;* and Rembrandt, *Girl Reading.* Batterson eventually presented these paintings to the Wadsworth Atheneum, Hartford.

16. Wadsworth Atheneum, *The Hudson River School: Nineteenth-Century American Landscapes in the Wadsworth Atheneum,* comp. Theodore E. Stebbins (Hartford: Wadsworth Atheneum, 1976).

17. White 1930, 20. Delia Tryon was employed by the Wadsworth Atheneum from 1867 until shortly before her death in 1886. She was responsible for greeting visitors, selling tickets, and handing out catalogues (Treasurer's Report, archives of the Wadsworth Atheneum).

18. Quoted in White 1930, 17; Tryon to Alfred Vance Churchill, n.d. [received 15 February 1916], typescript copy, SCMA documentary files.

19. As related by Leverett Belknap in White 1930, 17.

20. White 1930, 22. In a letter to George Alfred Williams (10 July 1914, Nelson White Papers/AAA), Tryon expressed his admiration for the "original Turner sketches for the Rogers' Italy." The painting Faxon bought may have been a copy after one of the illustrations to Samuel Rogers's *Italy, a Poem* (London, 1838), which Tryon bequeathed to Smith College.

21. Hartford Art Association, *Catalogue of the First Annual Exhibition* (Hartford: Geo. L. Coburn, 1872); Connecticut School of Design, *Catalogue of the Second Annual Exhibition* (Hartford: Case, Lockwood and Brainard, 1873).

22. NAD 1973, 2:946.

23. Carolyn C. Fitch (Mrs. Roger S.) to the author, 2 September 1986. Alice H. Belden was born 19 October 1848 and died 27 October 1929.

24. Quoted in Beulah Strong, review of *The Life and Art of Dwight William Tryon* by Henry C. White, *Smith Alumnae Quarterly* 22 (February 1931): 190.

25. Quoted in Tryon Papers/AAA.

26. Manuscript draft of chapter 5, *The Life and Art of Dwight William Tryon* by Henry C. White, Henry White Papers/AAA.

27. Mrs. Fitch to the author, 2 September 1986. When his student Henry White found himself ready to pursue painting as a profession, Tryon told him he would have to possess "so strong a love and desire" for art that he would be willing to sacrifice everything else (White 1930, 91–92).

28. Quoted in "What Some Famous Artists Have Said to Me," Walter Copeland Bryant's journal, Bryant Papers/AAA.

29. Hayward 1978, 59–90, discusses Tryon's luminist phase.

30. Barbara Novak, "On Defining Luminism," in *American Light: The Luminist Movement 1850–1875,* exhib. cat. (Washington, D.C.: National Gallery of Art, 1980), 23–29.

31. Tryon to F. F. Sherman, 2 October 1920, Philadelphia Archives of American Art, Philadelphia Museum of Art, Pennsylvania (on microfilm, AAA). The admiration seems to have been mutual: Mrs. Wyant, the artist's widow, told Walter Copeland Bryant, "I think Tryon is the greatest living master of American landscape painting. I do not know him but my husband knew him" ("Famous Artists," Bryant Papers/AAA).

32. The SCMA card catalogue indicates that *Scene in County Kerry, Ireland* was either purchased directly from Wyant or given to the collection by Tryon. Tryon also donated Wyant's *Lake Champlain,* which was sold from the SCMA collection in 1946.

33. Inness painted *Kearsarge Village* (Museum of Fine Arts, Boston) in 1875; Cikovsky and Quick 1985, no. 26.

34. Tryon's *Landscape* (Wadsworth Atheneum; fig. 17), though undated, may be the *Meadows of Conway* mentioned in Tryon Papers/AAA and White 1930, 30.

35. See, for example, Matthew Baigell, *A Concise History of American Painting* (New York: Harper and Row, 1984), 157, and Quick, "Late Style," in Cikovsky and Quick 1985, 59.

36. Cikovsky and Quick 1985, 128.

37. Tryon to Freer, 25 November 1917 (207). The letter was written after Tryon looked up several of his early works in Hartford: "How I managed to do it at that stage of the game 'gets my goat.'" Freer replied that Tryon should have a retrospective exhibit, not only to "give joy and stimulation at the time" but also to "help future

experts to better knowledge of both artistic and historical facts" (7 December 1917, Nelson White Papers/AAA).

38. White 1930, 30; Caffin 1905, 191.

39. Tryon's copy of *W. M. Hunt's Talks on Art* was bequeathed in 1930 to the library of Smith College, where it remains in the Hillyer Art Library.

40. Thomas L. Cheney to the author, 24 September 1986.

41. Caffin 1905, 192.

42. Bermingham 1975, 72.

43. Tryon's copy of *Scènes de la vie de bohème* was bequeathed to Smith College, where it remains in the Hillyer Art Library.

44. White 1930, 43.

45. Caffin 1909, 12–13.

46. Ibid., 14.

47. White 1930, 38.

48. Tryon's copies after Titian's *Man with a Glove* and Rembrandt's portrait of his son remained in Tryon's possession all his life. The copies were bequeathed to Smith College but no longer remain in the collection; their present location is unknown.

49. Tryon 1896, 155.

50. Ibid., 157.

51. Constant Troyon had died in 1865, Théodore Rousseau in 1867, Camille Corot in 1875, and Narcisse Diaz in 1876. Of the first-generation Barbizon artists, Daubigny, Jules Dupré, and Charles Jacque were alive in 1877.

52. Tryon 1896, 164. Tryon wrote Freer on 21 March 1896 (72) that he had "agreed to write the life of Daubigny for 'Century'" and looked forward to reaching the country, where he would be able to think in peace. Tryon may have met the editor of *Modern French Masters*, John C. Van Dyke, when Van Dyke presented a lecture on Italian art at Smith College (President's Report, 1895–96/SC Archives).

53. Caffin 1909, 17.

54. White 1930, 46; Lorenz Eitner, *An Outline of Nineteenth-Century European Painting* (New York: Harper and Row, 1987), 430.

55. White 1930, 37.

56. *Harvest in Normandy* (1881), oil on canvas, 30 × 48 inches, was exhibited at the NAD in 1882 as "Harvest Time in Normandy," for sale at $500. The painting is listed in Caffin 1909 as the possession of F. W. Cheney, South Manchester, Connecticut; its present location is unknown.

57. White 1930, 187.

58. Tryon's drawings are contained in two portfolios of sketches in the SCMA. Abbott H. Thayer painted *Cattle at Guernsey* in 1877 (Nelson C. White, *Abbott H. Thayer* [Hartford: Connecticut Printers, 1951], 28). Tryon's comments on *Toilers of the Sea* appear in a letter to Freer, 30 April 1894 (58), and White 1930, 47.

59. Tryon to Alfred Vance Churchill, n.d. [received 15 February 1916], typescript copy, SCMA documentary files.

60. Quoted in "Famous Artists," Bryant Papers/ AAA.

61. White 1930, 53.

62. Notation on a drawing in Tryon's portfolio of sketches, SCMA.

63. Tryon to Alfred Vance Churchill, 29 January 1924, Churchill Papers/SC Archives. Three studies of the river, including one preparatory sketch for *The River Maas at Dordrecht* (1881; collection of Nelson C. White), are in the SCMA. One of the resulting works, *Dutch Boats in a Breeze* (present location unknown), was exhibited at the Paris Salon of 1881.

64. Fragment of a letter from Tryon, n.d., in the folder of "unused material" relating to the Tryon biography, Henry White Papers/AAA; Tryon to Alfred Vance Churchill, 21 February 1916, Churchill Papers/SC Archives. A drawing in the SCMA collection, *The Weir—Monchaux*, charcoal and pencil with white chalk highlighting on brown wove paper, is dated and inscribed lower right: "Monchaux, Sept. 1880 The Weir—caught 3 trout here, 5, 5¾, and 7 pounds."

65. Tryon to George Alfred Williams, 15 February 1916, Nelson White Papers/AAA.

66. Tryon to Henry C. White, 14 February 1897, quoted in White 1930, 50; Williams 1924.

67. Freer to Bradley Redfield, 2 October 1893 (LB 1).

68. Tryon to George Alfred Williams, 14 December 1915, Nelson White Papers/AAA.

69. White 1930, 74; American Art Exhibition Catalogues, SAA/AAA. Because none of the artists exhibiting at the SAA listed 152 West Fifty-Seventh Street (The Rembrandt Building) as his or her address in 1881, and several listed it the following year (in every case a new address), the Rembrandt must have attracted artists all at once. Tryon, who would have been one of its first occupants, kept a studio there until 1889.

70. In his "Notes and Recollections" (Tryon Papers/AAA) Tryon says that he returned to New York in late June 1881, but to be in New York in time to see the Fourth Annual Exhibition of the Society of American Artists that year, he would have had to arrive before the end of April, when the exhibition closed. In another instance of memory lapse, Tryon wrote Dr. John Pickard, professor of classical archaeology and history of art at the University of Missouri, that he returned to the United States in 1882 (20 May 1907, John Pickard [1858–1937] Papers/AAA; Gift of Allen S. Weller, 1980).

71. Tryon to Freer, 20 August 1893 (47) and 22 November 1899 (107). At the 1881 SAA exhibition Thomas Dewing exhibited *Andante* and *A Concert* and Abbott H. Thayer exhibited six portraits and a landscape. Among the other exhibitors were Ralph Blakelock, George de Forest Brush, William Merritt Chase, Bruce Crane, Thomas Eakins, George Fuller, Robert Swain Gifford, George Inness, John La Farge, Will H. Low, Homer Dodge Martin, J. Francis Murphy, Albert Pinkham Ryder, Augustus Saint-Gaudens, John Singer Sargent, William Sartain, John H. Twachtman, J. Alden Weir, Candace Wheeler, and Alexander H. Wyant.

72. Only one painting by Tryon was exhibited in the Fifth Annual Exhibition of the SAA (1882)— *Cernay la Ville*, now in the SCMA—but another, *Early Spring*, was included in a supplementary exhibition.

73. Caffin 1905, 191.

74. *A Connecticut Cornfield* was exhibited at the NAD in 1882; *Glastonbury Meadows*, dated 1881, formerly in William K. Bixby's collection (St. Louis, Missouri; present location unknown), is reproduced in White 1930, supplementary plates.

Dwight Tryon's paternal ancestors were from Tryontown, at the southern end of Glastonbury Meadows (White 1930, 10).

75. *Landscape* (inscribed "East Chester, N.Y.") would become Tryon's diploma work in qualification for membership in the NAD in 1891. Other works inspired by the New York countryside and exhibited at the SAA include *Haymaking, East Chester, N.Y.* of 1883 and *Early Spring, Long Island* and *June, Westchester County* of 1884.

76. Tryon 1896, 161.

77. Ibid., 162.

78. Mrs. Fitch to the author, 2 September 1986.

79. Ibid.; quoted in "Dwight W. Tryon Dies at His Home in Padanaram," undated press cutting, Bryant Papers/AAA; White 1930, 2. The Cottage was designed by the Tryons' friend Ehrick Rossiter (E. K. Rossiter to William Allen Neilson, 6 May 1931, SCMA documentary files).

80. White 1930, 60–61.

81. See, for example, *Oaks—Dartmouth* and *Landscape with Trees,* graphite and charcoal sketches in the SCMA. In 1884, Tryon exhibited *Early Morning—Dartmouth* at the NAD and *Evening near Dartmouth* at the SAA.

82. Henry White mentioned a painting of about 20 × 30 inches that hung in the dining room of Tryon's South Dartmouth cottage and "showed distinctly the result of his study abroad applied to a native subject." White's description of the work corresponds exactly to the picture in the SCMA:

> The subject was a view of one of the streets of the village in summer. The roadway was bordered by old houses, their shingles mossy and silver gray. The graceful tower of the church rose above them, and daisies and wild flowers dotted the foreground. A man drove a couple of cows along the road, raising the dust as they walked, and over all the scene the heat of summer seemed to tremble and vibrate (White 1930, 61–62).

Milo Beach, a longtime summer resident of South Dartmouth, verified my hypothesis that "Village Scene in France" was in fact a scene of South Dartmouth. The church on the right (the Congregational Church) still stands, and the road would be recognizable to anyone familiar

with the town. *View of South Dartmouth,* as it is now titled, could be the work exhibited at the SAA in 1883 as "A Roadway, South Dartmouth."

83. White 1930, 60; folder of "unused material," Henry White Papers/AAA.

84. White 1930, 135–36. Tryon took his new friend Thomas Dewing with him on the canoe's trial trip on the Harlem River one windy day in March. The canoe predictably capsized and a longshoreman in a scow ran over them in a misguided rescue attempt, causing Dewing to exclaim, "Hell, Tryon, is this what you call canoeing?" (quoted in White 1930, 134). Although he had been in Paris at the ateliers of Gustave Boulanger and Jules-Joseph Lefebvre, Dewing seems to have met Tryon in New York, where he taught at the Art Students' League from 1881.

85. Tryon 1896, 162.

86. White 1930, 64.

87. Tryon 1896, 162.

88. Tryon to George Alfred Williams, 10 July 1914, Nelson White Papers/AAA. In a letter to a colleague at Smith College, Beulah Strong (12 April 1912, Churchill Papers/SC Archives), Tryon wrote that *Dartmouth Moorlands* (1885; SCMA) was painted "directly, not from nature but from a small study."

89. Notation on a drawing in Tryon's portfolio of sketches, SCMA.

90. Royal Cortissoz, "The Montross Collection and Some Other Exhibits," *New York Tribune,* 23 February 1919, Freer Press-Cutting Book 1:83.

91. Tryon to Beulah Strong, 15 July 1923, Churchill Papers/SC Archives.

92. Phillips 1918, 392.

93. Tryon to Edwin C. Shaw, 6 September 1922, Shaw Papers/AAA. Cf. James McNeill Whistler, "The Red Rag" in *The Gentle Art of Making Enemies* (London: William Heinemann, 1890), 127–28:

> As music is the poetry of sound, so is painting the poetry of sight, and the subject-matter has nothing to do with harmony of sound or of colour. . . . Art should be independent of all clap-trap—should stand alone, and appeal to the artistic sense of eye or ear, without confounding this with emotions entirely foreign

to it . . . ; and that is why I insist on calling my works "arrangements" and "harmonies."

94. Caffin 1909, 17; Tryon Papers/AAA.

95. Tryon 1896, 164.

96. Tryon to Churchill, 8 May 1924, Churchill Papers/SC Archives. Tryon said that he had come close to naming the painting "The Resurrection" but decided not to, as he disliked dramatic titles.

97. Tryon to Beulah Strong, 12 April 1912, Churchill Papers/SC Archives; "Famous Artists," Bryant Papers/AAA.

98. Tryon to Freer, 20 May 1889 (3). The Webb Prize was instituted in 1887 by Dr. W. Seward Webb and awarded by vote of the jury of the exhibition every year of the founder's lifetime. The first award, in 1887, went to J. Francis Murphy for *Brooks and Fields,* the second in 1888 to John H. Twachtman for *Windmills* (exhib. catalogues, SAA 1887–89/AAA).

99. Quoted in "Famous Artists," Bryant Papers/AAA.

100. Henry White notes that N. E. Montross began showing a few pictures in the hallway adjoining his store at 1380 Broadway as early as 1878 (White 1930, 75). In the early 1880s, Montross's advertisements announced his occupation as "Artists' Colorman," with "prices exceptionally low" (one appears in the SAA catalogue for 1882). Yet by 1887, Montross was not only selling "artists' materials for all branches of drawing, painting, and decorating" but was also showing "choice examples" of oil paintings "direct from the artists' easels" (exhib. catalogue, SAA 1887/AAA). In 1897, Sadakichi Hartmann mentioned Montross's "little sanctum, at the rear of his artist materials store" (*Art News* [April 1897]: 1). The Montross Art Gallery was established at 372 Fifth Avenue in 1900, then moved to 550 Fifth Avenue in 1910 and to East Fifty-Sixth Street in 1925 (White 1930, 75).

101. The American Art Association medal in 1886 went to Tryon for a work titled *Daybreak* (probably the painting in the collection of the Rhode Island School of Design, Providence; fig. 42); and in 1887, for *Moonlight* (cat. no. 2), which was exhibited and judged by the American Art Association, Third Prize Fund Exhibition, as "Night" (American Art Association Papers

[1853–1924]/AAA; Gift of the American Antiquarian Society, Worcester, Mass., 1978). Tryon's "Landscape," owned by Thomas B. Clarke (probably *A Lighted Village,* cat. no. 1), was awarded the Julius Hallgarten Prize in 1887 (Tryon to Clarke, 23 December 1892, Charles Henry Hart Autograph Collection/AAA; NAD 1973, 947).

102. Two paintings owned by Thomas B. Clark were exhibited at the SAA in the late 1880s: *Night-fall* in 1887 and *Moonrise in November* in 1888. Two more were shown at the NAD: *Landscape* in 1887 and *November Afternoon* in 1889. According to Henry White, Clarke purchased paintings directly from the artist (White 1930, 76).

103. Letters to Freer from Frederick Stuart Church indicate that Freer was in Detroit on 10 May 1889 but in New York, staying at the Brunswick Hotel, by 31 May 1889, when he might have seen the SAA exhibition. By the third week in May, Freer had purchased *The Rising Moon* (cat. no. 3) (Tryon to Freer, 19 and 20 May 1889 [2 and 3]).

While in New York Freer may have visited the showcase of N. E. Montross, who advertised in the 1889 SAA catalogue and invited a "visit of inspection." It was at Montross's shop that Freer saw Tryon's *Sea: Sunset* (cat. no. 4), which he purchased in 1890 (Tryon to Freer, 6 February 1890 [5]). If Freer had been in town in March for the exhibition of works by Whistler at H. Wunderlich & Co., "Notes—Harmonies—Nocturnes" (which seems likely considering his growing interest in Whistler's prints), he may also have visited the Sixty-Fourth Annual Exhibition at the NAD (April 1 through May 11, 1899), where he would have seen works by Tryon on display.

104. Saarinen 1958, 123; Hayward 1979, 118. Letters from Freer to Thomas Dewing dated 7 June and 30 September 1892 (LB 1) suggest that Freer did not meet Stanford White until 1892. Although Hayward's suggestion that Church recommended Tryon to Freer is more plausible, no evidence exists to support the claim.

105. By February 1888, Freer was negotiating to purchase *Knowledge Is Power* by Frederick Stuart Church (fig. 68); but according to letters from Church to Freer beginning 3 February 1888, he

did not yet have it in his possession. By 1889, Freer seems to have owned at least two works, possibly watercolors—*The Old Road* by William Merritt Chase and *The Wave* by Cleveland Coxe—which he lent to the Second Exhibition of the Detroit Museum of Art (now the Detroit Institute of Arts).

106. Tryon Papers/AAA and Mrs. Fitch to the author, 2 September 1986.

107. Tryon to Freer, 19 May 1889 (2).

108. Caffin 1905, 202; Tryon to Freer, 6 July 1889 (4).

109. Tryon to Freer, 6 February 1890 (5).

110. Ibid., 6 July 1889 (4).

111. Ibid., 6 February 1890 (5).

112. Quoted in "Famous Artists," Bryant Papers/AAA.

113. Freer to Harrison Morris, 2 October 1893 (LB 1), and to Thomas Dewing, 7 June 1892 (LB 1).

114. Tryon to Freer, 19 May 1889 (2) and 6 July 1889 (4).

115. Ibid., n.d. [postmarked 28 April 1890] (7). *The Sea: Sunset* went straight to Chicago after exhibition at the SAA in 1890. Although Freer is not listed as the lender of the painting in the catalogue (*Catalogue of the Paintings Exhibited by the Inter-State Industrial Exposition of Chicago, Eighteenth Annual Exhibition* [Chicago, 1890]), the asterisk beside the title means that it was not for sale.

116. Tryon to Freer, 18 September 1889 (1). In addition to *The Rising Moon,* Tryon exhibited *The First Leaves* (SCMA; fig. 44), *Evening—Early Spring,* and *Afternoon* (*Catalogue of the Paintings Exhibited by the Inter-State Industrial Exposition of Chicago, Seventeenth Annual Exhibition* [Chicago, 1889]).

117. Helen Nebeker Tomlinson, *Charles Lang Freer, Pioneer Collector of Oriental Art* (Ann Arbor: University Microfilms, 1981), 44. Tryon's initial correspondence with Freer went to an address on Alfred Street.

118. Tryon to Freer, 6 February 1890 (5).

119. Frank J. Hecker, *Activities of a Lifetime, 1864–1923* (Detroit: Privately printed, 1923), 25–26; City Council of Detroit, Historic Designation

Advisory Board, "Proposed East Ferry Avenue Historic District Preliminary Report," 1986. Brunk 1981, 4–53, provides a thorough history of the Freer house project.

120. Betsy Fahlman, "Wilson Eyre in Detroit: The Charles Lang Freer House," *Winterthur Portfolio* 15 (Autumn 1980): 258–59.

121. Brunk 1981, 51 (n. 5); Tryon to Freer, 10 April 1890 (6).

122. Tryon to Freer, n.d. [postmarked 28 April 1890] (7).

123. Brunk 1981, 12.

124. Tryon to Freer, 24 July 1890 (8).

125. Ibid., 5 March 1891 (9A), envelope marked "ansd." in Freer's hand (Freer did not begin keeping carbon copies of his correspondence until 1892).

126. Ibid., 5 April 1891 (10).

127. Ibid., n.d. [after 5 April 1891] (10B).

128. For example, Fullerton Waldo says that Tryon had been permitted to have "his own sweet will" with the hall ("Some Personal Memories of Charles L. Freer," *Christian Science Monitor,* January 1923, Freer Press-Cutting Book 2:29).

129. Tryon to Freer, 27 April 1891 (13).

130. Ibid., n.d. [after 5 April 1891] (10B), and 27 April 1891 (13). Based on the dimensions given in Tryon's drawing (fig. 51), space number 1 would have been for *Springtime* (cat. no. 8), number 2 for *Summer* (cat. no. 9), number 3 for *Autumn* (cat. no. 10), number 4 (beside the bay window) for *The Sea: Morning* (cat. no. 7), number 5 (opposite no. 4) for *The Sea: Night* (cat. no. 6), number 6 (overmantel on one side of the double fireplace) for *Dawn* (cat. no. 12), and number 7 (overmantel on the other side) for *Winter* (cat. no. 11).

131. Ibid., 13 May 1891 (14).

132. Ibid., 8 July 1891 (16 and 17).

133. Ibid., 23 November 1891 (18). Tryon suggested that Stanford White, who was "very happy in this line," might be able to make something appropriate if Eyre could not.

134. Ibid., 21 December 1891 (19).

135. Ibid., 16 February 1892 (23) and 22 February 1892 (24).

136. Ibid., 8 March 1892 (25).

137. Quoted in White 1930, 82–83.

138. Royal Cortissoz, "Some Imaginative Types in American Art," *Harper's New Monthly Magazine* 91 (July 1895): 170–71. Hayward 1979, 120–21, discusses Tryon's adaptation of principles of Asian art to the panels.

139. Freer to Charles J. Morse, 19 August 1904 (LB 14); Tryon to Freer, 22 February 1892 (24). Once the paintings were in place, Tryon modified their surfaces to bring them into harmony with the finished woodwork.

140. Tryon to Freer, 5 April 1891 (10); 15 April 1891 (11); and 14 March 1892 (26).

141. Thomas Dewing to Freer, 15 February 1892.

142. Tryon to Freer, 21 April 1892 (28) and 17 April 1892 (27).

143. Freer to Wilson Eyre, 22 June 1892 (LB 1); Freer to Charles C. Coleman, 12 December 1900 (LB 7). Whistler had used the dutch metal process in the staircase dado panels for the entrance hall of Frederick Leyland's house (see Curry 1984, 160).

144. Freer to Tryon, 21 March 1892 (LB 1); Tryon to Freer, 21 April 1892 (28) and 17 April 1892 (27).

145. Tryon to Freer, 21 April 1892 (28).

146. Regarding light fixtures, Freer to Wilson Eyre, 25 May 1892, 22 June 1892, and 8 July 1892 (LB 1); regarding wood carvings, Freer to Eyre, 22 June 1892 and 8 July 1892 (LB 1); regarding furniture, Freer to A. H. Davenport, 13 August 1892, 17 August 1892, and 22 August 1892 (LB 1).

147. Freer to Tryon, 3 August 1892 (LB 1); Freer to Eyre, 4 August 1892 (LB 1); Tryon to Freer, 7 August 1892 (34). Freer arrived in New Bedford on Thursday, 28 July, leaving South Dartmouth the following day for Boston (Freer's Diary, 28–29 July 1892, Freer Papers/FGA).

148. Freer wrote N. E. Montross, 25 November 1892 (LB 1), that he planned to move into his house on 26 November; Tryon to Freer, 23 November 1892 (38).

149. Tryon to Freer, 21 April 1892 (28). Le-Brocq came soon after Tryon and Dewing arrived, and Freer wrote N. E. Montross to order two ounces of aluminum bronze required for decorating "some parts of the hall" (Freer to N. E. Montross, 17 December 1892 [LB 1]). The cost of the aluminum bronze and a large order of paint was $1.50.

150. White 1930, 83.

151. Quoted in Fullerton Waldo, "Some Personal Memories of Charles L. Freer," *Christian Science Monitor,* January 1923, Freer Press-Cutting Book 2:29.

152. White 1930, 83. Tryon seems to have repeated the technique in 1904, when he decorated the walls of rooms in Walter Copeland Bryant's home in Brockton: "Tryon mixed and applied the paints to portions of woodwork and panels on the walls with his own hands, teaching the workmen how to apply gold bronze with a sponge making an effect of old Japanese bronze woodwork and greens and golds all the walls being enveloped in a snowstorm of gold. It came out finely and the room is very handsome" ("Famous Artists," Bryant Papers/AAA).

153. Tryon to Freer, 17 April 1892 (27).

154. Freer to Wilson Eyre, 2 October 1893 (LB 1).

155. Letters dated 16 December 1892 (LB 1) from Dwight to Alice Tryon and from Thomas to Maria Dewing say that the artists planned to return to New York on 17 December; Freer to Thomas Dewing, 27 December 1892 (LB 1).

156. Freer to Wilson Eyre, 25 January 1893 (LB 1); to Tryon, 1 February 1893 (LB 1); to A. H. Davenport, 28 December 1892 (LB 1).

157. Tryon to Freer, 6 April 1893 (42).

158. Ibid., 4 January 1897 (82).

159. Freer to Tryon, 18 September 1897, Nelson White Papers/AAA.

160. Ibid., 9 December 1894.

161. Freer to W. Eyre, 2 October 1893 (LB 2).

162. A critic writing in *Art Review,* for example, classified Tryon with Inness and Charles Davis as the foremost "poet-painters" in America (*Art Review* 1 [March 1887]: 14–15, quoted by Sarah

Lea Burns in *The Poetic Mode in American Painting: George Fuller and Thomas Dewing* [Ann Arbor: University Microfilms, 1980], 222). Royal Cortissoz argued that Tryon, even more than his direct followers, was Inness's successor—"both paint American landscape with deep, personal feeling and with a technique complete, original, modern" (Samuel Isham and Royal Cortissoz, *The History of American Painting* [New York: Macmillan, 1927], 454). More recently, Michael Quick has noted the similarity of Tryon's *Twilight: Early Spring* (cat. no. 13) and Inness's *Home of the Heron* (Art Institute of Chicago), both executed in 1893 (Cikovsky and Quick 1985, 59).

163. Freer to W. Macbeth, 1 February 1894, Macbeth Gallery Records, 1892–1964, Gift of Robert McIntyre/AAA; Freer to W. K. Bixby, 7 February 1902 (LB 9).

164. Freer to W. Eyre, 2 October 1893 (LB 1).

165. Freer to Thomas Dewing, 7 June 1892 (LB 1). *The Rising Moon* was awarded a first-class gold medal in landscape.

166. Tryon to Freer, 31 December 1892 (39). Freer's response to the exhibition appears in a letter to Tryon, 27 July 1893 (LB 1). Tryon's pictures hung with Whistler's at the Fair; as in Munich, he received the gold medal for his work. Elizabeth Broun discusses Tryon's exhibits in Chicago in "American Paintings and Sculpture in the Fine Arts Building of the World's Columbian Exposition, Chicago, 1893" (Ph.D. diss., University of Kansas, 1976), 101–5.

167. Freer to Thomas Dewing, 19 July 1893 (LB 1).

168. Thomas Dewing to Freer, 16 February 1901.

169. Tryon to Freer, 18 March 1893 (41); Freer to Tryon, 22 March 1893 (LB 1); Tryon to Freer, 6 April 1893 (42).

170. Freer to Tryon, 10 April 1893 (LB 1). Kathleen Pyne provides a full account of the commission in Detroit 1983, 222–24.

171. Detroit 1983, 223.

172. Tryon to Edwin C. Shaw, 30 April 1923, Shaw Papers/AAA.

173. Caffin 1902, 163; Tryon to George Alfred

Williams, 16 September 1923, Nelson White Papers/AAA.

174. Tryon to George Alfred Williams, 16 September 1923, Nelson White Papers/AAA.

175. Tryon to Beulah Strong, 15 July 1923, Churchill Papers/SC Archives.

176. Unsigned exhibition review, *New York Evening Post*, 3 February 1900, Freer Press-Cutting Book 1:1; Tryon to George Alfred Williams, 16 September 1923 and 10 February 1918, Nelson White Papers/AAA.

177. Kingsley, 255.

178. Tryon to George Alfred Williams, 16 September 1923, Nelson White Papers/AAA.

179. Tryon to H. C. White, 14 February 1897, quoted in White 1930, 50.

180. Freer to Tryon, 17 June 1895, from Amano-hashidate, Japan, Tryon Papers/FGA.

181. Tryon to George Alfred Williams, 16 September 1923, Nelson White Papers/AAA: "Not only does the anatomy of the earth change entirely but more subtle changes take place in the atmosphere."

182. Tryon to Henry C. White, 14 February 1897, quoted in White 1930, 50.

183. Caffin writes that Tryon is "akin to Emerson in the character of his spirituality" (Caffin 1909, 35); White says that the "Concord writers influenced him strongly, and I think perhaps his ideals of life and his religious views would be well contained in the philosophy of Emerson" (White 1930, 122).

184. The two Emerson books (one published in Albany, the other in New York City) were bequeathed to Smith College. Tryon told Walter Copeland Bryant (ca. 1904) to "be sure and read Emerson's 'Essay on Art'" ("Famous Artists," Bryant Papers/AAA).

185. Ralph Waldo Emerson, "Nature 1," *Nature* (1836). Hayward 1978, 91–114, discusses the influence of Emerson.

186. Tryon to G. A. Williams, 17 February 1918, Nelson White Papers/AAA; "Famous Artists," Bryant Papers/AAA.

187. White 1930, 122.

188. Henry David Thoreau, "The Village," "Where I Lived and What I Lived For," and "Higher Laws," in *Walden* (1854).

189. Tryon to William K. Bixby, 24 February 1905, Bixby Collection/MHS.

190. Caffin 1902, 162.

191. Tryon to Freer, 18 April 1896 (73).

192. Tryon to William K. Bixby, 21 April 1905, Bixby Collection/MHS.

193. Tryon to Freer, n.d. [May 1912] (150); Tryon to Ehrick Rossiter, 10 May 1922, Rossiter Papers/AAA; Tryon to George Alfred Williams, 8 May 1923, Nelson White Papers/AAA.

194. Tryon to Freer, 17 May 1915 (181).

195. Tryon to Ehrick Rossiter, 10 May 1922, Rossiter Papers/AAA.

196. Tryon to George Alfred Williams, 2 August 1923, Nelson White Papers/AAA.

197. Tryon to Freer, 7 March 1894 (53); Littmann 1930; Tryon to Freer, 13 August 1916 (196). Also Tryon to George Alfred Williams, 24 March 1922, Nelson White Papers/AAA: "When I am in the country I find so many things to do I am busy from morn' to night and I get very little time in my studio."

198. Tryon to George Alfred Williams, 24 March 1922, Nelson White Papers/AAA; Littmann 1923.

199. "Tryon, Artist, Was Fisherman," undated press cutting [July 1925], Bryant Papers/AAA.

200. Tryon to Freer, 25 November 1917 (207).

201. Merrick 1923, 501; Tryon to William K. Bixby, 16 January 1904, Bixby Collection/MHS; White 1930, 113.

202. Mrs. Fitch to the author, 2 September 1986.

203. Tryon to W. K. Bixby, 6 August 1904, Bixby Collection/MHS; "Famous Artists," Bryant Papers/AAA.

204. White 1930, 111 and 206, and Tryon to George Alfred Williams, 4 May 1914, Nelson White Papers/AAA.

205. "Tryon, Artist, Was Fisherman," undated press cutting [July 1925], Bryant Papers/AAA.

206. White 1930, 4.

207. Tryon to Freer, 21 May 1894 (59) and 17 June 1894 (60).

208. Tryon to George Alfred Williams, 24 October 1914, Nelson White Papers/AAA; White 1930, 202–3, also quoted in Littmann 1930.

209. Tryon to George Alfred Williams, 24 March 1922 and 30 March 1915, Nelson White Papers/AAA.

210. White 1930, 201.

211. Ibid., 155.

212. Tryon to Beulah Strong, 15 July 1923, Churchill Papers/SC Archives.

213. Bermingham 1975, 63.

214. Tryon to Freer, 14 October 1911 (131). Also Tryon to Beulah Strong, 29 September 1910, typescript copy, Tryon Papers/SC Archives: "I am gathering material for my winter work but the foliage is so slow in ripening, I fear I will not get the color which I most want."

215. Tryon to George Alfred Williams, 7 December 1921 and 28 September 1924, Nelson White Papers/AAA.

216. Tryon to Freer, 21 November 1915 (182).

217. "Famous Artists," Bryant Papers/AAA.

218. Tryon to Freer, 16 November 1893 (48) and 25 October 1895 (67).

219. Tryon to Freer, 16 November 1893 (48); Freer to Tryon, 12 October 1901 (LB 8).

220. Tryon to Freer, n.d. [postmarked 12 November 1902] (120). In a letter to Freer dated 25 October 1895 (67), Tryon referred to Padanaram as a "veritable gate to heaven."

221. Ibid., 13 November 1911 (133). From 1889 until 1910 the Tryons lived at 226 West Fifty-Ninth Street (The Gainsborough); they moved to Harperley Hall in 1910.

222. White 1930, 120. Freer commissioned *The Garland* in 1899 as a gift to Tryon (voucher, Thomas Dewing, 3 April 1899, Freer Papers/FGA); Tryon saw the painting in Dewing's studio that November and judged it to be "one of the things that will live for all time with the Elgin marbles, with Tanagra—with all that is beautiful and uplifting" (Tryon to Freer, 22 November 1899 [107]). It was probably delivered in time for Christmas and hung on 14 January 1900: "I

cannot conceive of anything more beautiful or more perfectly fitting the place," Tryon wrote Freer. "I go into the parlor the first thing in the morning to assure myself that it has not vanished in the night" (15 January 1900 [110]). Susan Hobbs owns a photograph of the painting in place in the parlor. Tryon bequeathed *The Garland* to Smith College; the painting is now in the Thyssen-Bornemisza Collection in Lugano, Switzerland. Kathleen Pyne discusses *The Garland* in Barbara Novak, *Thyssen-Bornemisza Collection: Nineteenth-century American Painting* (London: Philip Wilson Publishers for Sotheby's Publications, 1986), no. 109.

223. White 1930, 120. Tryon's library included several volumes of Flemish, Italian, and German engravings from the sixteenth and eighteenth centuries (now in the print room, SCMA) and hundreds of other books, most of them bequeathed to Smith College, where they remain in the Neilson Library and the Hillyer Art Library.

Many of Tryon's objets d'art were presents from Freer. In 1917, when he was culling his collection, Freer gave Tryon a number of "souvenirs," including an "early tea bowl made at Awata." Freer wrote to Tryon, "The peaches of that day must have been larger than those grown in your neighborhood, but the green and blue of the glaze are not unlike . . . the colors to be seen along your coast" (17 May 1917 [202]). Tryon presented a number of Asian objects to Smith College, and after his death several more were given as part of his bequest; some of the works undoubtedly had been gifts from Freer. The first SCMA accession books list sake bottles, Japanese vases, a Chinese urn and a Japanese rose jar, Ming-dynasty blue-and-white vases, Japanese lacquer boxes and trays, wood carvings, bronze vases, and a Chinese painting of a giant carp by Wei Tao Ren. Most of the objects have been sold or given away by the museum, but *Giant Carp* remains in the SCMA collection.

224. White 1930, 120. The Wyant painting was probably *Lake Champlain,* which was given to Smith College in 1920 and sold by the SCMA in 1947. One of the "Canalettos," *View of the Doge's Palace and Saint Mark's Place from the Grand Canal,* was presented to Smith College as part of Tryon's bequest; it remains in the collection, though it has been reattributed to a follower of

Michele Marieschi. The Blakelock painting, also part of the bequest, was sold by the SCMA in the forties.

225. Tryon to Freer, 14 March 1892 (26).

226. White 1930, 121, 101, 171–72. Tryon owned a large collection of Japanese prints, a few of which he presented to Smith College in 1915 and the rest in 1921 (Tryon to Alfred Vance Churchill, 19 February 1921, Churchill Papers/SC Archives). Most of the prints are now in Forbes Library, Northampton, Massachusetts.

227. Tryon to George Alfred Williams, 30 March 1915 and 6 January 1916, Nelson White Papers/AAA.

228. Tryon to Freer, 10 January 1897 (83).

22. "Famous Artists," Bryant Papers/AAA; Tryon to Freer, 13 November 1911 (133).

230. Tryon to Freer, 29 December 1912 (157); 7 April 1908 (126); and 27 February 1912 (138).

231. White 1930, 122; Tryon to William K. Bixby, 16 January 1904, Bixby Collection/MHS.

232. Tryon to William K. Bixby, 24 February and 29 March 1905, Bixby Collection/MHS.

233. Tryon to Henry C. White, 28 March 1911, typescript copy, Henry White Papers/AAA.

234. Tryon to George Alfred Williams, 24 March 1922 and 30 March 1915, Nelson White Papers/AAA; Tryon to Freer, 15 April 1897 (96).

235. Phillips 1918, 391; Caffin 1909, 43.

236. Tryon to George Alfred Williams, 12 November 1916, Nelson White Papers/AAA.

237. Hunt 1875, 8; inscription in Tryon's hand on page 2 of his copy, now in the Hillyer Art Library, Smith College.

238. Tryon to George Alfred Williams, 24 October 1914, Nelson White Papers/AAA.

239. Ibid., 8 February 1923; Freer to Tryon, 9 December 1911 (135); Tryon to Beulah Strong, 12 April 1912, Churchill Papers/SC Archives.

240. Tryon to Alfred Vance Churchill, 29 January 1924, Churchill Papers/SC Archives; Tryon to George Alfred Williams, 24 January 1923, Nelson White Papers/AAA.

241. Tryon to T. W. Dunbar, 19 January 1923, Shaw Papers/AAA.

242. Tryon to George Alfred Williams, 15 July 1918, Nelson White Papers/AAA; Tryon to T. W. Dunbar, July 1919, SCMA documentary files.

243. White 1930, 180.

244. Tryon to Beulah Strong, 12 April 1912, Churchill Papers/SC Archives; White 1930, 181.

245. White 1930, 181; Alfred Vance Churchill to Henry C. White, 3 August 1928, Henry White Papers/AAA (also quoted in White 1930, 181). According to Henry White, Tryon began a painting with a "mental conception" of its final form; Churchill's account, supposedly related by the artist himself, indicates that Tryon had no idea what he was going to do when he started to work on a picture.

246. Tryon to T. W. Dunbar, 6 July 1922, Shaw Papers/AAA; White 1930, 149.

247. Tryon to T. W. Dunbar, 6 July 1922, Shaw Papers/AAA.

248. Tryon to G. A. Williams, n.d. [winter 1923/24], Nelson White Papers/AAA.

249. Tryon to T. W. Dunbar, 6 July 1922, Shaw Papers/AAA.

250. Tryon to George Alfred Williams, 2 August 1923, Nelson White Papers/AAA. Nevertheless, Tryon wrote Beulah Strong (12 April 1912, Churchill Papers/SC Archives), "When by chance a good thing happens, it seems as much as ever to drop from the skies."

251. Freer to Tryon, 18 September [1897], Nelson White Papers/AAA.

252. Tryon to Alfred Vance Churchill, 29 January 1924, Churchill Papers/SC Archives. Henry White believed that Tryon produced only about six large pictures a year (White 1930, 189), but the quantity of Tryon's work appears to be much greater. I have located nearly three hundred oils and pastels, and at least twice that number can be named, though their present locations are unknown.

253. Freer to Bunkio Matsuki, 20 July 1904 (LB 14). When asked by some artists at the Century Club what the surest way of selling one's paintings was, Tryon replied, "Well, boys, I think the best way is to paint a damned good picture" (White 1930, 185).

254. Freer to W. K. Bixby, 5 February 1900 (LB

5). At the auction of William T. Evans's collection of American paintings in 1900, Freer bid discriminately on several paintings on Bixby's behalf and secured a landscape by George Fuller (*Bringing Home the Cow*) that would "harmonize . . . perfectly," he said, "with the Dewing and Tryon which are to follow." Although Freer did bid on one painting by Tryon, *Daybreak* (fig. 42), he refused to go above one thousand dollars, not only because he considered the work "sketchily painted" but also because he had just received word from Bixby authorizing the purchase of *Clearing after Showers* directly from the artist.

Tryon wrote Bixby (20 February 1900, Bixby Collection/MHS) that the motive of the work would be evident,

> but I would add that the effect in the picture has been to show the mystery of rain and shifting wind on a quiet New England scene. The forms of the trees and leafage generally not quite clear and sharp owing to the action of wind, the whole scene wet and moving shadows and light such as come with breaking up of rain clouds. The rain still falling on the distant hills.

The picture, signed and dated 1898–99 at lower left and measuring 31¾ × 39½ inches, would be described less poetically in the Kende Galleries sale catalogue: "Stones and clumps of bushes in the foreground in an open field; in the distance, groups of trees before low rolling hills. Misty atmosphere." *Clearing after Showers* was purchased for Washington University, St. Louis, through the W. K. Bixby American Art Acquisition Fund in 1917; it was sold from the collection through Kende Galleries at Gimbel Brothers, New York, in May 1945.

255. Freer to W. K. Bixby, 5 March 1900 (LB 6); Tryon to Bixby, 20 February 1900, Bixby Collection/MHS; and Freer to Bixby, 15 March 1900 (LB 6).

256. Freer to W. K. Bixby, 2 July 1904 (LB 14).

257. Tryon to W. K. Bixby, 5 April 1905, Bixby Collection/MHS.

258. Freer to Tryon, 17 June 1895, from Amano-hashidate, Japan, Tryon Papers/FGA; L. M. Bryant, *What Pictures to See in America* (New York: John Lane Company, 1915), 224.

259. Quoted in Littmann 1923; Tryon to Freer, 14 July 1900 (114).

260. Alice Tryon to Alfred Vance Churchill, 4 March [1926], Churchill Papers/SC Archives.

261. White 1930, 88.

262. Alice Tryon to Alfred Vance Churchill, 4 March [1926], Churchill Papers/SC Archives; Smith College President's Report, 1886–87/SC Archives. From 1886 until 1907, Mary R. Williams conducted the actual teaching of drawing and painting at Smith, and from 1907 until 1923, the year of Tryon's retirement, Beulah Strong served as associate professor of art in charge of instruction.

263. A. V. Churchill, "Tryon at Smith College: 1886–1923," *Smith Alumnae Quarterly* (November 1925): 9.

264. Official Circular, Smith College, October 1877, and Smith College President's Report, 1899–1900 and 1902–03/SC Archives.

265. Smith College President's Report, 1888–89 and 1902–03/SC Archives.

266. "Some Notes on Mr. Tryon," Henry White Papers/AAA; L. C. Seelye to Tryon, 4 June 1923, typescript copy, Nelson White Papers/AAA.

267. Smith College President's Report, 1886–87/SC Archives; Virginia J. Smith (class of 1907), "Dwight Tryon the Educator," *Smith Alumnae Quarterly* (July 1926): 404–5.

268. Alice Tryon to Alfred Vance Churchill, 4 March [1926], Churchill Papers/SC Archives; Tryon's copy of Hunt 1875, 46, in the Hillyer Art Library, Smith College.

269. Smith, "Dwight Tryon," 405; White 1930, 102.

270. White 1930, 43 and 98.

271. Tryon to Alfred Vance Churchill, 31 October 1924, Churchill Papers/SC Archives; and A. V. Churchill, "The Future of the Museum," *Smith College Museum of Art Bulletin* (June 1926).

272. Tryon to Alfred Vance Churchill, 31 October 1924, Churchill Papers/SC Archives; White 1930, 89.

273. Freer to A. V. Churchill, 18 February 1913, Churchill Papers/SC Archives.

274. Smith College President's Report, 1907–08/SC Archives.

275. Alice Manning, "First Art Building at Smith College," *Northampton* (Mass.) *Daily Hampshire Gazette,* 29 June 1977.

276. Among the paintings acquired during Tryon's years at Smith are Abbott H. Thayer's *Winged Figure* and *Study of a Nude,* Thomas Dewing's *Recitation in a Spring Wood* and *Lute Player* (now in the National Gallery of Art, Washington, D.C.), Maria Oakey Dewing's *Lilies and Delphinium* and *Lilies,* Albert Pinkham Ryder's *Perette,* and other works too numerous to name by John H. Twachtman, Benjamin Fitz, William Merritt Chase, George Fuller, Will H. Low, Horatio Walker, and James McNeill Whistler (*Smith College Museum of Art Catalogue* [1937], annotated by Alfred Vance Churchill, Churchill Papers/SC Archives; SCMA card catalogue; and White 1930, 90).

277. Tryon to George Alfred Williams, 17 December 1922, Nelson White Papers/AAA. Until about 1920 the Smith College collection remained limited to American paintings from the last quarter of the nineteenth century because, Tryon explained, the "best examples of other art are usually out of our reach financially, and as I do not believe in adding any but the best it leaves us little scope" (Tryon to Churchill, 4 January 1921, Churchill Papers/SC Archives). Tryon himself donated to the collection a number of works by American artists, including R. Swain Gifford, Samuel Coleman, George de Forest Brush, and Alexander H. Wyant. He also presented several of his own works.

278. Freer to President Theodore Roosevelt, 14 December 1905, Freer Papers/FGA.

279. Freer to Tryon, 6 February 1905 (LB 16).

280. Smithsonian Institution, *Catalogue of a Selection of Art Objects from the Freer Collection Exhibited in the New Building of the National Museum,* United States National Museum Bulletin no. 78 (Washington, D.C.: Smithsonian Institution, 1912), 5.

281. Mechlin 1907, 358.

282. See Theodore Child, "American Artists at the Paris Exhibition," *Harper's New Monthly Magazine* 79 (September 1889): 498. Child points out the similarity of Whistler's Nocturnes to prints by Hiroshige but says that the "coincidence only shows that those prodigiously delicate and exquisitely tasteful people, the Japanese, have long

been sensitive to the renderings of certain phases of nature which Mr. Whistler has been the first Western artist to appreciate and to depict, with especial and persistent effort, in the extensive series of studies which figure in his work under the name of 'Nocturnes,' and which are absolutely original, personal, and unlike anything that has ever been done before."

283. Hartmann 1902, 1:135.

284. Hayward 1978 and 1979.

285. Tryon to Freer, 2 February 1897 (84).

286. Ibid., 23 December 1895 (69).

287. Ibid., 25 October 1895 (67). Tryon had been reading Hearn's *Glimpses of Unfamiliar Japan* (Boston: Houghton, Mifflin and Co., 1894).

288. Tryon to Freer, 21 March 1896 (72). Tryon's remarks on *Springtime* were occasioned by its exhibition at the SAA in 1896, four years after the execution of the painting.

289. Freer to Tryon, 3 August 1907 (LB 22).

290. Tryon to Freer, 7 August 1907 (124).

291. Freer to B. Matsuki, 30 September 1896 (LB 2). Matsuki owned at least one of Tryon's "characteristic subjects," which he purchased in 1904 and lent to an exhibition in 1908 (Freer to Matsuki, 20 July 1904 [LB 14]; "The Matsuki Collection," n.d. [1908], *New York Times,* Freer Press-Cutting Book 1:26). The Kingsley engraving after Tryon's *Winter Evening* was intended for Mrs. Matsuki.

292. Tryon to Freer, 21 July 1907 (122).

293. Ibid., 23 December 1895 (69); Littmann 1923.

294. Tryon to George Alfred Williams, 7 October 1916, Nelson White Papers/AAA; Charles Caffin, "How American Taste Is Improving," *World's Work* 8 (July 1904): 5009.

295. Freer to Thomas Dewing, 2 November 1904 (LB 15).

296. Gerdts, Sweet, and Preato 1982, 27.

297. "Art Notes. Dwight W. Tryon's Work Well Represented in a Loan Exhibition at a New Gallery," *Mail Express,* 14 February 1900, Freer Press-Cutting Book 1:1. Following the honored appearances of his work in Munich and Chicago, Tryon had gone on to win first prize at the

Cleveland Interstate Exposition in 1895 and at the Tennessee Centennial in Nashville in 1897; a gold medal at the Carnegie Art Galleries in 1898; and the Carnegie Chronological Medal in 1899.

298. Tryon to Freer, 9 February 1900 (111).

299. "Art Notes. Landscapes by Mr. Tryon at the Montross Gallery," *New York Sun,* 2 February 1900, Freer Press-Cutting Book 1:1.

300. Tryon to Freer, 9 January 1900 (109).

301. Ibid., 29 January 1913 (170); "Early Pictures of Arthur Davies," *New York Times,* n.d. [1913], Freer Press-Cutting Book 1:51.

302. A. H. Thayer to Tryon, 7 December 1914, Nelson White Papers/AAA.

303. Tryon to G. A. Williams, 16 April 1917, Nelson White Papers/AAA; Tryon to T. W. Dunbar, 6 July 1922, Shaw Papers/AAA.

304. Tryon to G. A. Williams, 30 March 1915 and 15 September 1916, Nelson White Papers/AAA. Among the other artists who exhibited at the Montross Gallery in 1916 were Karl Anderson, James Butler, Randall Davey, Arthur B. Davies, William Glackens, I. Lichtenstein, Max Weber, Eugene E. Steichen, and Maurice Prendergast (Montross Gallery Catalogue [1916], Art Division, New York Public Library, on microfilm, AAA).

305. "Mr. Freer Speaks His Mind," *Boston Transcript,* 15 July 1915, Freer Press-Cutting Book 1:63.

306. Tryon to George Alfred Williams, 27 June 1915, Nelson White Papers/AAA.

307. Albrecht Montgelas, "Industrial Arts Develop Taste of Next Generation," *Chicago Examiner,* 11 August 1915, Freer Press-Cutting Book 2:16.

308. The First Codicil to the Last Will and Testament of Charles L. Freer, 4 May 1919, section 4; Katharine Nash Rhoades, "An Appreciation of Charles Lang Freer," *Ars Orientalis* 2 (1957): 3.

309. The introduction to the Freer Gallery repeated the arrangement in Freer's own home, in which paintings by Tryon were "first met upon crossing Mr. Freer's threshold" with the relatively more esoteric objects encountered further in (Mechlin 1907, 367).

310. "At the Freer Art Gallery," *New York Times Magazine,* 13 May 1923, Freer Press-Cutting Book 2:35.

311. In a letter to A. V. Churchill dated 4 January 1921 (Churchill Papers/SC Archives), Tryon indicated that he planned to make a "Washington trip," but no evidence of the journey has come to light. According to "Tryon, Artist, Was Fisherman" (undated press cutting [July 1925], Bryant Papers/AAA),

> Mr. Tryon never saw his paintings as displayed in the Freer Museum. He sought to select the background for the walls of the museum that would show his paintings to the best advantage. The curator chose something entirely different for the wall hangings, hence, Mr. Tryon never went to Washington to see the famous Tryon room.

312. According to Henry White, Tryon "had in mind to present an art gallery to Smith College for a number of years before 1914," but the war had interrupted his plans (White 1930, 108).

313. Tryon to A. V. Churchill, 31 October 1924, Churchill Papers/SC Archives.

314. A. V. Churchill to Tryon, 17 December 1924, and Tryon to Churchill, 20 January 1925, Churchill Papers/SC Archives.

315. Tryon to A. V. Churchill, 18 December 1924, Churchill Papers/SC Archives. Also Frederick Ackerman to W. A. Neilson (9 December 1924, Office of the President records/SC Archives): "I am very much in favor of the idea of a brick structure which would recall New England tradition and at the same time I think more appropriately house this particular collection. I think that a simple, dignified structure can be made along these lines and be thoroughly in keeping with the environment."

316. A. V. Churchill to Tryon, 24 June 1925, Churchill Papers/SC Archives. Tryon died 1 July 1925.

317. Tryon Gallery dedication plaque, text in the Tryon Gallery building file/SC Archives. The original Tryon Gallery was demolished in 1970 to make room for the Fine Arts Center, but the new museum building continues to bear Tryon's name.

318. Quoted in White 1930, 71.

319. Tryon to George Alfred Williams, 8 May 1923, Nelson White Papers/AAA; Tryon to Freer, 5 August 1894 (62).

320. Quoted in "Dwight W. Tryon Dies at His Home in Padanaram," undated press cutting [July 1925], Bryant Papers/AAA.

321. Tryon to George Alfred Williams, 7 May 1916, Nelson White Papers/AAA.

322. Tryon to Freer, 5 May 1897 (91); quoted in White 1930, 71.

323. Tryon to A. V. Churchill, 31 October 1924, Churchill Papers/SC Archives.

324. Tryon to George Alfred Williams, 12 March 1925, Nelson White Papers/SC Archives.

325. Marjorie Hassell, interview with the author, Washington, D.C., 9 December 1986. An obituary notice in the *New Bedford* (Mass.) *Evening Standard* ("Noted Painter Dies Today," 1 July 1925, press cutting in Bryant Papers/AAA) reported that Tryon died at his home on July 1 at 11:00 A.M. of cirrhosis of the liver, but according to Henry White, Tryon died from cancer of the stomach (White 1930, 212). The unfinished pastel is in a private collection.

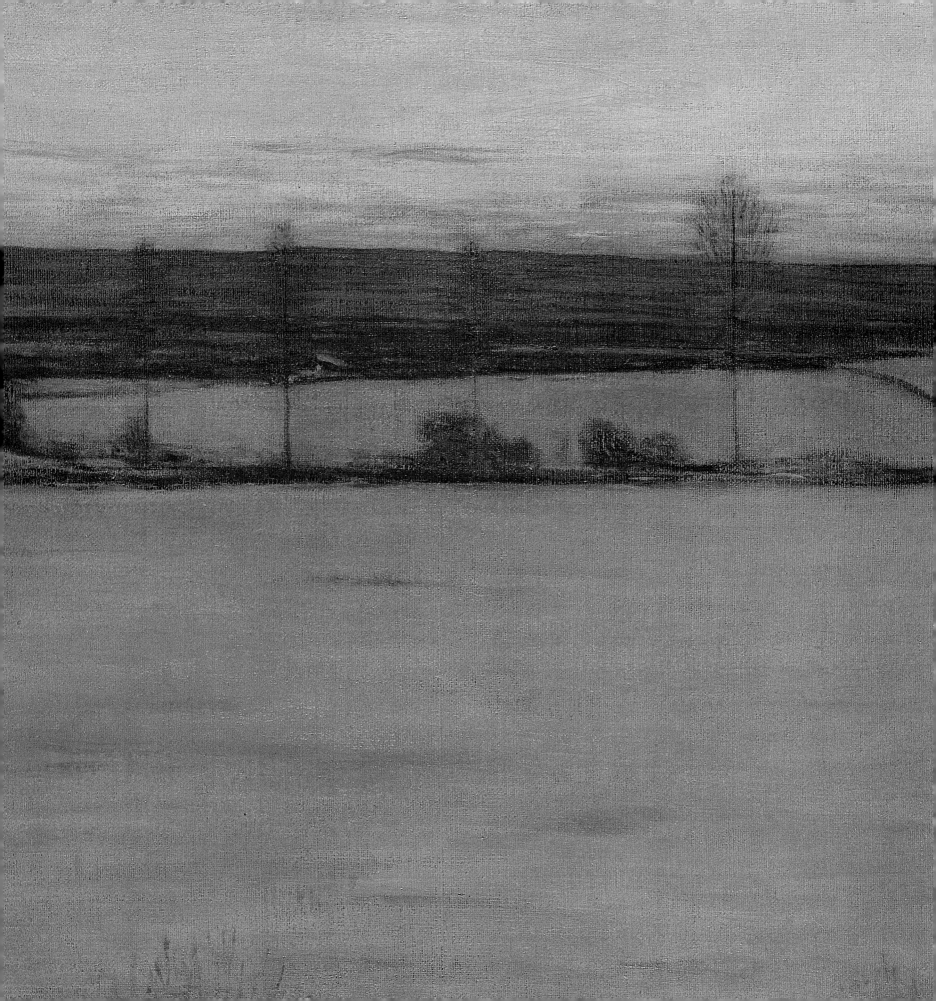

CATALOGUE

THE CATALOGUE is organized in roughly chronological order. Punctuation of titles has been edited for consistency; significant variations, together with other details of acquisition, exhibition, and publication of the Freer Gallery's Tryon paintings, are noted in the History section that follows. Abbreviations for frequently cited archival sources are given on page 13. In the dimensions, height precedes width.

Detail of *Winter,* cat. no. 11.

1 *A Lighted Village*

ca. 1887
Oil on wood panel
13⅝ × 21¾ in. (34.8 × 55.2 cm)
Signed, lower right: D. W. TRYON
06.74

2 *Moonlight*

1887
Oil on canvas mounted on wood panel
19⅝ × 31⅜ in. (49.8 × 79.7 cm)
Signed and dated, lower right: D. W. TRYON
1887

91.2

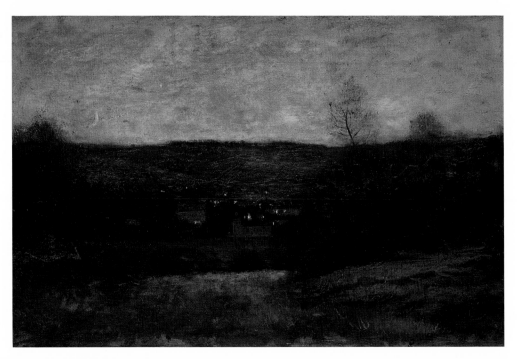

1 *A Lighted Village*

Two of the oldest works in the collection, *A Lighted Village* and *Moonlight*, were never among the most venerable: both were acquired inexpensively at auction, and neither was exhibited more than once after coming into Charles Lang Freer's hands. For the collector these pictures seem to have represented little more than an early stage of Tryon's artistic development and an antiquated phase of American taste. The artist himself must have considered *A Lighted Village* an honorable work, however, since he asked the original owner, Thomas B. Clarke, to send the painting to the World's Columbian Exposition of 1893.[1] Freer also lent works by Tryon to that World's Fair, and must have seen *A Lighted Village* there. Six years later, in 1899, he bought it at the celebrated sale of Clarke's collection in New York City.

The village is an unusual feature in

Fig. 77 "Motif," ca. 1887. Graphite on paper, 7⅜ × 4⅞ in. (19.0 × 12.3 cm). Tryon Papers/ FGA.

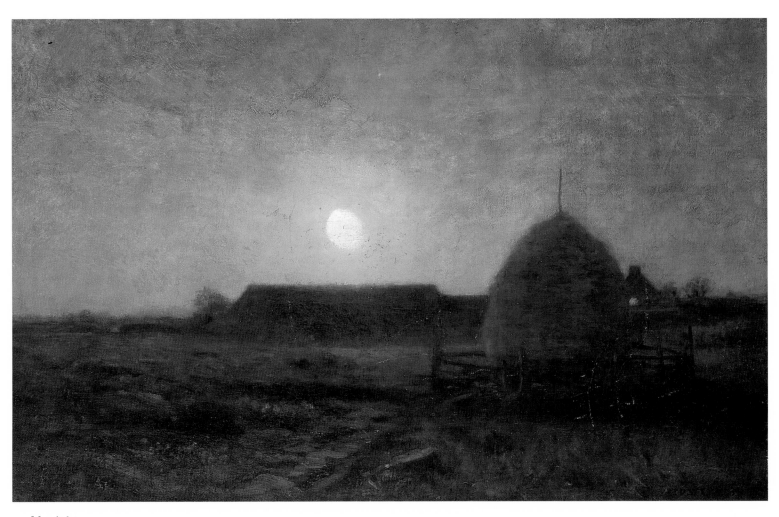

2 *Moonlight*

Tryon's art of pure landscape, but the one that appears in this early work conforms to the countryside, revealing itself through the heavy dusk by an unobtrusive show of yellow lights. *Moonlight*, the rural counterpart of *A Lighted Village*, is also a nocturnal picture, but its somber foreground, bright sky, and smooth surface impart a distinctly French note to the American scene. Sketches from nature contained in the artist's sketchbook (see fig. 77) show the motif of the "moonlight" with notes, in French,

inscribed in Tryon's hand. By grafting the Barbizon manner onto a native subject, Tryon assured his success with conservative American collectors who preferred to buy European art. It was Tryon's departure from that measure of artistic appreciation, however, that would capture Freer's enduring admiration.

1. Tryon to T. B. Clarke, 23 December 1892, Charles Henry Hart Autograph Collection/AAA; Anonymous gift, 1954.

3 *The Rising Moon: Autumn*

1889
Oil on wood panel
20 × 31⅝ in. (51 × 80.3 cm)
Signed and dated, lower right:
D. W. TRYON 1889
89.31

4 *The Sea: Sunset*

1889
Oil on wood panel
20 × 30⅛ in. (50.9 × 76.5 cm)
Signed and dated, lower left:
D. W. TRYON 1889
06.76

Although *The Rising Moon: Autumn* may not have been, as Tryon believed, the first oil painting Freer ever bought, it can be distinguished as the earliest of those that remain in the Freer collection and therefore the first manifestation of the collector's mature taste in painting.[1] *The Sea: Sunset*, the second painting by Tryon that Freer acquired, was purchased as a pendant to *The Rising Moon*.[2] Containing the essential elements of Tryon's oeuvre, the two paintings make a handsome pair—the rising moon above the fields mirrors the setting sun over the sea—and together survey the environs of South Dartmouth.

The artist's biographer, Henry C. White, remembered seeing *The Rising Moon* on an easel in Tryon's studio just before Freer made his purchase, which was directly after the Potter Palmers of Chicago visited Tryon in 1889.[3] Mrs. Palmer had assured the artist she would be back for *The Rising Moon*, provided she found nothing in France she liked better; Tryon, prudently, made no promises. Upon her return some months later, Mrs. Palmer was annoyed to discover the painting was gone, and when she reached Chicago must have been dismayed by the news that during her absence *The Rising Moon* had been shown at the Art Institute—and awarded the Potter Palmer Prize.[4]

Tryon loved to recount this tale of the painting's appeal, which was all the more piquant, he thought, since he never expected *The Rising Moon* to be popular. Warning Freer not to expect a "general appreciation of it by many," Tryon alerted him to the perils of good taste: "It will be a picture which the average person will see nothing in, and at first sight will not reveal itself to even more cultured ones." He felt sure, however, that *The Rising Moon* was his best work so far (it was, at least, the only one he could enjoy without feeling the urge to work on more) and confident that Freer's powers of appreciation were equal to the painting.[5]

Fig. 78 Elbridge Kingsley (1842–1918), *The Rising Moon*, ca. 1897, after Tryon. Wood engraving, 11¼ × 17⅞ in. (28.6 × 45.4 cm). FGA Study Collection.

Fig. 79 *Moonrise at Sunset*, 1890. Oil on wood, 24⅛ × 23⅛ in. (61.3 × 58.7 cm). The Metropolitan Museum of Art, New York (10.64.12); Gift of George A. Hearn, 1910.

Indeed, Freer's admiration for this particular work sealed the bond of sympathy between painter and patron. Tryon was so eager for Freer to buy *The Sea: Sunset* the following February that he offered it, complete with frame, at a reduced rate (an arrangement that was not in any way, he said, to set a precedent for future acquisitions). "It is a picture which I consider in many ways one of my best," Tryon said, making it companionable with *The Rising Moon*. "I

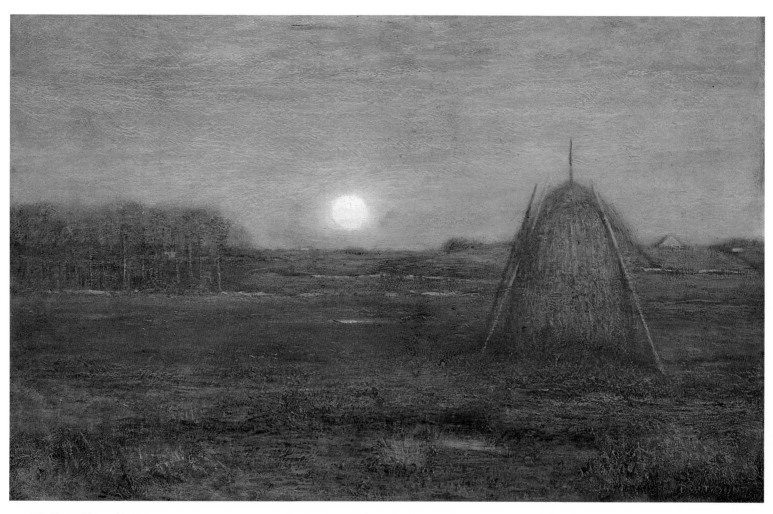

3 *The Rising Moon: Autumn*

find it holds with me continually and gives me pleasure which is my only test in art." He stipulated only that it be shown that year in Chicago even though, like its pendant, it had not been intended for public exhibition and therefore might not appear to best advantage.[6]

Freer must have considered *The Sea: Sunset* aesthetically dependent upon his earlier acquisition, for it was rarely exhibited out of the company of *The Rising Moon*. Both paintings display Tryon's lingering alle-

giance to European painting. The play of light on the surface of *The Sea: Sunset* calls to mind impressionist paintings, and the pensive, twilight tone of *The Rising Moon* suggests the artist's enduring affinity with the landscape art of Henri Harpignies and Charles-François Daubigny. But the arrangement of color is too carefully contrived in *The Sea: Sunset* to indicate a truly impressionist frame of mind, and the haystacks in *The Rising Moon* are not the haystacks of Monet but the hayricks of Mas-

sachusetts, drawn from the fields of South Dartmouth, where Tryon had settled several summers before.

Beside Tryon's later evocations of moonlight, *The Rising Moon* looks something less than subtle. Its vaunted refinement becomes apparent, however, when the painting is contrasted to Tryon's earlier works. In its day it must have appeared a refreshing rendition of an ever-popular subject in American art, the pastoral landscape; and in spite of Tryon's opinion that it was not an "exhibition picture," *The Rising Moon* represented him on so many illustrious occasions that Tryon had cause to call it his "mascot."[7] After its premiere at the 1889 exhibition in Chicago, *The Rising Moon* was awarded gold medals at the International Art Exposition in Munich in 1892 and at the World's Columbian Exposition in Chicago the following year.

Believing Tryon's painting deserved a wider audience than it could have in temporary exhibitions, Freer commissioned Elbridge Kingsley to execute a wood engraving after *The Rising Moon*, "one of the most satisfying of the very many beautiful things done by our mutual friend Tryon," he wrote Kingsley.[8] The project to translate the painting to black and white was a struggle from the start, since *The Rising Moon* was a "tonal atmospheric harmony," as Kingsley said; moreover, the original work had been motivated by the "mood of the moment," making it particularly difficult to reproduce so many years after its inception.[9] Kingsley's trials and errors, annotated in Tryon's hand, are preserved at Smith College; fifteen trial proofs testify to the problem of capturing a colorist's nuances in a graphic art.[10] The engraving (fig. 78) was accomplished at last by 1897, when Tryon wrote Freer that Kingsley had become the "happiest man," attributing his contentment to a new ten-dollar suit, one of the fruits of the commission.[11]

The Rising Moon was to become the most famous of Tryon's "haystacks." An earlier version, *Moonlight* (cat. no. 2), shows a similar scene in darker shades, and *Moonrise at Sunset* (fig. 79), a piece composed one year after the Freer painting in a slightly higher key of color, appears a simplified *Rising Moon*: a pentimento visible even in photographs betrays a second haystack that originally occupied the left side of the composition. These paintings make the transition from Tryon's Barbizon-inspired works of the 1880s to the more decorative landscapes of the 1890s and the tonal paintings of Tryon's mature period. By 1912, when representatives of the Metropolitan Museum of Art asked Tryon if he could disguise the ghostly form in *Moonrise at Sunset*, the artist replied that his technique had changed so much in the intervening years that he felt apprehensive about touching it, as though the work had been produced by a hand other than his own.[12]

But if the methods he employed were soon to be rendered out of date, the elements of *The Rising Moon*'s composition—the line of slender, nearly barren trees, the marshy, rock-strewn meadow, and the dim, opalescent sky—were to appear in almost all of Tryon's future landscape paintings. Already the hayrick and background buildings were diminishing in stature, leaving room for the characteristic landscape on the left half of the picture. *The Sea: Sunset* also holds an understated sign of human habitation, a solitary sail on the horizon, which is incorporated asymmetrically into the design so that its purpose becomes decorative rather than narrative. In Tryon's quiet shows of nature, humanity would be ever after strictly incidental.

1. According to Tryon's autobiographical notes (Tryon Papers/AAA), Freer himself told Tryon that *The Rising Moon* was the first oil painting he purchased.

2. Tryon to Freer, 6 February 1890 (5).

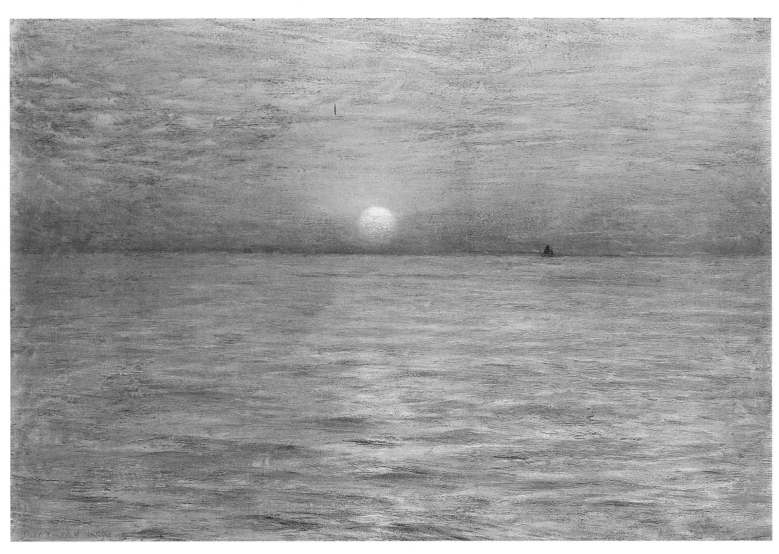

4 *The Sea: Sunset*

3. Letter from H. C. White, 1930, typescript copy in registrar's object file (89.31), FGA.

4. Tryon Papers/AAA and White 1930, 77–78; Carolyn C. Fitch (Mrs. Roger S.) to the author, 2 September 1986.

5. Tryon to Freer, 6 July 1889 (4) and 19 May 1889 (2).

6. Ibid., 6 February 1890 (5) and 24 July 1890 (8).

7. Ibid., 27 August 1892 (36).

8. Freer to E. Kingsley, 1 February 1893 (LB 1).

9. Kingsley, 257.

10. Tryon presented the set of Kingsley's engravings to Smith College in 1915. There are also trial proofs at the Mount Holyoke College Museum of Art (South Hadley, Massachusetts) and in the FGA Study Collection.

11. Tryon to Freer, 15 April 1897 (96).

12. Tryon to the Metropolitan Museum of Art, New York, 20 November 1912, quoted in Burke 1980, 108.

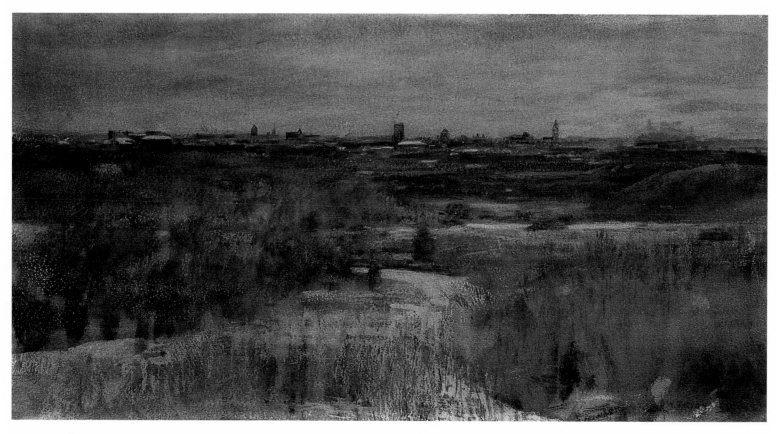

5 *Winter: Central Park*

5 *Winter: Central Park*

1890
Watercolor on cream paper
11¼ × 21⅞ in. (28.6 × 55.7 cm)
Signed and dated, lower right:
D. W. TRYON 1890
00.12

Although Tryon became a member of the American Water Color Society in 1882, he disliked watercolor painting as a rule and made only occasional concessions to its popularity in America during the 1880s and 1890s. *Winter: Central Park* (originally titled "Early Snow") is a watercolor in disguise: as though he were planning to paint the picture in oil, Tryon began with a ground of green and blue, depriving the work of the translucent quality generally associated with watercolor pigments on paper. The technique effectively reduced the color range of the painting by dimming the view of the park in imitation of the cold gray light of winter, a season Tryon particularly disliked.

Although he spent six months of every year in New York, Tryon rarely painted the "haunts of man"[1] or the winter gloom he associated with urban life, and *Winter: Central Park* documents his attitude toward the city: the composition reduces the metropolis to indistinct forms relegated to the edges of an uninhabited landscape.

1. Tryon to Freer, 25 November 1917 (207).

6 *The Sea: Night*

1892
Oil on canvas
16⅜ × 34½ in. (41.8 × 87.7 cm)
Signed and dated, lower right:
D. W. TRYON 92
06.84

7 *The Sea: Morning*

1892
Oil on canvas
16¼ × 34⅜ in. (41.4 × 87.4 cm)
Signed and dated, lower left:
D. W. TRYON 1892
06.85

The Sea: Night and *The Sea: Morning* are a pair of wall panels Tryon produced in 1892 for Freer's house in Detroit. They were meant to be seen in the context of the entry hall, where they would have faced each other across an alcove, catching natural light as it fell into the room through the front bay window. Although each was exhibited independently on occasion, the paintings work best as a duet. The serenity of the nighttime marine balances the agitation of the sea at morning, which is depicted from a lower vantage point than *The Sea: Night,* as if to give the ocean adequate room to roll. Daytime is expressed through action; the sea is awake.

In keeping with the decorative requirements of the room, *The Sea: Night* and *The Sea: Morning* have horizontal formats that emphasize the border between sea and sky. Tryon may have conceived the compositions as echoes of an earlier work called *The Wave* (fig. 80), a broad moonlit scene of an undulating sea; the Freer paintings also present the ocean as seen from the shore. Like Whistler, whose works these paintings may consciously recall, Tryon arranged color on canvas to the exclusion of other considerations.[1] A comparison of these decorations with *The Sea: Sunset* of 1889 (cat. no. 4) shows how far Tryon traveled toward ab-

straction in the intervening years. The dramatic sunset, together with every sign of human life, is gone; the solitude of the sea has become infinite. Color is reduced to a few essential tones, and the paint so thinly applied in *The Sea: Night* that the red ground of the canvas shows through. Whistler had employed a similar wash of pigment in *Symphony in Grey: Early Morning, Thames* (fig. 81) to create an effect of morning fog without disguising the texture of oil on cloth. Tryon's decorations, never presuming to imitate the natural world, proclaim themselves paintings.

1. Hayward 1979, 121.

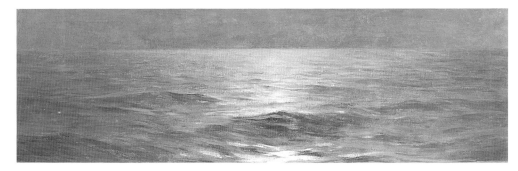

Fig. 80 *The Wave,* 1885. Oil on canvas, 19¼ × 59¼ in. (48.1 × 148.1 cm). Smith College Museum of Art (1930:3–138); Bequest of Dwight W. Tryon.

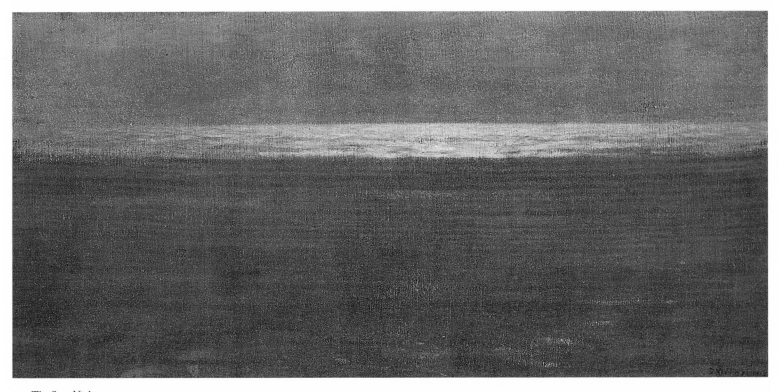

6 *The Sea: Night*

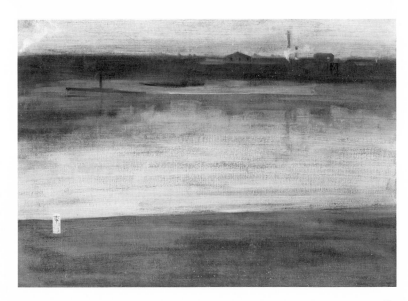

Fig. 81 James McNeill Whistler (1834–1903), *Symphony in Grey: Early Morning, Thames,* 1871. Oil on canvas, 18 × 26½ in. (45.7 × 67.5 cm). FGA (04.50).

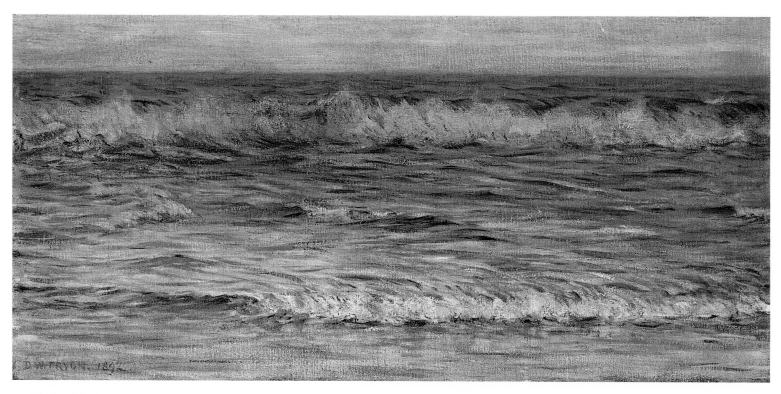

7 *The Sea: Morning*

8 *Springtime*

1892
Oil on canvas
38⅛ × 83⅛ in. (96.8 × 211.4 cm)
Signed and dated, lower right:
D. W. TRYON MDCCCLXXXXII
93.14

9 *Summer*

1892
Oil on canvas
38⅛ × 61 in. (97.0 × 155.2 cm)
Signed and dated, lower left:
D. W. TRYON MDCCCLXXXXII
93.15

10 *Autumn*

1892
Oil on canvas
37¾ × 49¼ in. (96.0 × 125 cm)
Signed and dated, lower right:
D. W. TRYON MDCCCLXXXXII
93.16

11 *Winter*

1893
Oil on canvas
28⅛ × 61 in. (71.5 × 155.2 cm)
Signed and dated, lower left:
D. W. TRYON 1893
93.17

12 *Dawn*

1893
Oil on canvas
28 × 60¾ in. (71.0 × 154.6 cm)
Signed and dated, lower left:
D. W. TRYON 1893
06.86

Tryon began his panel decorations for Freer's house with a picture representing spring, his favorite time of year, and continued through the full cycle of the seasons. The sequence was probably set in his mind when he undertook the commission, since the earliest indication of his idea for the project (see fig. 82) shows a scene that appears in modified form as *Springtime*, the most strictly architectonic, and the most meticulously conceived, of Tryon's precisely executed paintings.

Perhaps because it was the first, the design of *Springtime* articulates the structure of a room more clearly than any of the works that followed. Standing like pillars in the middle distance, tall, bare trees support the composition. Tryon, taking pains to permit only one or two of the treetops to touch the edge of the canvas, chiseled away at the inner edge of the frame to achieve the perfect balance he envisioned; fearing the cropping common to photographic reproduction, he insisted that the slightest alteration would upset a composition so carefully planned. But for all its structural integrity, Tryon insisted that the color rather than the form of

Fig. 82 Detail of sketch of a fireplace (fig. 50), 1891.

Springtime accounted for its success. Though there is rarely enough sunshine in a Tryon landscape to produce a single shadow, daylight heightens the palette of this picture and makes even the darkest tones "mainly bluish."[1]

At the exhibition of the Society of American Artists in 1896, *Springtime* was designated "one of a series of decorations." Assuming a status separate from the other landscapes on display, it appealed for special consideration. Tryon happened to be a member of the hanging committee that year, and seeing his painting out of the context for which it was intended and placed among "brutal realistic works," he found *Springtime* strange and disappointing at first, "but I think it holds on long study," he said, "better than almost anything I could have sent." Observing its decorative demeanor, Tryon associated *Springtime* with Asian art. "It seems in the exhibition a curious and undefinable mingling of the real and ideal," he wrote Freer, "and in some ways reminds me of some of the very old Japanese work in colors and abstraction."[2] Freer may have made the connection himself. He believed *Springtime* to be "one of the most satisfactory landscapes yet produced by any artist," and engaged Elbridge Kingsley to reproduce it by wood engraving, a method more or less outmoded by 1894, the year of the commission. The result (fig. 83), he said, was "doubtless the most artistic piece of reproductive wood engraving" ever accomplished.[3]

The decorative scheme demanded a picture of summer, a season Tryon rarely took time to paint. "Dark greens" did not appeal to him aesthetically; moreover, he preferred to spend the warmer days of summer fishing and sailing.[4] As a reflection of his attitude toward the season, *Summer* is thinly painted and more relaxed in style and execution than *Springtime*. Tryon related the two paintings by inscribing their dates in roman

8 *Springtime*

numerals positioned in opposite corners of the compositions, and *Autumn*, the next in the series, follows the pattern with a roman date appearing on the other side of *Summer*. The autumn scene is more elaborate than the summer view and includes many of the standard features of Tryon's future landscapes—an open, marshy foreground meadow with a coppice in the middle distance and tilled farmland beyond.

Winter was the season Tryon was least happy to portray. He did not care for snow scenes, and resented the severe New England weather that drove him indoors.[5] *Winter*, a low-toned rendering of a snow-covered meadow at sunset, appears to embody his melancholy response: at the sight of the painting his friend the artist Thomas Dewing remarked, "A thousand miles from home, and friends all dead!"[6] *Winter* was

Fig. 83 Elbridge Kingsley (1842–1918), *Springtime*, ca. 1894, after Tryon. Wood engraving, 11¼ × 17⅞ in. (28.6 × 45.4 cm). FGA Study Collection.

not completed until the spring of 1893, when Tryon admitted he was happy to be relieved of responsibility for the series.[7]

In the recollections the artist recorded for his biographer, Henry C. White—in which he referred to *Winter* as "Evening"—Tryon noted that the painting hung above one mantel of Freer's double fireplace, with *Dawn*, the final decoration, above the other. The matching silver gilt frames of the paintings, embellished with a leaf pattern that Tryon suggested to Wilson Eyre, reconfirm the pairing of *Winter* and *Dawn*.[8] Although he does not indicate which of the two paintings faced the entrance, the comparatively uninviting *Winter* presumably was directed to the interior of the room so that visitors to Freer's house would be greeted, initially, by *Dawn*.

Though painted in oil on canvas, Tryon intended *Dawn*, like the other decorations in the hall, to call little attention to itself. He wrote to the collector Edwin C. Shaw in 1923:

> An isolated easel picture may be deep, rich, and almost deceptive in its modelling—decoration on the other hand aims rather to preserve the flatness of a wall instead of destroying it. . . . A decoration of Puvis de Chavannes is eminently better suited to decorate a wall than a fine Rembrandt. Each is good but they serve different moods and purposes.[9]

After devoting so much time and attention to the mural paintings for Freer's house, Tryon attempted, nevertheless, to embody their decorative theme in "isolated easel pictures" such as *Dawn—Early Spring* (fig. 84), paintings that were, he maintained, "unlike the work of any other man."[10] It might be argued that these works bear more than an incidental resemblance in color and mood to contemporary decorations by Thomas

9 *Summer*

10 *Autumn*

11 *Winter*

Fig. 84 *Dawn—Early Spring,* 1894. Oil on wood, 20⅜ × 36¼ in. (51.8 × 92.1 cm). The Metropolitan Museum of Art, New York (17.140.4); Gift of Mrs. George Langdon Jewett, 1917.

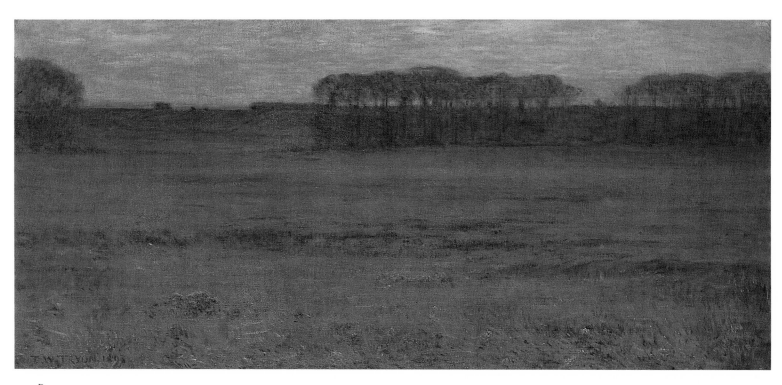

12 *Dawn*

Dewing; and a critic writing of the exhibition of *Dawn* at the Montross Gallery in 1907 observed that the "gossamer-like brushwork, dewy harmonies, ineffable touch of morning and vaporous sweetness" reminded him, above all, of the paintings of Camille Corot.[11]

When the commission for the Freer house was finally completed in April 1893, Tryon wrote Freer as he left for his country home that he felt "much like a squeezed lemon, no juice left."[12]

1. Tryon to Freer, 12 June 1892 (32) and 24 May 1892 (30).

2. Ibid., 21 March 1896 (72).

3. Freer to E. Kingsley, 5 May 1892 (LB 1), and to J. H. Jordan, 19 March 1894 (LB 2).

4. Tryon to George Alfred Williams, 2 August 1923, Nelson White Papers/AAA.

5. Ibid., 30 March 1915, Nelson White Papers/AAA.

6. Quoted in White 1930, 82.

7. Tryon to Freer, 6 April 1893 (42).

8. Tryon Papers/AAA; Tryon to Freer, 23 November 1891 (18).

9. Tryon to E. C. Shaw, 30 April 1923, Shaw Papers/AAA.

10. Tryon to George Alfred Williams, quoted in White 1930, 83. Freer greatly admired *Dawn— Early Spring* and might have bought it himself had Tryon not sold it to George Langdon Jewett. Tryon hoped Freer's disappointment would be tempered by the knowledge that the painting was going "into very appreciative hands" (Tryon to Freer, 10 March 1896 [71]).

11. *New York Sun*, 1 March 1907, Freer Press-Cutting Book 1:25.

12. Tryon to Freer, 6 April 1893 (42).

13 *Twilight: Early Spring*

1893
Oil on canvas
22 × 33¼ in. (58.8 × 84.5 cm)
Signed and dated, lower right:
D. W. TRYON 1893
93.12

Twilight: Early Spring is one of the few easel paintings Tryon produced during the first years of the 1890s, when he was primarily occupied with the Freer house project. Its silvery green tones recall the "decorations" of his collaborator, Thomas Dewing. Both artists dematerialized their subjects by design, working in the "ethereal and heavenly manner" probably inspired by the works of Whistler.[1] Guy Pène duBois favorably compared Tryon's *Twilight* to Whistler's Nocturnes—"its refinement runs rampant, and yet it is very solid, very wholesome and healthy." Another critic remarked that beside this particular work, even a Whistler painting would look "crisp and declaratory and realistic."[2]

Freer thought *Twilight: Early Spring* one of the most charming landscapes he had ever seen,[3] but twenty years later Tryon himself all but denounced it, together with other decorative paintings from the same period that were light in key with "very little depth or richness in color or modelling." Conceding that a "light song may satisfy a certain mood and a Beethoven sonata appeal to quite another moment," he stated that he took more satisfaction in the "richer tonal pictures" of his later years. The decorations he relegated to a phase long past of which, he said, "there is certain to be no recurrence."[4]

1. "National Gallery Pictures," *New York Evening Mail*, 10 February 1910, Freer Press-Cutting Book 1:34.

2. Guy Pène duBois, "Whistler, Tryon, Dewing and Thayer Contribute to a Remarkable Collection," unidentified newspaper [New York], 10 February 1910, Freer Press-Cutting Book 1:3; and "National Gallery Pictures," *New York Evening Mail*, 10 February 1910, Freer Press-Cutting Book 1:34.

3. Freer to N. E. Montross, 7 April 1893 (LB 1).

4. Tryon to Edwin C. Shaw, 30 April 1923, Shaw Papers/AAA.

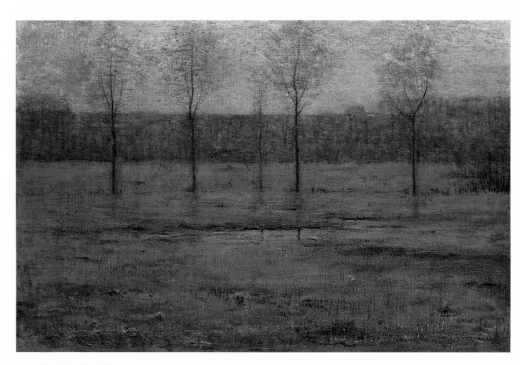

13　*Twilight: Early Spring*

14 *Central Park: Moonlight*

1894
Pastel on medium brown paper mounted on paperboard
9 ¹⁵/₁₆ × 13 ¹³/₁₆ in. (25.2 × 35.2 cm)
Signed and dated, lower center (crayon):
D. W. T. 94
06.87

15 *Winter: Connecticut Valley*

1894
Pastel on medium brown paper mounted on paperboard
9⅞ × 13 ¹³/₁₆ in. (25.1 × 35.1 cm)
Signed and dated, lower left (crayon):
D. W. TRYON 94
06.88

16 *Late Spring*

1894
Pastel on olive paper mounted on paperboard
9 ¹/₁₆ × 12¼ in. (23 × 31 cm)
Signed and dated, lower right (chalk and pencil): D. W. TRYON 94
06.89

14 *Central Park: Moonlight*

15 *Winter: Connecticut Valley*

After two years' labor on large commissions for Freer's house, Tryon felt ready for the liberation of pastel, a medium that promised "new beauties and possibilities."[1] In comparison to the decorative panels, the pastel paintings of 1894 appear practically spontaneous, but the simplicity Tryon sought in pastel could only be achieved, he said, after countless attempts. The unlabored, uncluttered schemes of these pastels belie the effort that produced them.[2]

The austere compositions of *Central Park: Moonlight* and *Winter: Connecticut Valley* recall a watercolor painting, *Winter: Central Park* (cat. no. 5). In depicting scenes from life, especially scenes of winter and the city, Tryon seems to have preferred pastel and watercolor to oil, which he reserved for painting from memory. Tryon was usually disinclined to appreciate winter, but the season lent itself irresistibly to pastel. In *Central Park: Moonlight* the city is all but lost to a dusting of pigment, and in *Winter: Connecticut Valley*, a landscape the artist might have observed on his way from New York to Northampton, white chalk on brown paper makes a perfect picture of early snow on barren ground. Freer shared Tryon's appreciation of surface quality. When he sent the artist pastel paper of the sort Whistler liked to use, Tryon wrote of his pleasure at the "very sight of pastels on paper." The medium suited their mutual preference for ethereality of effect—"it smacks less of the earth than any other," as Tryon put it—and was well suited to delicate springtime as well as winter scenes.[3]

Late Spring, a pastel that displays the composition of the decorative oil paintings, appears to have lost some of its original pigment (Tryon would eventually acquire a better command of colored chalk) but retains the delicacy that Freer admired. After seeing one "wonderfully fine early Spring scene" on a visit to South Dartmouth, Freer told Tryon the picture had haunted him all day and "because of it," he said, "New York has seemed less ugly than usual."[4] Like Tryon, Freer recognized no distinction between the power of oil paintings and pastels to "stimulate the emotions and the imagination." When a set of pastels arrived in Detroit early in September, he wrote the artist that the pastels expressed "charm of the highest order in the most delightfully mysterious way, being flower-like, pearl-like, musical and weird, and at the same time brimming with the solidity of old mother earth. I doubt," he said, "if art can do more."[5]

1. Tryon to Freer, 24 January 1894 (51).

2. Tryon to George Alfred Williams, 7 October 1916, Nelson White Papers/AAA.

3. Tryon to Freer, 5 April 1894 (55).

4. Freer to Tryon, 7 September 1894, Nelson White Papers/AAA. The pastel to which Freer refers is probably *Early Spring*, described in 1911 as a "light yellowish-green meadow with a small bush at the right in the foreground; four tall trees in middle distance." Freer presented the painting to E. A. Hauss in 1917 ("Miscellaneous List, January 1, 1911. Paintings in Oil, Pastel and Silver Point by Dewing, Tryon, and Thayer," Freer Papers/FGA); its present location is unknown.

5. Tryon to E. C. Shaw, 30 April 1923, Shaw Papers/AAA; Freer to Tryon, n.d. [September 1894], Nelson White Papers/AAA.

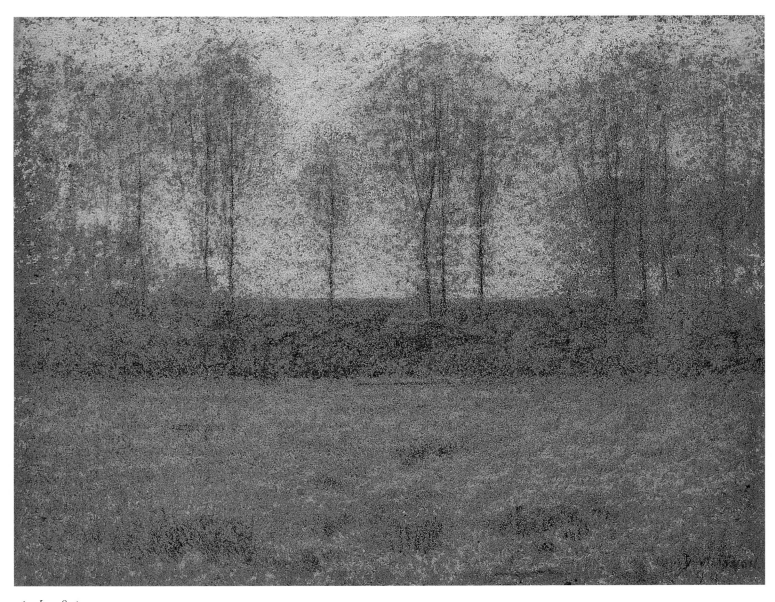

16 *Late Spring*

17 *Night: A Landscape*

1894
Pastel on brown paper mounted on
paperboard
7⅝ × 9¾ in. (19.4 × 24.9 cm)
Signed and dated, lower right (crayon):
D. W. TRYON 94
06.90

18 *Night: A Harbor*

1894
Pastel on brown paper mounted on
paperboard
7½ × 11½ in. (19.2 × 29.2 cm)
Signed, lower left (crayon):
D. W. TRYON
Dated, lower right (crayon): 1894
06.92

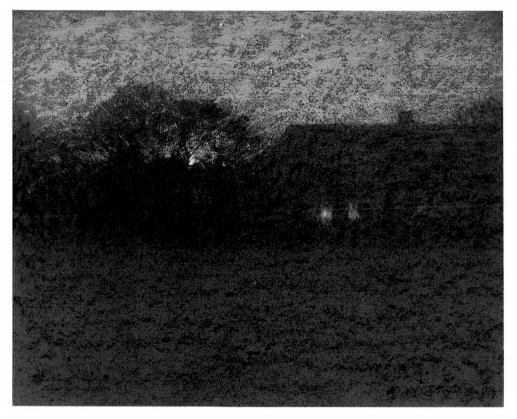

17 *Night: A Landscape*

In his new studio by the sea Tryon continued to paint in pastel during the summer of 1894.[1] When Freer paid a visit in September, he saw several works in progress and afterward wrote Tryon that his day in South Dartmouth had been "one of the rarest of days, one filled with beautiful impressions and sympathetic companionship." As a souvenir, he purchased *Night: A Landscape.*[2] Its deep blue tones punctuated by spots of gold must have reminded Freer of Nocturnes by Whistler and may have accounted in part for his keen appreciation of this particular pastel. It was appropriately placed in one of Freer's "Whistler frames," a practice that set a precedent for the treatment of Tryon's later works.[3]

The second in a pair of nocturnal pastel paintings, *Night: A Harbor* was produced with rich blue pigment on dark, pebbled paper. Tryon divided the composition into broad horizontal bands, emphasizing the moonlit water in the foreground and diminishing the town at the harbor's edge. *Night: A Harbor* recalls *Evening, New Bedford Harbor* (fig. 85), an oil painting of 1890. In comparison, the pastel appears the less contrived. "In the hands of a master," Tryon said of pastel, "I think it more directly and with less effort translates the thought."[4]

1. Tryon to Freer, 5 August 1894 (62).

2. Freer to Tryon, 7 September 1894, Nelson White Papers/AAA.

3. Tryon to Freer, 9 September 1894 (64).

4. Ibid., 5 April 1894 (55).

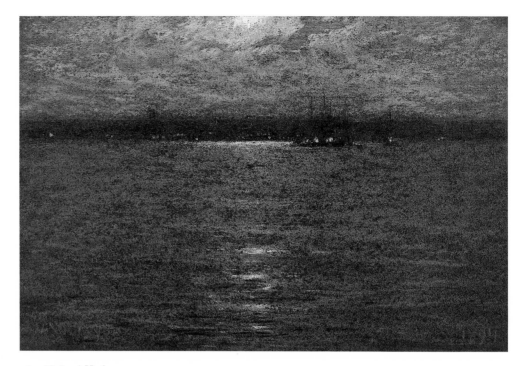

18 *Night: A Harbor*

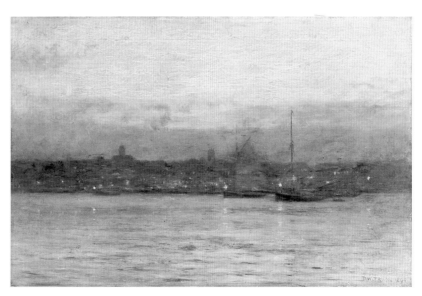

Fig. 85 *Evening, New Bedford Harbor,* 1890. Oil on wood, 20¼ × 31½ in. (51.4 × 80 cm). The Metropolitan Museum of Art, New York (17.140.3); Gift of Mrs. George Langdon Jewett, 1917.

19 *Pasture Lands: Early Spring*

1896
Gouache on wood panel
11½ × 22½ in. (29.3 × 57.3 cm)
Signed and dated, lower left:
D. W. TRYON 1896
00.11

The spring of 1896 was unseasonably warm in New York City and Tryon feared he would "be late for those early leaves" if he delayed his departure too long—the "early artist," he wrote Freer, "catches the spring."[1] Tryon evidently arrived in South Dartmouth in time to see trees just barely in bud, though the fields were already green: *Pasture Lands: Early Spring* shows the countryside alive with spring colors but still shaded by a wintry gray sky.

Because he delighted in every nuance of the season, Tryon continually experimented with technical methods in his search for an appropriate means of expression. "I feel more and more that the true art of landscape is to record and produce for others these moods of nature," he said. "The difficulty is to find the materials which most di-

rectly translate and convey the sensations which one feels."[2] *Pasture Lands* is the result of an unusual procedure: Tryon grounded a wood panel with lead white, then painted the picture with pure pigments that show through the final washes of watercolor paint.[3] It was not a method Tryon often had occasion to employ, but his experiment did produce the desired effect, a landscape that looks cool with winter air though moist and green with the dew of early spring.

1. Tryon to Freer, 18 April 1896 (73).

2. Tryon to George Alfred Williams, 24 October 1914, Nelson White Papers/AAA.

3. Exhibition label text by David Park Curry (1982), registrar's object file (00.11), FGA.

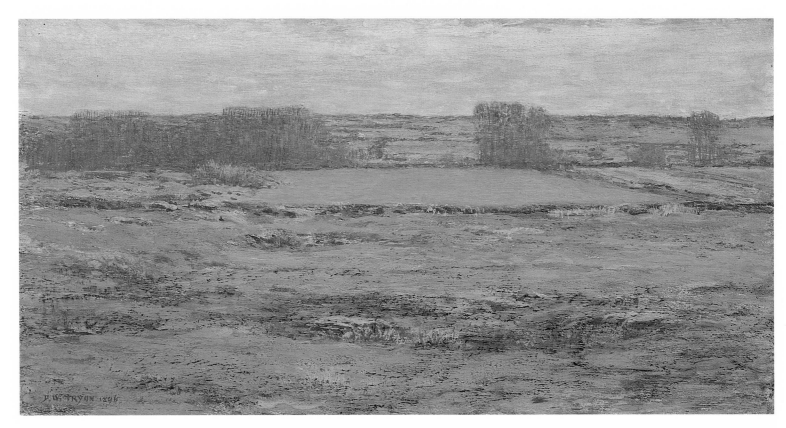

19 *Pasture Lands: Early Spring*

20 *Early Spring in New England*

1897
Oil on canvas
71⅜ × 58⅜ in. (181.2 × 148.3 cm)
Signed and dated, lower right:
D. W. TRYON 1897
06.77

Tryon was at first reluctant to accept Freer's invitation to execute yet another work for the house he had decorated five years before. He was troubled by the "undefined and perhaps morbid sense" that Freer already had so many Tryon paintings hanging in the hall that one more might prove to be one too many, and that he was claiming "too large a share in the 'House that Freer built.'" Nevertheless, Tryon had always believed that the hall required the "right note" to be complete; indeed, he had been conceiving plans for a final decoration for some time. With little apparent effort, therefore, Freer persuaded the artist to overcome his hesitation and take the commission. "The fact is," Tryon conceded, "your house is the only one which interests me and I find myself going on mentally treating it as if it were mine and I intended it as a monument to not only myself but to us all represented there."[1]

The space that this final painting would occupy was interesting, Tryon thought, but for a number of reasons difficult to manage. Its size, to start, was daunting. The panel would have to be larger even than the largest of the four decorations, but Tryon, undeterred, observed that so spacious a canvas would provide "room to spread and breathe."[2] Its position presented another problem. The space was in the upper hall, where the painting would be visible at a distance from two distinct points of view: from below, on the ground floor, and at eye level, from the second-floor gallery and perhaps obliquely from an oriel window looking out of the guest room. Tryon assured Freer he could treat the surface so that the canvas could be seen in spite of poor illumination; more difficult to calculate was the painting's relation to the observer. Before beginning the project, therefore, Tryon "thought out all possible contingencies" and eventually solved the problem with a trick of perspective.[3] A pen-and-ink preparatory sketch (fig.

86) indicates that Tryon altered his early conception of the painting the better to fit the space. By deepening the foreground of the composition, he rendered the scene rational from two points of view. Although it could be construed out of context as an element of Asian style, the unusually high horizon is more likely to have been designed with the ground-floor observer's angle of vision in mind.

The greatest challenge of the commission, however, was to make the last panel for the hall complement the others without repeating themes the artist had already explored.[4] Tryon chose to interpret his favorite subject, "early Spring, in the bud," but determined to distinguish it from the other springtime paintings in the house by rendering it in more detail. "As it goes by itself," Tryon assured Freer, "I can do so without detriment to the others."[5] Compared to the simply constructed, clearly decorative panels Tryon had painted five years before, *Early Spring in New England* appears vibrant and complex. A foreground meadow, stone wall, and rocky outcrop suggest the familiar South Dartmouth countryside, but the hills in the background resemble the Berkshires of western Massachusetts. A hybrid grown from aesthetic imagination, the painting presents early spring in New England in spirit if not in fact.

The panel is further distinguished from the decorations in its emphasis on furrowed fields, an image of cultivation. In September 1896, during the days when Tryon was only dreaming up schemes for *Early Spring in New England*, he remarked in a letter that a recent trip to Maine had afforded "vivid and new" impressions of landscape but little that appeared valuable for art. "It all seemed too rash and scattered," he wrote, "lacking in quality and organization." To be appropriate for painting, a landscape should show "some association of men to wild nature."[6] Accordingly, in *Early Spring in New*

Fig. 86 Preparatory sketch for *Early Spring in New England*, ca. 1897 (inscribed, "1st sketch for Springtime in New England for C. L. Freer"). Pen and ink on paper, 6⅜ × 5⅞ in. (16.2 × 14.1 cm). Smith College Museum of Art (1930:3–134); Bequest of Dwight W. Tryon.

England, Tryon made sure that nature was tame and that the agent of civilization was present in the picture, if indistinctly. The worse the figures were painted, Tryon maintained, the better the landscape.[7]

Although the problems of the composition never seemed insurmountable to the artist, Tryon did confide to Freer at one point that he might have bitten off more than he could chew. "Some day I hope to arrive at the age of discretion," he said, "but it is some time off." In March 1897, Tryon estimated that the picture would not be ready for a year at least,[8] but he became so absorbed in the project that he abandoned his other work for it; by mid-April he declared the picture "near the danger line" but difficult to complete because the crowds who came to see it interrupted his work.[9] When he left his studio for the peace of South Dartmouth, Tryon instructed the elevator attendant to allow visitors to see *Early Spring in New England* in his absence; none of his paintings, he said, had ever generated so much interest.[10] As a sign of their esteem a number of admirers from Boston campaigned to purchase a painting by Tryon for the Museum of Fine Arts, and tried to secure a space in the Boston Public Library for him to decorate.[11] Thomas Dewing pronounced *Early Spring in New England* Tryon's "high water mark," and Elbridge Kingsley, Freer told the artist, would "not reach earth again" until Tryon painted something equally impressive.[12]

Having heard this effusive praise of his most recent acquisition, Freer was naturally eager to judge for himself. Both times he had seen *Early Spring* in progress he had felt "bowled over by the possibilities," he wrote Tryon in April. "Since I saw it first, a mere outline sketch, I have entertained great expectations for both your sake and my pleasure—but you have doubtless carried its success entirely beyond what I fondly hoped for—and perhaps even what you

deemed possible." Freer was not to be disappointed. "I don't like to say 'I told you so,' but I have felt from the very first that you would make a 'corker' of the big picture," Freer wrote Tryon, "if you undertook it at all."[13]

When it finally hung in its place in Detroit, *Early Spring in New England* appeared to Freer an essential addition to the ensemble. "Without the latest one the others would lack a sort of guardian-like leader to prevent questions of precedence," he wrote Tryon. Moreover, he said, although its notes differed from those of the other choristers, they were "all in harmony, and ever indescribable."[14] Freer may have suggested the musical analogy to the critic Charles Caffin, who visited Freer in Detroit just before beginning his written "appreciation" of Tryon's art:

The structure, like Thebes, has grown to music. The rhythm and relation of the values are so discernible that the austerity of the scene melts into melody; its assemblage of inconsiderable items becomes united in harmonious chorus, the very air palpitates with song. As the far-off singer of a distant choir, trembling in the sky, it faintly stirs the awakening foliage and hovers like a sigh over the earth that after its long sleep begins again to be awake.

The painting not only amazes but even bewitches the viewer with a charm, Caffin wrote, "that the technical precision of excellence has wrought."[15]

Tryon noticed that *Early Spring* deeply impressed everyone who saw it, and he told Freer that he had received countless letters from strangers relating the effect the painting had on them.[16] One of the admirers was Ralph Plumb, chairman of both the exhibition and accession committees of the Buffalo Fine Arts Academy, where *Early Spring* had been the principal attraction of 1897. Plumb himself owned a painting by Tryon and

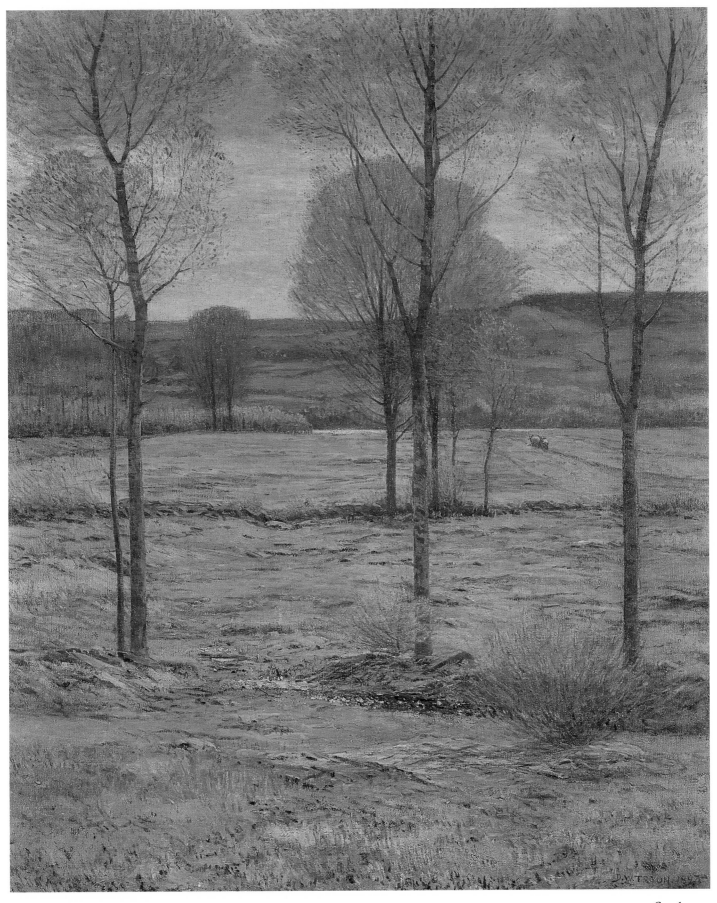

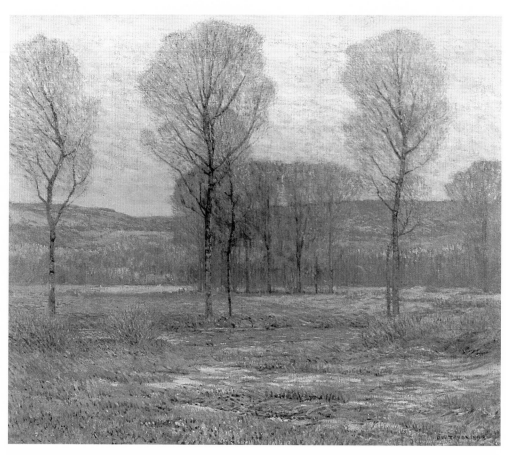

Fig. 87 *May*, 1898–99. Oil on canvas, 40½ × 48¾ in. (102.9 × 123.8 cm). Collection of Mr. and Mrs. Willard G. Clark.

would gladly have purchased *Early Spring* for the gallery, Tryon informed Freer, if only it had been for sale.[17] Aware of his good fortune in acquiring a painting others were eager to own, Freer was unselfish with *Early Spring in New England.* "Think of the long time I am to have it," he wrote Tryon, suggesting only that the painting be reserved for worthy exhibitions—"swell shows like Boston and Pittsburgh are conducting."[18] *Early Spring* accordingly traveled from its celebrated debut in Buffalo to the Carnegie Institute in Pittsburgh, where it was awarded the Medal of the First Class. The

Pittsburgh Times dispatched a reporter to record the public's reaction to the picture:

> Ain't it absurd? There's no life in that thing; the trees are scrawny, uninviting things, and the grass ain't natural. I don't want to say anything against this place, but I don't see how a man with a conscience could give a prize to a picture like that.[19]

But among members of the artistic elite, the painting appeared a masterpiece. John Caldwell, chairman of the Carnegie Art Committee (and, in Freer's opinion, a man of ex-

quisite taste), wanted to purchase *Early Spring* for the gallery's "Chronological Collection," inaugurated in 1896 by Andrew Carnegie, who envisioned a "chronological display of American art from this time forth."[20] Freer admired Carnegie's interest in the fine arts and believed Tryon's work would be appropriately placed in the collection; nevertheless, he denied Caldwell's request, explaining that *Early Spring* was one of a series of eight decorations—"naturally enough," he said, "I do not feel that the collection should be broken."[21] Tryon could not reasonably resent Freer's refusal to part with the picture, but he must have recognized the advantage so prominent a position in Pittsburgh would afford. The very next year he produced a strikingly similar work called *May* (fig. 87), which predictably received an honor of its own, the Chronological Medal, in 1899.

Early Spring in New England continued to attract attention at "swell shows" around the nation. Freer allowed its exhibition at the Society of American Artists and the Pennsylvania Academy of the Fine Arts in 1899, the Pan-American Exposition in Buffalo in 1901, and the Tryon retrospective at the Montross Gallery in New York in 1913. But however enthusiastically he endorsed the idea of exhibiting American art in Berlin, Freer could not bring himself to let the painting travel overseas, explaining to Tryon that he would never forgive himself if any harm should come to it.[22] As for the artist's own opinion of *Early Spring in New England*, "I put about all there was of me in it," he said, "and feel I must grow some before I start another."[23]

1. Tryon to Freer, 4 January 1897 (82).

2. Ibid., 10 January 1897 (83).

3. Ibid., 4 January 1897 (82) and 22 June 1897 (93).

4. Ibid., 4 January 1897 (82).

5. Ibid., 13 March 1897 (87).

6. Ibid., 3 September 1896 (78). To Charles Caffin the "rock-strewn patch" in the foreground of *Early Spring in New England* suggested the "graveyard of an extinct phase of nature"; beyond it lay a "stretch of arable land, pale violet-brown, reddened in the furrow, upturned by the plough . . . snatched from the waste and desolation" of disorganized nature (Caffin 1909, 31).

7. Henry White Papers/AAA.

8. Tryon to Freer, 8 March 1896 (86).

9. Ibid., 12 April 1897 (89).

10. Ibid., 21 April 1897 (88).

11. Ibid., 12 April 1897 (89).

12. Ibid., 21 April 1897 (88); Freer to Tryon, 2 May [1897], Nelson White Papers/AAA.

13. Freer to Tryon, 17 April [1897], Nelson White Papers/AAA.

14. Ibid., 18 September [1897].

15. Caffin 1909, 32.

16. Tryon to Freer, 22 June 1897 (93).

17. John Sanford (archivist, Albright-Knox Art Gallery, Buffalo) to the author, 14 February 1986; Tryon to Freer, 22 June 1897 (93).

18. Freer to Tryon, 2 May [1897], Nelson White Papers/AAA.

19. "Popular vs. Artistic Ideas," *Pittsburgh Times* (4 November 1897), press cutting, William Nimick Frew Scrapbook, Carnegie Library, Pittsburgh.

20. "Communication from Mr. Carnegie to the Board of Trustees of the Carnegie Fine Arts and Museum Fund, January 2, 1896," *Constitution and By-Laws of the Board of Trustees together with Mr. Carnegie's Letter and Deed of Trust* (Pittsburgh, 1907), 1–2.

21. Freer to J. Caldwell, 9 November 1898 (LB 5); Freer to Tryon, 9 November 1898 (LB 5).

22. Freer to Tryon, 17 March 1903 (LB 11).

23. Tryon to Freer, 12 September 1897 (95).

21 *Sunrise: April*

1897–99
Oil on wood panel
20 × 30 in. (50.9 × 76.3 cm)
Signed and dated, lower left:
D. W. TRYON 1897–9
06.79

22 *Daybreak: May*

1897–98
Oil on wood panel
26⅜ × 32⅝ in. (66.9 × 82.8 cm)
Signed and dated, lower right:
D. W. TRYON 1897–8
06.78

"The place looks somewhat bleak but fine all the same," Tryon wrote Freer in April 1897, having arrived in South Dartmouth before the winter chill had quite left the country. "The wind has a nipping quality which braces one up. Signs of spring abound, a few dandelions in bloom. Grass green and buds showing on all the early trees."[1] *Sunrise: April*, a technically complicated painting that occupied Tryon intermittently throughout two winters' work, probably owes its genesis to that vision of early spring. Its surface is dense with paint, as if the artist's nostalgia had become palpable over the years. Layers of pigment subdue the colors of sunrise, yet the decorative effect of the painting looks artless; Tryon's pale palette naturally suggests early morning light. Three tall trees in the middle distance rise above the phalanx beyond, sweeping the top of the panel with their branches,

still bare. The composition is a subtle variation on Tryon's favorite theme —a meadow with trees, open to the observer through the artist's designing eye.

Another dawn picture whose surface attests to the passage of time is *Daybreak: May*. The effort of producing it nearly exhausted Tryon, since, he said, "every change of light or mood seemed to be reflected in the picture."[2] In the process, the artist himself vacillated between hope and despair.[2] "I believe it is the most subtle of all my works," Tryon wrote Freer, "and it seems to have more moods and phases than any picture I know—at least it seems so to me and I will be curious to see if you agree with me in this."[3] Prepared by the artist to approach *Daybreak* with unprecedented sensitivity, Freer spent all of a Sunday moving the painting from room to room, observing it in various lights until it revealed its "ex-

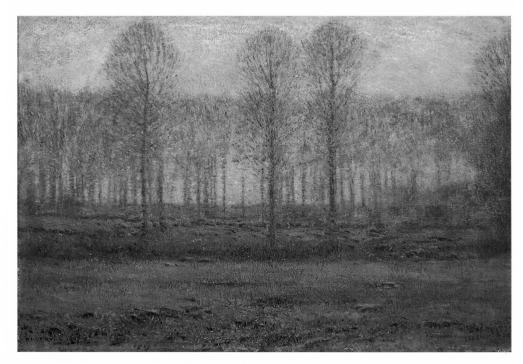

21 *Sunrise: April*

tremely subtle qualities," and reported to Tryon at last: "I must agree with you in this respect, it is most unusual and I think exceeds any picture I know."[4]

Freer's detailed response reveals his extraordinary sympathy with the artist's aesthetic aims and apprehensions. Anticipating Tryon's concern that *Daybreak* might not appear to advantage in any light but the one by which it was painted, Freer assured him in advance that while it looked best when well lit from above, the painting also showed great beauty (to his surprise) "in certain low lights, lights so dull that the pink in the sky would be merely suggested." Indeed, the connoisseur could even imagine a probable source of inspiration, the "pink flush" on a white ceramic bowl that called to mind the sky of *Daybreak*. "I am sure that I will find many new beauties in the picture as I familiarize myself with it," Freer wrote, "but I am already impressed with its marvelous interpretation of the mystery accompanying day-break during the spring days. The moist atmosphere and morning dampness are weirdly and beautifully shown, and every inch of the picture seems complete and perfect." Freer concluded with the assurance that *Daybreak: May*, yet another painting to appoint his Detroit home, was different from but harmonious with Tryon's other works. "I need not add," Freer said, "how proud I am to possess it."[5]

Gratified to learn that Freer had detected the chameleon qualities of *Daybreak: May*, Tryon wrote in reply, "If sensations felt in production are again revealed to the spectator through the completed work (as I believe) then I feel sure that you will not soon exhaust it but will find it responds to many moods." Tryon had apparently been reading Browning, for he went on to paraphrase the words of a painter of very different mettle, Fra Lippo Lippi: "'Tis thus we lend our minds out."[6]

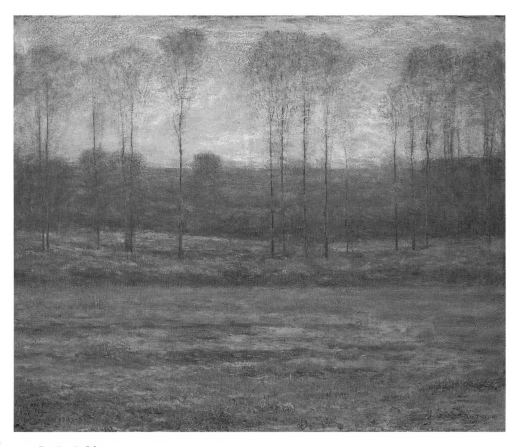

22 *Daybreak: May*

1. Tryon to Freer, 21 April 1897 (88).

2. Ibid., 31 March 1898 (102).

3. Ibid., 18 March 1898 (100).

4. Freer to Tryon, 21 March 1898 (LB 4).

5. Ibid.; Tryon to Freer, 31 March 1898 (102).

6. Tryon to Freer, 26 March 1898 (101). Tryon alludes to Robert Browning's "Fra Lippo Lippi." The passage that concludes with the words, "Art was given for that; / God uses us to help each other so, / Lending our minds out," is reprinted in Hunt 1875, a copy of which Tryon bequeathed to Smith College.

23 *Niagara Falls*

1898
Pastel on medium brown paper mounted on paperboard
11 $^{15}/_{16}$ × 14 $^{15}/_{16}$ in. (30.3 × 38.0 cm)
Dated, lower left (pencil):
NIAGARA, FEB. 16, 1898
Signed, lower right (pencil): D. W. TRYON
Inscribed in blue-gray chalk on wood board that formerly backed the pastel: To my friend C. L. Freer / a souvenir of / "A Sentimental Journey" / D. W. Tryon
06.91

"A souvenir of 'A Sentimental Journey,' " as the inscription on the backboard states, *Niagara Falls* was a gift from Tryon to Freer in February 1898. According to Freer's diary, the two had traveled together from New York to Detroit and then back again a few days later; they must have visited the famous falls en route.[1] It was a predictable place to stop. Though Frederic E. Church's awesome painting of 1857 (fig. 88) was the most celebrated, Niagara had long been a stock subject of the American art repertoire. Tryon, however, rarely represented sights so patently picturesque, and his version almost obscures the identity of the tourist attraction. Rendered on a modest scale in the softest shades of pastel chalk, Tryon's *Niagara Falls* evokes the effect of eddying water, foams, and mists, leaving the more dramatic aspects of the scene to those who choose a panoramic point of view.

1. Freer's Diary, 12–17 February 1898, Freer Papers/FGA.

Fig. 88 Frederic Edwin Church (1826–1900), *Niagara*, 1857. Oil on canvas, 42½ × 90½ in. (108 × 229.9 cm). The Corcoran Gallery of Art, Washington, D.C.; Museum purchase, 1876.

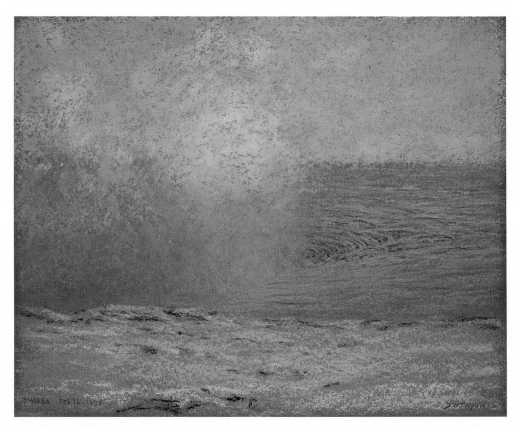

23 *Niagara Falls*

24 *New England Hills*

1901
Oil on wood panel
33 × 40 in. (83.8 × 101.6 cm)
Signed and dated, lower right:
D. W. TRYON 1901
06.80

25 *Twilight: May*

1904
Oil on wood panel
32⅞ × 43½ in. (83.6 × 110.6 cm)
Signed and dated, lower left
D. W. TRYON 1904
06.81

An unwooded stretch of rolling ground awash with golden light assumes unprecedented prominence in *New England Hills*. Though Elbridge Kingsley often tried to persuade his friend to depict the landscape of western Massachusetts, Tryon generally preferred to paint the meadows around South Dartmouth.[1] The "principal motive" of *New England Hills*, identified on a sketch in the Smith College Museum of Art as a scene near Worcester, Massachusetts, is one the artist might have observed from the train on his way to Northampton.[2]

Having seen the painting in Tryon's studio during the winter of 1901, Freer had been surprised to learn that in April the artist was still hard at work on *New England Hills*:

> Surely you are a wonder! I thought it was perfect, but I am sure that if it had been so in your own mind, you would not have tackled it again. I think it one of the very finest of your works, and I have most delightful memories of it.[3]

But when he viewed the painting again at the end of May, Freer had to admit that Tryon's "final touches" (or, he corrected himself, "the work you did upon it after the last time I saw it in your studio") were incredibly effective, and that *New England Hills* was so wonderful as a result that he could not resist buying it. "You may have painted a greater picture, but if so I have never seen it," he told Tryon. "In fact, I can recall no landscape that seems finer."[4] The architect Stanford White was so taken with the painting when he saw it at the Montross Gallery that he designed a special frame for it; and when Freer saw the completed work of art he was more charmed, he wrote Tryon, than he could say. "Stanford White has produced another of his masterly things, and I don't believe a more harmonious setting was ever conceived for a picture," he said, assuring Tryon that his back was sure to go "goose

flesh" when he saw it: "The painting can now, for the first time, be fairly seen, and I don't believe you have ever done anything quite so exquisitely perfect as this canvas. It deserves a little temple of its own."[5]

Three years later Freer ordered an identical frame for Tryon's *Twilight: May*. The artist seems to have been eager to glimpse its effect, for traces of blue and green paint on the rabbet suggest the painting was still wet when the frame was attached. "The Big Trees," as Freer called *Twilight: May* before he learned its proper name, also looked "very beautiful in its new home"[6] and might well have hung beside *New England Hills*. They make an arresting pair, one ground in solid earthly masses, the other etherealized by an understated sunset.

Twilight: May was one of two paintings by Tryon exhibited in 1910 in Berlin and Munich at what was said to be the "most comprehensive and truly representative display of modern American art ever shown."[7] Freer chose this painting, he said, because he thought it would hold its own among the brighter canvases sure to be selected by the organizer of the show, Hugo Reisinger.[8] Tryon's *Twilight: May* would have fit perfectly into the landscape section dominated by tonalist artists such as Henry Ward Ranger, J. Francis Murphy, and Bruce Crane. "There is nothing violent or decisive in the work of these men," Christian Brinton observed. "It is pacific enough to satisfy the most shrinking soul."[9]

1. Kingsley, 255.

2. The drawing is included in an envelope containing loose drawings in Tryon's portfolio of sketches in the SCMA. The notation reads: "near Worcester / summer clouds / hills gn." On the verso is: "Original motive for New England Hills owned by C. L. Freer."

3. Freer to Tryon, 4 April 1901 (LB 8).

4. Ibid., 27 May 1901, Nelson White Papers/AAA.

5. Ibid., 12 October 1901 (LB 8).

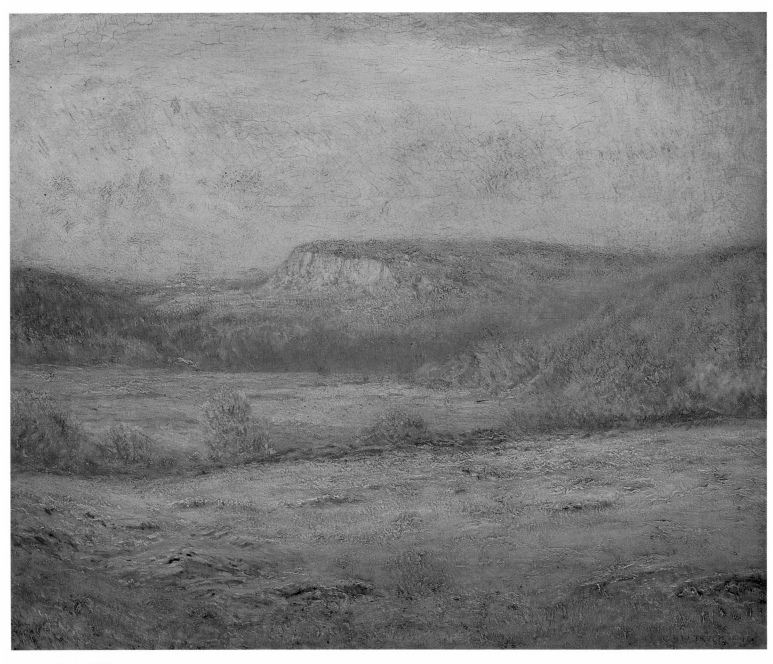

24 *New England Hills*

6. Freer to N. E. Montross, 2 April 1904 (LB 13) and 30 April 1904 (LB 14).

7. Christian Brinton, *Masterpieces of American Painting: A Selection of Photogravures after Paintings Exhibited at the Royal Academy of Arts, Berlin 1910*

(New York: Berlin Photographic Company, 1910), introduction.

8. Freer to Tryon, 4 January 1910 (LB 28).

9. Brinton, *Masterpieces of American Painting*, 13.

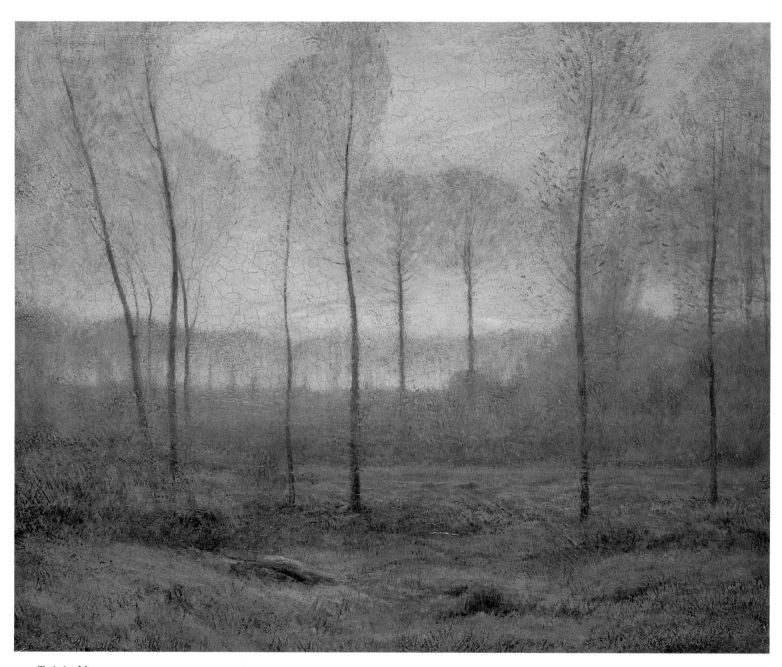

25 *Twilight: May*

26 *Early Night*

1903
Pastel on dark gray-brown paper mounted
on paperboard
8 × 12 in. (20.2 × 30.5 cm)
Signed and dated, lower left (crayon):
D. W. TRYON 1903
06.93

27 *November Afternoon*

1905
Pastel on medium brown paper mounted on
paperboard
8 ¹/₁₆ × 11 ¹⁴/₁₆ in. (20.4 × 30.2 cm)
Signed and dated, lower right:
D. W. TRYON 05
05.289

During the decade that separates these two
works from the pastel landscapes in the
Freer collection they immediately recall—
Late Spring and *Night: A Landscape* (cat. nos.
16 and 17) of 1894—Tryon's technique in
oil had become so involved that the simple
sight of powdered chalks on paper seems to
have lost some of its appeal. *Early Night* and
November Afternoon demonstrate Tryon's
early efforts to achieve the rich color tones
and textures of oil painting in a medium that
is by nature superficial. As his friend the
artist George Alfred Williams wrote in an
essay on Tryon's work, an "effect is easily
obtained in pastel, but to produce an effect
that expresses a substantial quality and
depth of mood, that is another matter."[1]

A romantic rendition of one of Tryon's fa-
vorite themes, *Early Night* portrays a cottage
in the country illuminated by a rising moon.
Other Barbizon-inspired landscapes such as

Moonlight of 1887 (cat. no. 2) and its relative
in pastel, *Night: A Landscape* (cat. no. 17),
had been constructed of horizontal planes
that encouraged the viewer's eye to move
slowly from the foreground through the
picture space to the house at the horizon,
and finally to the sky beyond. *Early Night*
introduces a different approach: a diagonal
dirt road directs attention to the cottage at
the edge of the meadow, where a tree sil-
houetted against the moon catches the eye
and draws it further into the picture.

November Afternoon repeats the customary
composition of Tryon's oil paintings—a row
of trees spanning the horizon—but it too
appears to be an experiment, an attempt to
make pastel more a medium for painting
than drawing. The November afternoon is
dark and foreboding, almost all of its color
gone with the autumn leaves, but the bright
sky is strung with clouds that hint of incle-

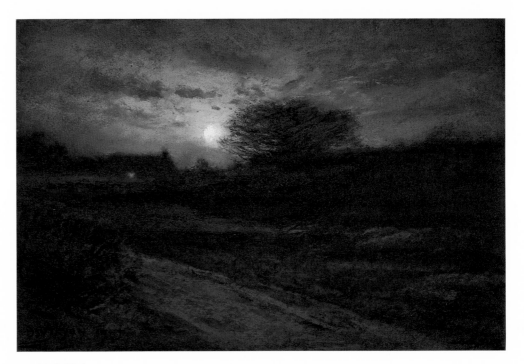

26 *Early Night*

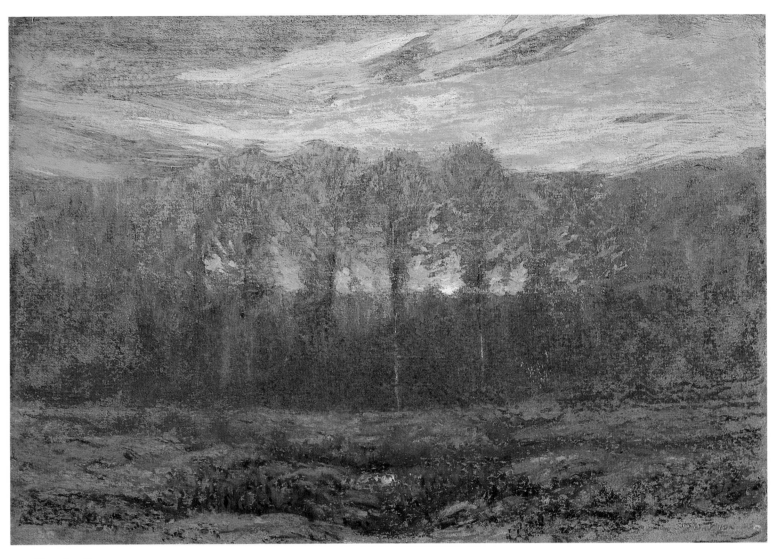

27 *November Afternoon*

ment weather. The unusually opaque effect of the pastel was apparently achieved by mixing chalk with water. When the work arrived in Detroit early in December 1905, probably no more than a week or two after its execution, Freer found it delightful. "I wish you could have been present at my home this morning when I took it out of its box," he wrote Tryon with his usual enthusiasm. "It is truly a wonder!"[2]

1. Williams 1924.
2. Freer to Tryon, 8 December 1905 (LB 18)

28 *The Evening Star*

1905
Oil on wood panel
20 × 30⅛ in. (51.0 × 76.5 cm)
Signed and dated, lower left:
D. W. TRYON 1905
06.82

The Evening Star exhibits a pronounced departure from Tryon's traditional landscape scheme, as though the artist temporarily took a different point of view. A pool of water replaces the customary meadow in the foreground, and Tryon's familiar row of trees is unexpectedly truncated, making naturalistic forms more than usually abstract. The palette of the picture, moreover, is reduced to the sepia shades associated with photographic prints. Indeed, Tryon's *Evening Star* appears to respond to innovations in the art of photography, particularly as practiced by Edward Steichen.

In a review of "pictorial photographs" exhibited in Pittsburgh in 1904, Sadakichi Hartmann, a champion of artistic photography who also praised Tryon's paintings, noted that Steichen had carried the possibilities of photography farther than any other artist. A painter as well as a photographer, Steichen had employed his artistic imagination to enhance a photographic record: Hartmann observed that in *Moonrise—Mamaroneck, New York* (fig. 89), a photograph showing a "row of tree trunks reflected in a pool," Steichen had "with astonishing cleverness faked the rising moon."[1] Consistent with the pictorialist aim of making photography more like painting, *Moonrise—Mamaroneck* bears the aspect of a watercolor, and the motif of moonlight through the trees suggests an affinity with contemporary tonalist paintings, which typically present such intimate sylvan scenes. This particular print, elaborately layered to produce subtle tones of blue and green, recalls in style and spirit Tryon's landscapes

generally, and in subject and mood *The Evening Star* specifically—a resemblance made all the more striking by the peculiarity of Tryon's composition. If only because both painting and print appeared under various titles (N. E. Montross called the painting "Evening—The Lake" and Freer named it "Twilight"; Steichen's photograph seems to have been exhibited variously as "Moonrise," "The Pond Moonlight," and "The Pond—Moonrise"), it becomes almost impossible to untangle the threads of influence. Tryon's work was not exhibited in New York City until 1908, but Steichen's

was shown in 1905 at the inaugural exhibition of the Little Galleries of the Photo-Secession at 291 Fifth Avenue, where Tryon might have seen the photograph, recognized a sympathetic sensibility, and produced his own interpretation in oil.[2]

When *The Evening Star* did make its New York appearance at the Montross Gallery, one critic detected its kinship with another art form altogether. Designating the painting "a souvenir of 'Tannhäuser,' without the star," the writer read the title of Tryon's work as a reference to the melancholy prayer to the evening star in Wagner's op-

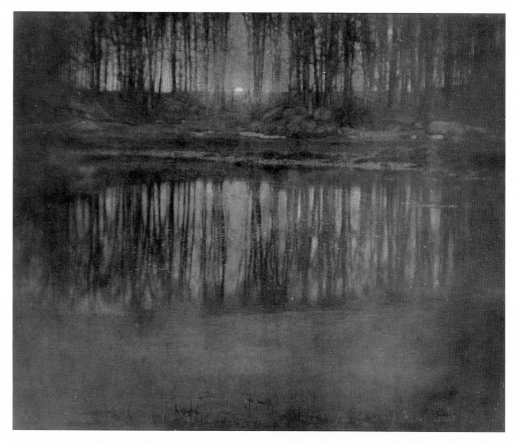

Fig. 89 Edward Steichen (1879–1973), *Moonrise—Mamaroneck, New York,* 1904. Platinum, cyanotype, and ferroprussiate print, 15¹⁵⁄₁₆ × 19 in. (38.9 × 48.3 cm). The Museum of Modern Art, New York; Gift of the photographer.

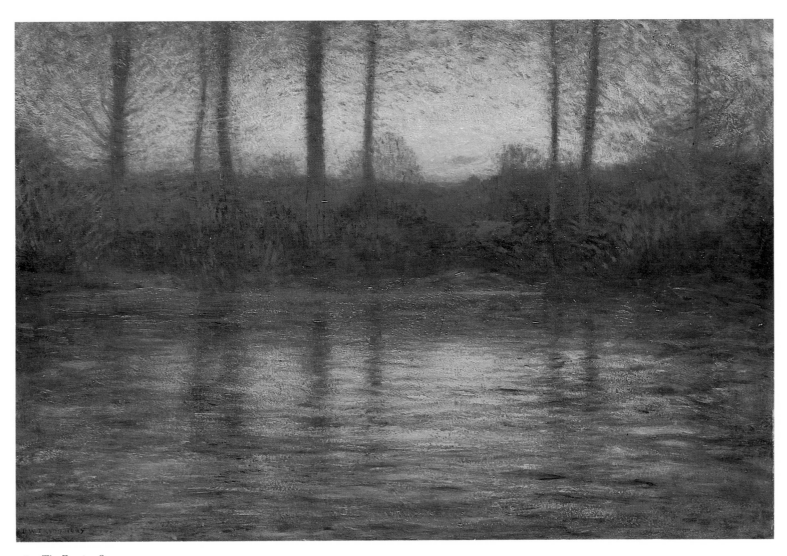

28 *The Evening Star*

era.[3] But if the artist had a literary associa-
tion in mind, it was probably Tennyson's
"Crossing the Bar," a stanza of which is in-
scribed on Tryon's headstone in South Dart-
mouth.

1. Sadakichi Hartmann, "A Collection of Ameri-
can Pictorial Photographs as arranged by the
Photo-Secession and exhibited under the Aus-
pices of The Camera Club of Pittsburgh, at The
Art Galleries of the Carnegie Institute, February
1904," *Photographic Times-Bulletin* 36 (March
1904): 98. Another print of this photograph,
titled *The Pond—Moonrise*, is in the Metropolitan
Museum of Art, New York.

2. Voucher, N. E. Montross, 24 March 1905,
Freer Papers/FGA. *Moonrise—Mamaroneck* was ex-
hibited in Pittsburgh as "Moonrise" (1904), and
in New York at the Little Galleries of the Photo-
Secession ("291") as "The Pond Moonlight"
(1905) and "The Pond—Moonrise" (1906). *The
Evening Star* was exhibited in Buffalo in 1905 and
in Philadelphia in 1906.

3. "A Quintet of Painters," *New York Sun*, 2 Feb-
ruary 1908, Freer Press-Cutting Book 1:26.

29 *Morning*

1906
Oil on wood panel
16 × 24 in. (40.7 × 60.9 cm)
Signed and dated, lower right:
D. W. TRYON 1906
06.83

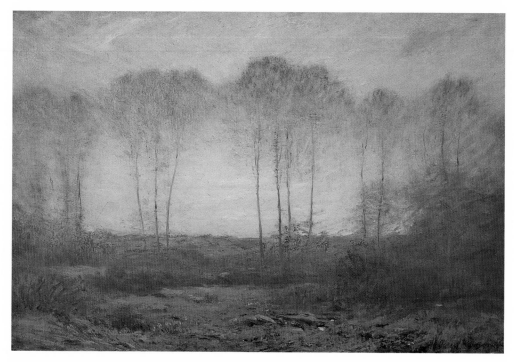

29 *Morning*

In an article titled "The Tonal School of America" published the year *Morning* was painted, Clara Ruge defined the qualities of a "national school of landscape painting . . . destined to leave a mark in the history of art." Ruge named as the leader of the movement Henry Ward Ranger, who had designated his landscapes "tonal" at a Lotos Club exhibition in New York City fifteen years earlier, and designated Alexander H. Wyant, Homer Dodge Martin, and Ralph Blakelock pioneers in tonal methods. Although she considered Tryon (together with Horatio Walker) an artist related to the school though "decidedly individual," Ruge's explanation of the characteristic "motive" of the tonalist painters appears to describe a typical painting by Tryon:

> The arrangement of colors must be kept in harmony because it must reproduce not merely the facts of the landscape, either separately or in mass, but, rather,

the effect of the scene upon the painter's feelings, the emotion it evokes. Not alone the grass and the trees, with whatever delicate recognition of gradation of color, but the mood, of which they are the embodiment and cause, is to be transferred to the canvas.[1]

If artists of the "Tonal School" communicated mood through color, Tryon's *Morning* reflects a radiant state of mind. Freer declared it a "real masterpiece" and assured the artist that "in its own appropriate frame," sensitively toned to harmonize with the painting, it appeared "more wonderful than ever."[2] Suffused with a golden light reminiscent of Claude Lorrain's dawn scenes, *Morning* follows the tradition of the ideal landscape.

1. Ruge 1906, 57, 60, and 64.
2. Freer to Tryon, 22 February 1906 (LB 19).

30 *The Sea: Moonlight*

1905
Pastel on dark tan paper mounted on
paperboard
8 × 12 ¹/₁₆ in. (20.2 × 30.7 cm)
Dated, lower left (pencil): 1905
Signed, lower right (crayon): D. W. TRYON
06.94

31 *The Sea: East Wind*

1906
Pastel on dark tan paper mounted on
paperboard
8 × 13 in. (20.2 × 30.4 cm)
Signed, lower left (crayon): D. W. T.
Signed and dated, lower right (pencil):
D. W. TRYON 1906
06.264

32 *The Sea: A Freshening Breeze*

1906
Pastel on dark taupe paper mounted on
paperboard
7 ¹⁵/₁₆ × 11 ¹⁵/₁₆ in. (20.2 × 30.4 cm)
Signed, lower left (crayon): D. W. T.
Signed and dated, lower right (pencil):
D. W. TRYON 1906
Dated, lower right (crayon): 1906
06.265

The low tones and quiet mood of *The Sea: Moonlight*, a marine painted in 1905, make it closely related to the pastels Tryon produced the following year, *The Sea: East Wind* and *The Sea: A Freshening Breeze*. In fact, the "moonlight" pastel appears like a preview of attractions at Ogunquit, Maine, where night after night Tryon and his friend Walter Copeland Bryant watched the moon rise over the sea and illuminate the path at their feet. At the end of August 1906, Bryant had suggested the coast of Maine as a place for Tryon to paint a "moonlight on the beach with the waves coming in," and in September they went together to Ogunquit. Every morning for a week they walked to the shore before dawn to witness the sun rise "like Venus from the sea," as Tryon described it to Freer. They spent their days fishing for pollack and clambering over boulders on the beach, and while Bryant played the banjo, they admired the sea as it rolled to the shore. On the first day alone they were able to observe a five-minute rainfall, a sandstorm, a rainbow, a "beautiful pink opal sea," and the northern lights; and five nights in a row from a spot thirty feet from the water's edge, they watched the moon "rise over a noble beach."

Tryon was entranced. He later told Bryant he would not have missed the trip for a thousand dollars: Ogunquit was finer than England or France, he said. Mont-Saint-Michel was "nowhere to this wonderful place."

Tryon did not produce a single finished sketch or picture in Ogunquit,[1] though he did make notes of color and composition in pencil and watercolor. Tryon told Freer that he hoped to use the rudimentary sketches as foundations for paintings suggesting his sensations,[2] and later that autumn executed about twenty studies of the sea from the shore, predominantly in pastel. As he painted, Tryon whistled and sang Bryant's "wave song," working the tune of the banjo into every picture. "Bryant," he said when he had finished, "your song is immortal."[3]

Those musically inspired studies, Tryon explained to Freer, were among the first in a series of marine paintings in pastel "which may hint at the wonders of the various times of day and night on the shore." Freer wished the artist every success with his plan: "What a great scheme it is to anticipate one's work and then to prepare for it! How entertaining, too, the preparation, and what inspiration one can acquire in studying as you have been doing!"[4] In November, Freer visited Tryon in New York en route to Egypt and selected for purchase *The Sea: East Wind* and *The Sea: A Freshening Breeze* (originally titled "The Sea: South East Wind") before he sailed.[5]

Freer's pair was exhibited at the Montross Gallery that winter, together with a dozen other pastels of the sea. One critic noted that Tryon's modest memoranda of natural effects recalled Whistler's Notes, small oil paintings on panel such as *Violet and Silver: The Great Sea* (fig. 90), but asserted that Tryon's pastels showed "quite as much beauty of color" and far more truth:

> While they are all executed with a light touch, befitting the medium employed, they have in each case a pictorial unity

Fig. 90. James McNeill Whistler (1834–1903), *Violet and Silver: The Great Sea*, ca. 1884. Oil on panel, 5⅜ × 9¼ in. (13.8 × 23.5 cm). FGA (02.148).

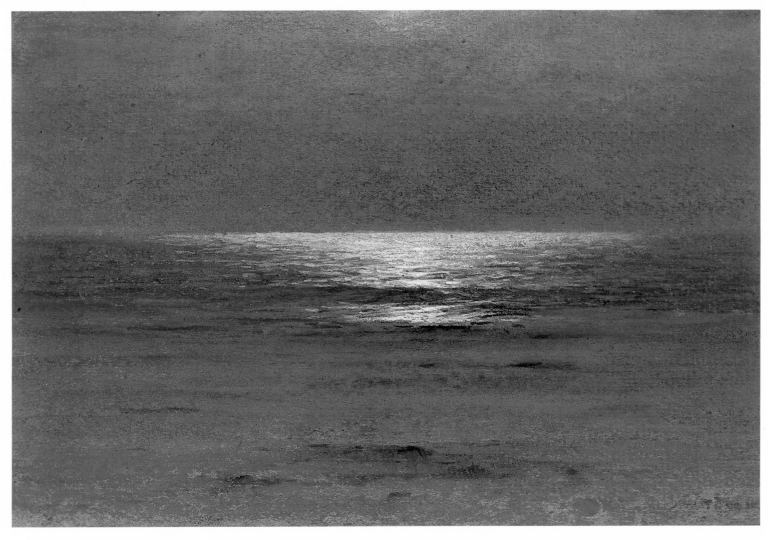

30 *The Sea: Moonlight*

which Whistler was rarely at pains to secure in works of the same sort. Mr. Tryon gives nature her chance; he tries not simply to register his own mood, but to give us an adequate statement of the facts. He has never been more imaginative, he has never been more veracious, than in these swift impressions.

Another writer remarked that the pastels revealed an "appreciation of the poetic side of nature in her many moods."[6] Indeed, these works anticipate the larger scheme that Tryon had in mind, which culminated a decade later in a series called "Sea Moods."

1. "What Some Famous Artists Have Said to Me," Walter Copeland Bryant's journal, Bryant Papers/AAA.

2. Tryon to Freer, 12 September 1906 (121).

3. Tryon to William K. Bixby, 18 January 1907, Bixby Collection/MHS; quoted in "Famous Artists," Bryant Papers/AAA.

4. Tryon to Freer, 12 September 1906 (121); Freer to Tryon, 14 September 1906 (LB 20).

5. Tryon to W. K. Bixby, 18 January 1907, Bixby Collection/MHS; pencil inscription at top left (verso) of voucher, D. W. Tryon, 17 November 1906, Freer Papers/FGA.

6. "New Paintings by Mr. T. W. Dewing and Mr. D. W. Tryon," *New York Daily Tribune*, 20 February 1907, Freer Press-Cutting Book 1:24; and untitled press cutting in *New York Globe*, 21 February [1907], Freer Press-Cutting Book 1:24.

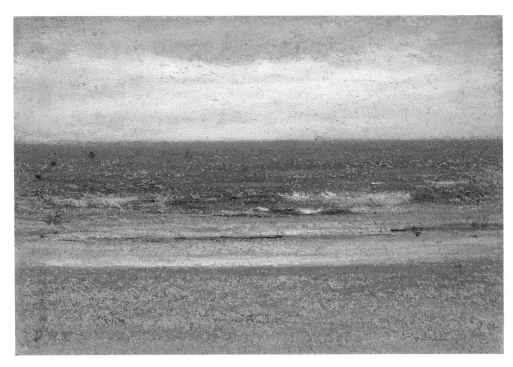

31 *The Sea: East Wind*

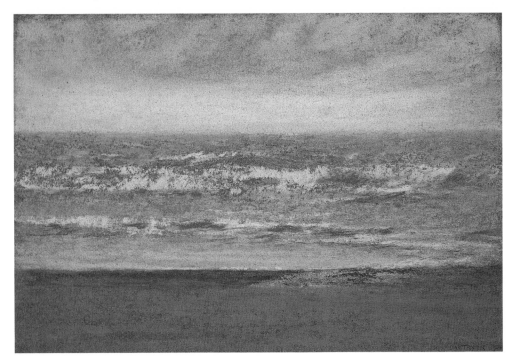

32 *The Sea: A Freshening Breeze*

33 *The Sea: Evening*

1907
Oil on canvas
30 × 48 in. (76.2 × 21.8 cm)
Signed and dated, lower left:
D. W. TRYON 1907
07.151

"I have felt ever since I painted it that in some ways it was the nearest to a masterpiece of any I have produced," Tryon said of *The Sea: Evening*, one of the large oil paintings that grew from his recollection of the ocean at Ogunquit.[1] Few of his works were so carefully prepared and simply painted, and none received a more sympathetic response from Freer.

William K. Bixby, the businessman from St. Louis who had come to appreciate Tryon's art through Freer's careful guidance, had longed for a moonlight marine ever since seeing a work called *The Wave* on the walls of the Tryons' New York apartment (see fig. 64); Bixby had offered Alice Tryon a considerable sum for the painting, but she sentimentally refused to sell. His desire for a picture of moonlight on the waves had motivated Tryon's first trip to Ogunquit with Walter Copeland Bryant in the summer of 1906.[2]

After returning to his studio in New York City late that autumn, Tryon executed a number of pastels inspired by his visit to the Maine coast; by the beginning of winter he was occupied with several large oil paintings, and by mid-January 1907 had completed the major work of the series.[3] *The Sea*, Tryon wrote Bixby, was the "principal picture of the year"—Tryon's very best marine and unlike anything he had painted before. The method he employed was "free and powerful in order to express the living moving force" and to represent the "power and vastness of the sea and sky as elemental forces, untamed and enduring."[4]

In retrospect, Tryon realized that the picture he had created for Bixby had been a preparatory piece, that all of the marines in pastel and oil he produced in 1906 were essentially exercises leading up to the monumental *Sea: Evening*. Though similar in "material and time of day," Tryon wrote Freer, the first sea painting was "more complicated and less direct" than the second; and

although a "dignified work" in itself, *The Sea* was primarily important as the predecessor of a more compelling work. In painting *The Sea* for Bixby, Tryon had reconsidered "certain technical qualities," which ultimately inspired the genesis of *The Sea: Evening*.[5]

During February 1907, Tryon made an unusual venture out of the city to Maine, intending to produce studies for other seascapes.[6] That winter journey to the coast probably accounts for the chilly, monochromatic austerity of *The Sea: Evening*. Although Tryon managed to complete a few smaller marines that season, *The Sea: Evening* occupied his attention almost exclusively until April, when he left his studio for South Dartmouth. Freer was out of the country at the time, but as soon as he heard about the "twilight Seas" he wrote Tryon expressing the hope that he was not too late to buy it.[7] Before leaving New York, Tryon had sent the painting to N. E. Montross with strict instructions to limit its exposure; upon receiving Freer's letter, he had *The Sea: Evening* packed and sent to Detroit at once—"to get it away so it will not be much seen until we are ready to show it," he said. "I consider it the most masterly piece of work in a technical sense that I have done, and am therefore very careful about its being seen in a desultory way." Tryon was of course delighted for Freer to have the painting, and offered the customary assurance that the canvas would not be rendered redundant by other works in his collection. "It certainly touches a new note in many ways," he said, "and will greatly help to round out the circle."[8]

Possessing the "convincing feeling" that the painting would exceed his expectations,[9] Freer was prepared to be impressed. Tryon had reported that everyone who saw *The Sea: Evening* declared it to be the "most spacious picture they had ever seen," and that one critic had said it was the "only marine

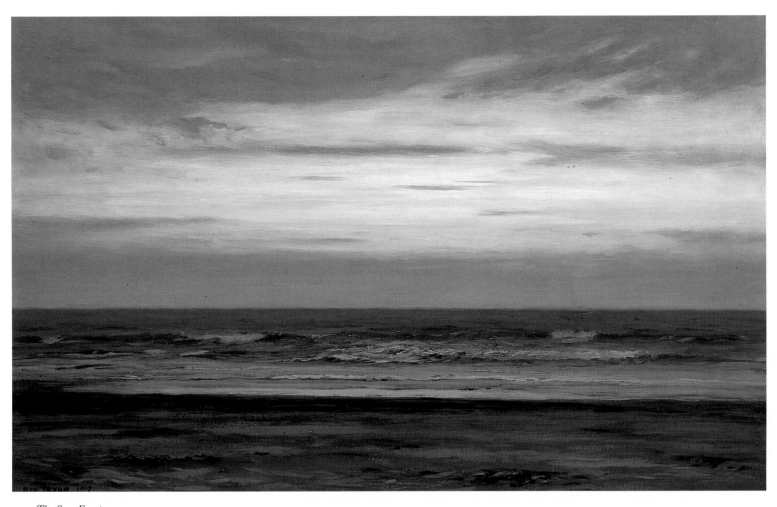

33 *The Sea: Evening*

picture which had ever given him the feeling of the sea and its grandeur." Tryon himself considered *The Sea: Evening* a peerless painting. "I hope you will find it all you have pictured . . . and more," he had written to Freer.

It is decidedly a gallery picture, being very simple in its masses and a picture that requires distance to be seen at its best. I think you will at least find it a note entirely by itself. I intended to express in

it the grand elemental forces and feel that I have succeeded in this to a greater extent than in any of my other marines.[10]

He had reason to wonder what Freer would think.

The Sea: Evening arrived in Detroit on the first of April, and Freer was so taken by it that he wrote Montross immediately to say that although he had only given it a hurried glance he was sure the painting was a masterpiece.[11] The following day he found time

to acknowledge the work fully, writing Tryon that he had been "soaking in the marine since its arrival" and finding it wonderful indeed—"marvelously convincing, tremendously powerful and extremely dignified. Nothing could be more truthful, and, at the same time, so subtle." He concurred with other critics that *The Sea: Evening* was both spacious and evocative of a "particular mood of the sea," and with the artist that it was "top-notch," the masterful outcome of Tryon's "splendid experience

and study."[12]

But when he began to consider Tryon's work in light of the Asian art he had recently encountered, Freer's remarks reached new realms of praise. "The coloring is very beautiful," Freer said of *The Sea: Evening*, "and its directness recalls the work of the great Masters of the early Kāno-school— Sesshū, Sesson and Masunobu." He went on to describe a treasure he had seen in the temple of Chishaku-in (fig. 91):

In one of the great Kyoto Temples there is an ink drawing of a hung waterfall by a Sung painter called Okamatsu [*sic*]. This picture I was permitted to study most carefully on several occasions during my stay in Japan, and I believe it to be one of the greatest pictures in existence. You, I am sure, would be fascinated by it. Its great qualities are simplicity, line and no-tan (light and dark). Color, if added, might have given it additional charm, but it certainly could not have increased its subtlety or suggestion. Your Marine, while totally different in subject, has to me the same big qualities of excellence.[13]

Tryon, who would not have been expected to know that a Sung painter meant a Chinese one, replied that he was glad Freer had detected his painting's affinity to the work of "one of Japan's great artists," and that "this kinship with former great minds really makes life interesting—not only do we have the kinship of living souls but we are linked to all that is past and to come." He denied its similarity to any Western work, however, stating that he knew "nothing like it in any way." Echoing Freer, Tryon wrote: "Its great simplicity of line mass and color as well as the perfect treatment technically mark it distinctly as a note alone."[14]

Despite its dissimilarity to other productions, *The Sea: Evening* remains consistent with Tryon's aesthetic intentions. Tryon told Freer that like his landscapes, the painting would initially appear simple and direct but eventually disclose a universe of feeling, expressing the "utmost physical truth . . . subject always to the thought or mood of the hour."[15] Indeed, Freer's attention to the endless variation of *The Sea: Evening* never wavered. "For certain moods I might prefer two or three of the wholly tender specimens of earlier periods," he told Tryon in 1910, "but when it comes to the point of having my spine twisted, I think I must go to the big Marine."[16]

Fig. 91 *Waterfall*, a Southern Song painting by a follower of Li Tang (A.D. 1050–1130). Formerly attributed to Wang Wei (A.D. 697–759). Hanging scroll; ink on silk, 25½ × 40½ in. (64.5 × 103.2 cm). Chishaku-in, Kyoto, Japan.

1. Tryon to Freer, 7 August 1907 (124).

2. Tryon to W. K. Bixby, 18 January 1907, Bixby Collection/MHS.

3. "What Some Famous Artists Have Said to Me," Walter Copeland Bryant's journal, Bryant Papers/AAA. According to Bryant, Bixby offered Mrs. Tryon $5000 for her picture; he eventually paid $10,000 for *The Sea* (Tryon to W. K. Bixby, 2 February 1906 and 26 January 1907, Bixby Collection/MHS).

4. Tryon to W. K. Bixby, 26 and 29 January 1907, Bixby Collection/MHS. *The Sea* (present location unknown) was sold from the collection of the Washington University Gallery of Art, St. Louis, in 1945. The catalogue indicates that the painting measured 25 × 37 inches and portrayed a "sandy beach, washed by the surf of a calm sea, under blue sky with rose and grey clouds. The sail of a boat visible at the horizon" (Kende Galleries sale catalogue no. 201, 4 May 1945, in the archives of the Washington University Gallery of Art).

5. Tryon to Freer, 7 August 1907 (124) and 21 July 1907 (122).

6. Tryon to W. K. Bixby, 4 February 1907, Bixby Collection/MHS.

7. Freer to Tryon, 7 July 1907, Nelson White Papers/AAA.

8. Tryon to Freer, 21 July 1907 (122).

9. Freer to Tryon, 25 July 1907 (LB 22).

10. Tryon to Freer, 21 July 1907 (122) and 27 July 1907 (123).

11. Freer to N. E. Montross, 2 August 1907 (LB 22).

12. Freer to Tryon, 3 August 1907 (LB 22).

13. Ibid. "Omakitsu" is the Japanese equivalent for Wang Wei, to whom *Waterfall* is traditionally attributed, though the painting has recently been identified as the work of a Southern Song painter, a follower of Li Tang (James Cahill, *An Index of Early Chinese Painters and Paintings* [Berkeley: University of California Press, 1980], 18).

14. Tryon to Freer, 7 August 1907 (124). Hobbs 1977, 86, compares *The Sea: Evening* with Whistler's work.

15. Ibid., 7 August 1907 (124).

16. Freer to Tryon, 9 March 1910 (LB 29). *The Sea: Evening* was one of three "spine twisters" Freer mentioned; the others are *Autumn Morning* and *Twilight: Autumn* (cat. nos. 39 and 41).

34 *Easterly Storm*

1907
Pastel on dark taupe paper mounted on
paperboard
9 × 11⅞ in. (20.3 × 30.1 cm)
Dated, lower left (chalk): 1907
Signed, lower right (chalk): D. W. T.
08.1

34 *Easterly Storm*

For all their praise of *The Sea: Evening* (cat. no. 33), both artist and owner hoped it would lead to an even greater work. Freer refused to believe that Tryon could have reached the pinnacle of excellence so early in his career, writing to Tryon that if it were possible to paint a better picture he would surely do so; he continued to look forward to "higher and higher expressions of beauty."[1] Tryon responded with the hope that *The Sea: Evening* might indeed be a "step toward a finer work." He was off to Ogunquit to study the sea once again.[2]

Tryon's monumental marine, however, was not to be surpassed. In September 1907 the ocean was in quite a different mood. Tryon arrived at the coast of Maine in time for a powerful gale, which he experienced firsthand as Turner might have done. As soon as he could find shelter, he painted a pair of pastels intended as studies for a major work, another seascape in oil to complement *The Sea: Evening*. But when a modest

pastel called *Easterly Storm* was delivered to Detroit, Tryon explained to Freer that a large painting would probably not express the theme as well and that, consequently, he would probably "never attempt to treat the subject more fully." The pastel represented the "best of two attempts," Tryon said, "to suggest somewhat the might and mystery of a powerful manifestation of nature," an effect that a more studied, reflective work like *The Sea: Evening* might well have lost. *Easterly Storm* speaks not of the artist's control of his subject but of human inadequacy before natural forces. Perhaps the perfect finish of *The Sea: Evening* was not the mark of a masterpiece after all. "So Browning says," Tryon wrote Freer, "the incomplete greater than completion matches the immense."[3]

1. Freer to Tryon, 3 August 1907 (LB 22).

2. Tryon to Freer, 7 August 1907 (124) and 21 July 1907 (122).

3. Ibid., 5 January 1908 (125).

35 *Autumn Day*

1907–09
Oil on wood panel
23⅜ × 38 in. (59.5 × 96.7 cm)
Signed and dated, lower left:
D.W. TRYON 1907–8–9
Signed and dated, lower right:
D. W. TRYON 1909
09.2

36 *October*

1908
Oil on wood panel
20 × 30¼ in. (50.8 × 76.7 cm)
Signed and dated, lower left:
D. W. TRYON 1908
08.22

35 *Autumn Day*

After the turn of the century, Tryon painted autumn scenes at least as often as spring-time ones, and in the years around 1908 produced a number of works on the theme of fall that are cast in the light of day. The sunshine Tryon uses to illuminate these landscapes is naturally dim, however, so the color tones remain muted and serene.

After exploring the motions of turbulent seas, Tryon composed a landscape of imperturbable stability, *Autumn Day*. Its execution was especially slow and laborious, spanning three seasons' work. The scene itself, a dull day in autumn well after the peak of the season, is as unremarkable as the weather; with *Autumn Day* the artist returned to solid ground. *October* also pictures a daylight scene, though the sky is dim, with darkening clouds toward the top of the panel, an autumn day that looks cold and damp. The meadows of these paintings are plush with paint, but the trees, ranged in a row across the horizon in *Autumn Day* and grouped to the left and right of center in *October*, appear almost immaterial, as if their forms had faded with the artist's memory.

Freer was pleased with both paintings. He wrote Tryon that he placed *October* among his finest works,[1] and said of *Autumn Day* when it finally arrived in Detroit in 1909: "The picture pleases me greatly, and I am under renewed obligation to you for so kindly having allowed me to purchase it. It will, I am sure, add a very important note to the collection."[2]

1. Tryon to Freer, 7 April 1908 (126).

2. Freer to Tryon, 16 January 1909 (LB 26).

36 *October*

37 *April Morning*
1908
Oil on wood panel
13¾ × 19⅞ in. (35.0 × 50.6 cm)
Signed and dated, lower left:
D. W. TRYON 1908
08.16

38 *An Autumn Evening*
1908
Oil on wood panel
16 × 24 in. (40.7 × 61.0 cm)
Signed and dated, lower left:
D. W. TRYON 1908
13.33

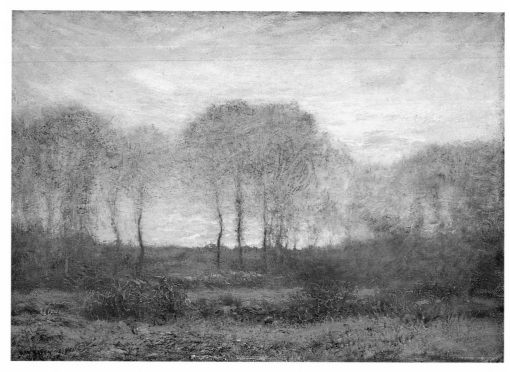

37 *April Morning*

April Morning and *An Autumn Evening* represent the temporal boundaries of Tryon's summers in South Dartmouth. The first, which evokes the limited light of dawn, appears wistful but less melancholy than the second: the colors of the countryside in *An Autumn Evening* incline toward gray and brown, possibly reflecting Tryon's last look at the landscape before moving inside for the winter season. Both landscapes show richly textured surfaces, the result of repeated reworking of the panels. Beginning with a grayish white ground, Tryon applied dense layers of oil paint, which he overlaid with veils of softer pigments. These were rubbed down in some areas for emphasis, exposing the higher-toned colors of the underpainting.[1] Layers of paint embody months of memory.

An Autumn Evening was originally owned by William T. Evans, the most prodigious collector of American art before the First World War. Evans had purchased the painting at the Montross Gallery in 1908, the year of its execution. At his first auction in 1900, a sale that secured the status of American art in the marketplace, Evans had sold four landscapes by Tryon; Freer purchased *An Autumn Evening* at the second record-breaking auction held in 1913 at the Plaza Hotel in New York.[2]

1. Conservator's examination (Ben B. Johnson, 1966), registrar's object file (13.33), FGA.

2. Truettner 1979, 78, lists the Tryon paintings owned by Evans. *An Autumn Evening* was in Evans's possession by the time Charles Caffin published his list of paintings and their owners in 1909.

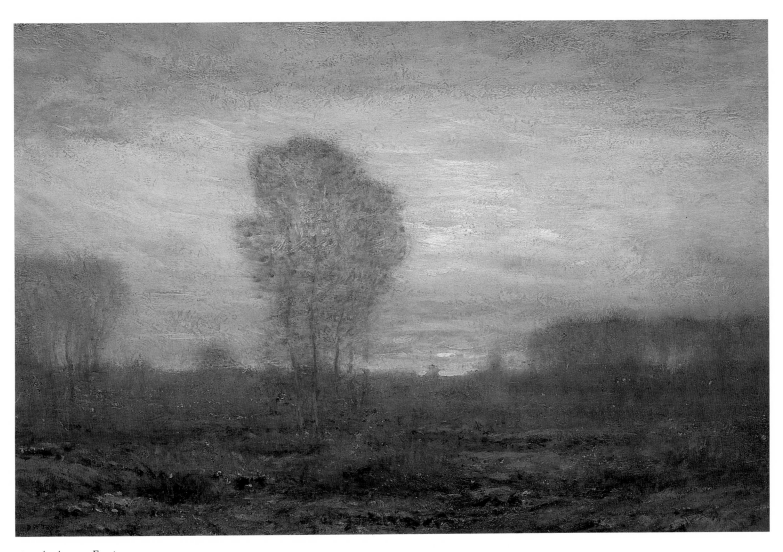

38 *An Autumn Evening*

39 *Autumn Morning*

1908–09
Oil on wood panel
29 × 42¾ in. (73.7 × 108.7 cm)
Signed and dated, lower right:
D. W. TRYON 1908–9
10.4

When *Autumn Morning* was exhibited for the first time in 1909, critics detected an "unexpected vigor" in its design and observed that its color scheme appeared "simpler, stronger and more direct" than that of Tryon's earlier works: "The picture is low-toned and cool, but sharper in definition than usual, and the oak tree in the foreground, which is faintly purpled with the autumn, bends with a superb grace of actual movement which none but a master could have caught." [1] Despite its appearance, however, the sway of the oak that the critic admired was probably not a sign of movement but the distinguishing feature of a tree Tryon knew in the country. A sketch made from nature (fig. 92) shows a solitary oak tree, marked by roughly the same configuration of branches, inclining slightly to the left. Tryon so rarely granted special consideration to any one element in a landscape that that particular oak must have exercised a hold on his imagination. Indeed, the stalwart tree, grappling autumn leaves to its branches in spite of the change of the season, appears oddly anthropomorphic.

Freer, too, acknowledged that *Autumn Morning* was out of the ordinary, but hesitated to buy it in 1909 because, he said, "I do not want the notion to get abroad that my purchases of your work prevent either Museums or private collectors from obtaining specimens of your very best productions." However unfounded, Freer said, such "foolish remarks" might injure Tryon's reputation or implicate his New York dealer, N. E. Montross, in allegations of monopoly. Freer suggested, therefore, that *Autumn*

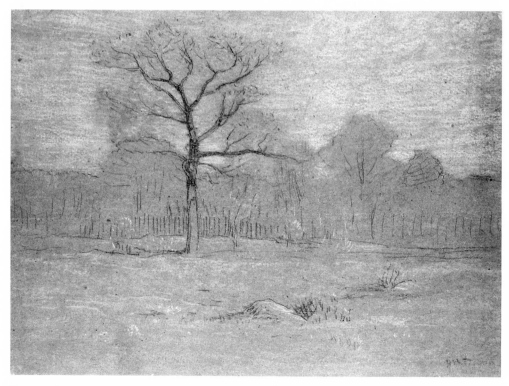

Fig. 92 *Landscape*, ca. 1908. Pastel on paper, 10 × 14 in. (25.4 × 35.5 cm). Smith College Museum of Art (1930:3–148).

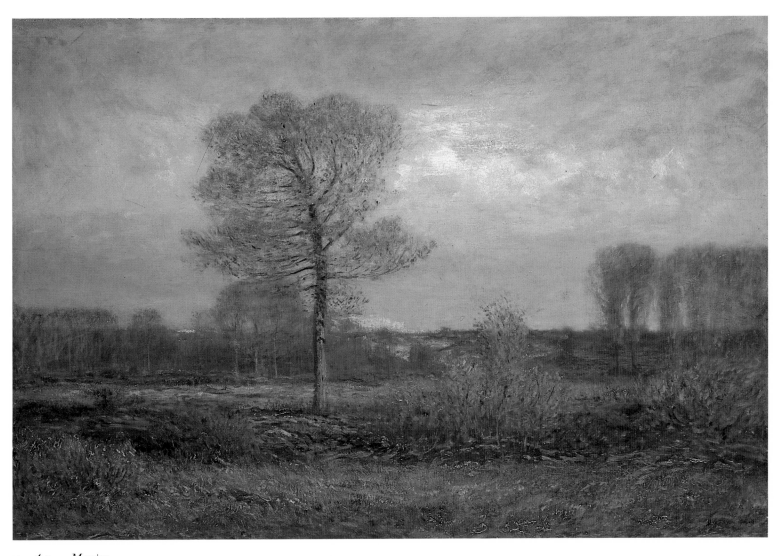

39 *Autumn Morning*

Morning—a painting "preeminently suited to a Museum"—should seek another home. "If in the end it does not find a purchaser," he wrote Tryon, "I am perfectly willing to become its care-taker."[2] Montross accordingly offered the painting to another collector, William K. Bixby, and hopefully sent it to Buffalo and St. Louis for exhibition.[3] But when this "important specimen" was still

for sale in January 1910, Freer bought it without a qualm for a princely sum. At the loan exhibition inaugurating the new Montross Gallery that year, *Autumn Morning* was shown for the first time as part of the Freer collection.[4]

1. Untitled press cutting, *New York Tribune*, 3 February 1909, Freer Press-Cutting Book 1:30;

and Joseph Edgar Chamberlin, "Two American Masters: A Harmony of the Pictures of Tryon and Dewing," *New York Evening Mail*, 3 February 1909, Freer Press-Cutting Book 1:30.

2. Freer to Tryon, 15 February 1909 (LB 26).

3. N. E. Montross to Freer, 22 February 1909.

4. Freer to Tryon, 21 January 1910 (LB 29), and voucher, D. W. Tryon, 21 January 1910, Freer Papers, FGA.

40 *Night*

1909
Oil on wood panel
14 × 19¾ in. (35.5 × 50.4 cm)
Dated, lower left: 1909
Signed, lower right: D. W. TRYON
09.39

"I think you will find in this specimen of Tryon's work, small though the picture be, much to admire," Freer wrote John Trask, manager of the Pennsylvania Academy of the Fine Arts, in 1910.[1] This simple painting that Freer considered a "little masterpiece" marks Tryon's return to evening landscapes after a series of works showing South Dartmouth in daylight. It includes the hallmark motif of a rising moon, which also appears in *Spring Evening—Sunset* (fig. 93), a picture painted the following year. But the remarkable serenity of this autumn *Night* is imposed by the horizon, modulated but undisturbed by low-lying masses of thinly foliated trees.

1. Freer to J. Trask, 5 January 1910 (LB 28). The critic Charles Caffin also considered *Night* "particularly beautiful" when he saw it in New York in 1909 (Caffin to Freer, 15 February 1909).

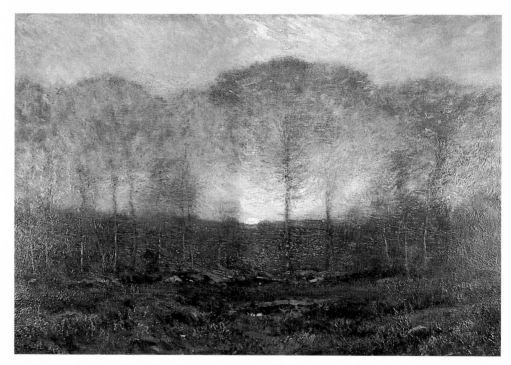

Fig. 93. *Spring Evening—Sunset,* 1910. Oil on wood, 16 × 24 in. (40.8 × 60.5 cm). Museum of Art and Archaeology, University of Missouri–Columbia; Bess Schooling Memorial Gift.

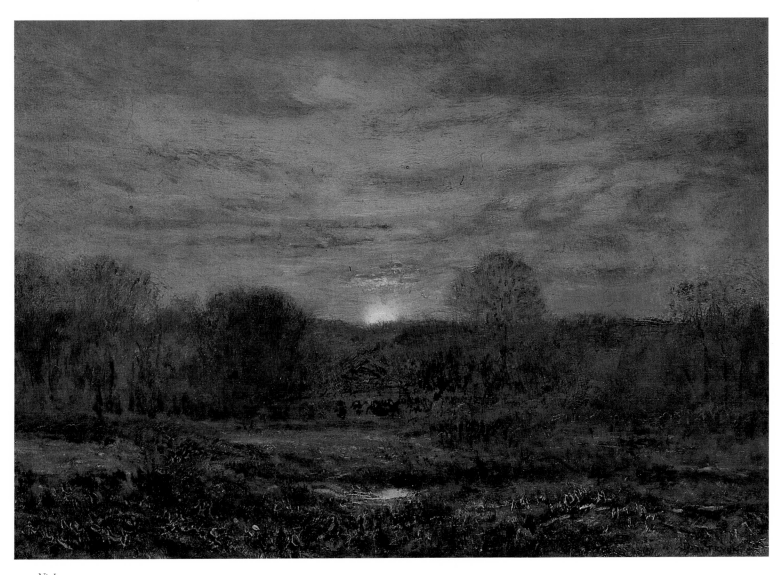

40 *Night*

41 *Twilight: Autumn*

1909–10
Oil on wood panel
20 × 30 in. (50.9 × 76.2 cm)
Signed and dated, lower left:
D. W. TRYON 1909–10
10.11

After 1908, Tryon became more experimental with his compositions and often modified his customary line of trees ranged across the horizon with more striking arrangements of the elements of landscape. He sometimes worked out the schemes on paper: two chalk and pencil drawings in the Smith College Museum of Art labeled in Tryon's hand as the first and second sketches for *Autumn Twilight* indicate the progress of a painting from its conception to its eventual execution in oil on panel.

With each revision, Tryon distanced himself from the literal truth of the landscape. The first sketch for *Twilight: Autumn* (fig. 94), drawn in pencil with white chalk lightening the sky, clearly describes the essential elements of the painting's composition, though Tryon eventually covered much of the open tract on the right side of the drawing with trees and underbrush. The basic plan of the first sketch is retained in the second (fig. 95) but rendered with less precision: the prominent pair of trees in the middle ground has gained stature and lost substance. The later sketch approximates the effect of *Twilight: Autumn* and suggests the same intention, the transformation of objective fact into artistic vision; but it remains only distantly related to the finished work, in which layers of oil paint settle over the scene like a damp autumn fog at twilight.

The evolution of *Twilight: Autumn* occupied two seasons of work. Even unfinished, it made a strong impression on Freer, who considered it one of Tryon's "most mysterious and beautiful pictures"—aloof, as he put it, from all others of its kind. "It appeals to me as one of your most profound interpretations of Nature," he wrote Tryon at the end of January 1910.[1] The painting made its debut at the Montross Gallery, but its installation in Detroit secured its aesthetic standing. Freer took pleasure in comparing *Twilight: Autumn* with other works by Tryon in

his collection, and enjoyed hearing the opinions of visitors as well. Occasionally, he said, the "unseeing and unfeeling" offered worthless remarks, but "intelligent people" who viewed the painting one morning in March when the light in the exhibition room was exceptionally good indicated their ap-

Fig. 94 Sketch for *Twilight: Autumn* (inscribed, verso, "1st sketch for Autumn Twilight owned by C. L. Freer 20 × 30"), ca. 1909. Graphite with white chalk on paper, 3 7/16 × 5 1/16 in. (8.7 × 12.8 cm). Smith College Museum of Art (1930:3–134); Bequest of Dwight W. Tryon.

Fig. 95 Sketch for *Twilight: Autumn* (inscribed, verso, "2nd sketch for Autumn Twilight 20 × 30"), ca. 1909. Graphite with white chalk on paper, 3⅞ × 5 9/16 in. (9.8 × 14.1 cm). Smith College Museum of Art (1930:3–134); Bequest of Dwight W. Tryon.

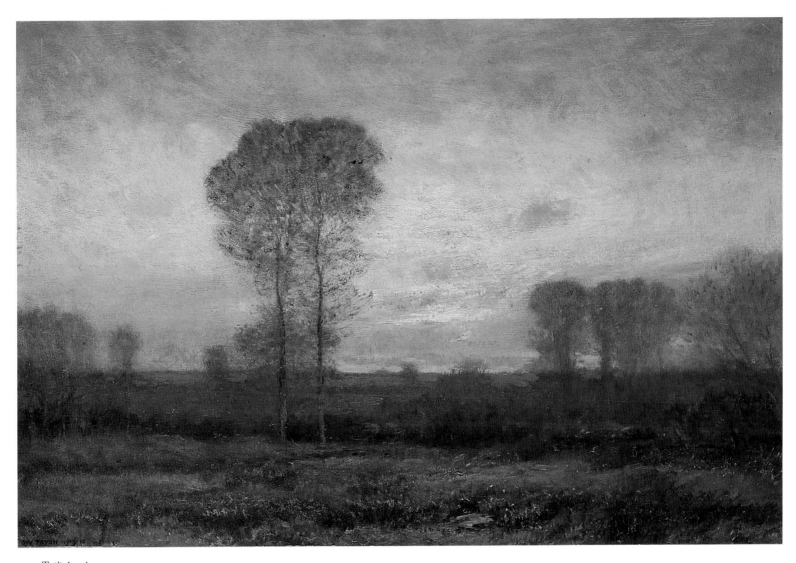

41 *Twilight: Autumn*

proval of Freer's new acquisition. "Personally, I am convinced that 'Twilight—Autumn' is one of your very finest paintings," Freer wrote Tryon. "Its combination of strength and delicacy is in my judgement not excelled by any other specimen in my care. Its range is tremendous!"[2]

1. Freer to Tryon, 21 January 1910 (LB 29).

2. Ibid., 9 March 1910 (LB 29) and 21 March 1910 (LB 30).

42 *Evening: September*

1912
Oil on wood panel
20 × 30 in. (50.9 × 76.4 cm)
Signed and dated, lower right:
D. W. TRYON 1912
12.7

43 *Twilight: November*

1912
Oil on wood panel
16 × 24 in. (40.7 × 61.0 cm)
Signed and dated, lower left:
D. W. TRYON 1912
12.14

Despite its golden overtones, *Evening: September* is a companionable painting with an informal air. Like all Tryon's works, however, its simplicity belies the care of composition: branches of attenuated trees brush the borders of the scene but part just off center to frame a sunset reflected in a foreground pool. Freer must have seen *Evening: September* in Tryon's studio soon after it was finished in the winter of 1912. When the painting was delivered to Detroit early in March, he found he liked it as well "on renewed acquaintance."[1]

Ordinarily, September was early in the season for Tryon's taste. Even in October the countryside appeared too garish for Tryon to paint.[2] Not until the splendor of South Dartmouth had been subdued by cooler weather did he find inspiration for *Twilight: November*. Freer anticipated the painting's arrival with "haunting dreams," and when it was placed in the new picture gallery of his home was charmed by its effect. "Quite a large party visited the galleries yesterday and they all expressed great delight with your work," he wrote Tryon. "I wish you could yourself see the group and note the wonderful line and color harmony running through the various pictures."[3] Frederic Fairchild Sherman observed in 1918 that the technique Tryon employed in *Twilight: Autumn*, though not new, was decidedly personal: "It helps him to re-create in delicate gradations of light and of shadow subtle atmospheric effects that are the visible signs of the moods of nature just as smiles and tears are the visible signs of human emotion." Tryon interpreted not the face of nature, Sherman said, but the feelings.[4]

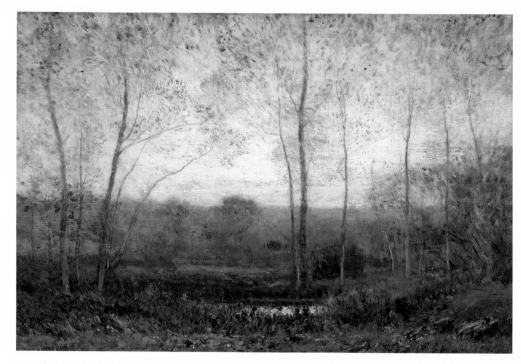

42 *Evening: September*

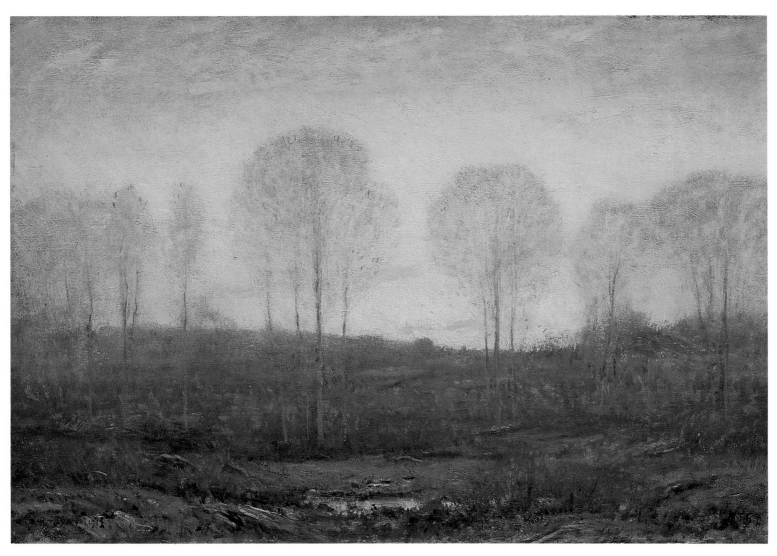

43 *Twilight: November*

1. Tryon to Freer, 27 February 1912 (138) and 4 March 1912 (140).
2. Ibid., 14 October 1911 (131).
3. Freer to Tryon, 7 May 1912 (151).
4. Sherman 1918, 38.

44 *Night: The Sea*

1912
Pastel on brown paper mounted on
paperboard
8 × 11⅞ in. (20.2 × 30.1 cm)
Signed and dated, lower left (pencil):
D. W. TRYON 1912

12.15

45 *Moonlight*

1912
Pastel on gray-brown paper mounted on
paperboard
7⅞ × 12 in. (20.1 × 20.5 cm)
Signed, lower left (chalk): D. W. TRYON
Dated, lower right (chalk): 1912

13.7

46 *Sunset before Storm*

1913
Pastel on gray-brown paper mounted on
paperboard
8 ⅙ × 11⅞ in. (20.5 × 30.2 cm)
Signed and dated, lower left (pencil):
D. W. TRYON 1913

14.11

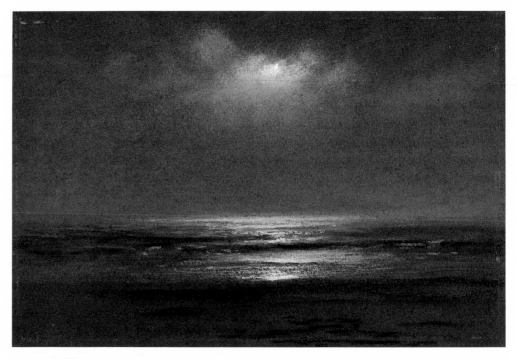

44　*Night: The Sea*

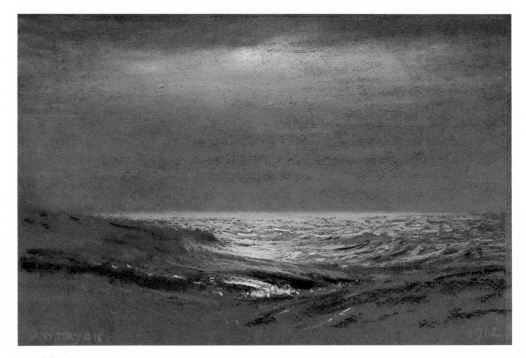

45　*Moonlight*

For Tryon, a sailor and fisherman as well as a painter, the ocean provided inexhaustible opportunities for art, especially when observed at night. As George Alfred Williams pointed out in an essay on Tryon's pastels, the artist's particular talent for the intangible is shown to advantage in evocations of the "crepuscular effects of the eerie hours."[1] The two pastels from 1912 depicting still and then swirling waters in moonlight do suggest the qualities of mystery and romance that Tryon seems to have found in the nocturnal sea. *Night: The Sea* and *Moonlight* look forward to the series of marines executed three years later, in which serenity is but one of many "Sea Moods." *Sunset before Storm*, completed in 1913, shows Tryon setting a more ominous mood, with orange-tinged clouds covering a turbulent sea as the sun's last light fades on the horizon.

All three of these pastel paintings were exhibited in San Francisco at the Panama-Pacific International Exposition in 1915. Celebrating the construction of the Panama Canal, the exposition was meant to be a "vehicle of education, enlightenment and progress," and Freer, whom the press referred to as an "art missionary," served on the art advisory committee.[2] Oil paintings and pastels by Tryon, almost all lent by Freer, hung in Gallery 4 together with a number of works by J. Alden Weir. It was a room, Eugen Neuhaus observed, in which "peace reins supreme."[3]

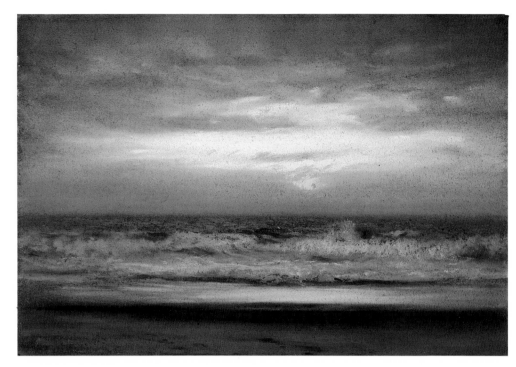

46 *Sunset before Storm*

1. Williams 1924.

2. Charles C. Moore (president, Panama-Pacific International Exposition) to Freer, 7 September 1912; Count Albrecht Von Montgelas, "Freer, Art Missionary, Is Critical," unidentified press cutting, 9 May 1915, Freer Press-Cutting Book 1:66.

3. Eugen Neuhaus, *The Galleries of the Exposition: A Critical Review of the Paintings, Statuary, and the Graphic Arts of the Palace of Fine Arts at the Panama-Pacific International Exposition* (San Francisco: Paul Elder and Co., 1915), 80.

47 *Autumn Evening*

1913
Pastel on brown paper mounted on
paperboard
7 $^{15}/_{16}$ × 12 in. (20.2 × 30.5 cm)
Signed and dated, lower left (pencil):
D. W. TRYON 1913
14.12

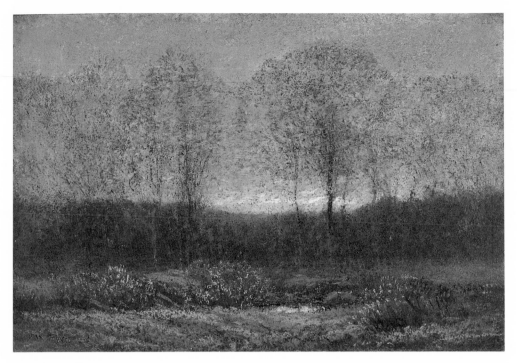

47 *Autumn Evening*

Purchased by Freer at the same time as *Sunset before Storm* (cat. no. 46) and equally charming in the collector's eyes, *Autumn Evening* illustrates another aspect of Tryon's work in pastel.[1] Not since 1905, the year he produced *November Afternoon* (cat. no. 27), had Tryon sold a landscape in pastel to Freer; his increased proficiency becomes apparent in a comparison of the two works. In *Autumn Evening*, Tryon's technique in pastel no longer looks experimental: he has applied chalks and fixatives with a conviction formerly seen only in his oil paintings. To create an ethereal effect in the sky and the branches of the trees, Tryon exploited the advantages of powdered pigments. The land itself is given substance through repeated reworking: "All you saw was the result of many paintings," he wrote his friend George Alfred Williams, "some, probably twenty to thirty separate processes, to reach the extreme simplicity which alone satisfies me." After years of experimenting, Tryon successfully translated the technique of oil painting to the medium of pastel. The result appears effortless, but "what Whistler says is very true," Tryon told Williams. "The only way to conceal work is by more work."[2]

1. Freer to Tryon, 24 January 1914 (173).
2. Tryon to G. A. Williams, 7 October 1916, Nelson White Papers/AAA.

48 *Morning Mist*

1914
Oil on wood panel
14 × 20 in. (35.8 × 50.9 cm)
Signed, lower left: D. W. TRYON
Dated, lower right: 1914

14.32

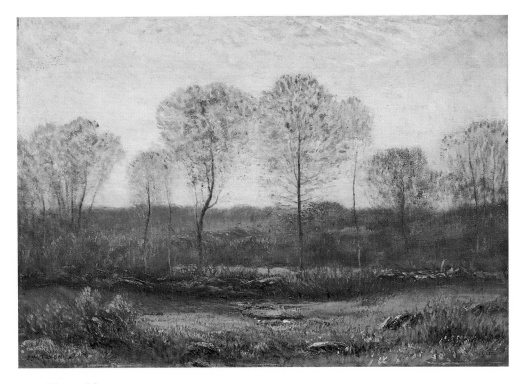

48 *Morning Mist*

As if in answer to the revelations of the International Exhibition of Modern Art, known as the Armory Show, Tryon's paintings became less ethereal and subdued in the years following 1913. *Morning Mist*, painted in 1914, vibrates with color and energy; even the trees appear unusually animated. Its brilliance appealed to Freer, who cited the painting as an example of the "higher standard" Tryon believed was lacking in modern times. Freer seems to have known that *Morning Mist* was bound to be neglected by critics under the influence of the Armory Show, for he wrote to assure Tryon of the painting's importance:

> The little landscape just received should and I believe will in the future cause those who have sight and feeling to look for the higher things discernible in both human life and nature. Although the picture is small in actual size, it suggests some of the most wonderful features of universal truth and life.[1]

1. Freer to Tryon, 13 March 1914 (175).

49 *Night*

1914

Pastel on dark gray-brown paper mounted
on paperboard

7 ¹⁴⁄₁₆ × 11 ¹⁵⁄₁₆ in. (20 × 30.4 cm)

Signed and dated (pencil), lower left:

D. W. TRYON 1914

Signed (crayon), lower left, partially rubbed
out: D. W. TRYON

Signed and dated (pencil), lower right:

D. W. TRYON 1914

14.98

50 *The Sea: Evening*

1915

Pastel on taupe paper mounted on
paperboard

7 ¹³⁄₁₆ × 11 ¹⁰⁄₁₆ in. (19.9 × 29.5 cm)

Signed and dated, lower left (pencil):

D. W. TRYON 1915

15.123

51 *East Wind*

1915

Pastel on taupe paper mounted on
paperboard

7 ¹³⁄₁₆ × 11 ¹³⁄₁₆ in. (19.8 × 30 cm)

Signed and dated, lower left (pencil):

D. W. TRYON 1915

15.124

52 *A Northeaster*

1915

Pastel on taupe paper mounted on
paperboard

8 × 11 ¹³⁄₁₆ in. (20.3 × 30 cm)

Signed, lower right (chalk and pencil):

D. W. T.

Signed and dated, lower right (pencil):

D. W. TRYON 1915

15.125

53 *A Shift of Wind from East to
Northwest*

1915

Pastel on taupe paper mounted on
paperboard

8 ¹⁄₁₆ × 11 ¹⁵⁄₁₆ in. (20.5 × 30.4 cm)

Signed and dated, lower left (pencil):

D. W. TRYON 1915

Inscribed, lower center: Wind shifting from
E to NW

Inscribed, verso: A Shift of Wind from
E to NW

15.126

54 *The Sea: Night*

1915

Pastel on dark taupe paper mounted on
paperboard

8 × 12 in. (20.2 × 30.4 cm)

Signed, lower left (pencil): D. W. TRYON

Dated, lower right (pencil): 1915

15.127

55 *Drifting Clouds and Tumbling
Sea*

1915

Pastel on light taupe paper mounted on
paperboard

7 ¹⁰⁄₁₆ × 11 ¹³⁄₁₆ in. (19.3 × 30.1 cm)

Signed and dated, lower right (pencil):

D. W. TRYON 1915

15.128

56 *Sunrise*

1915

Pastel on taupe paper mounted on
paperboard

8 × 11 ¹³⁄₁₆ in. (20.3 × 30.0 cm)

Signed and dated, lower left (pencil):

D. W. TRYON 1915

15.129

57 *Early Evening: Looking East*

1915

Pastel on light taupe paper mounted on
paperboard

7¾ × 11¾ in. (19.7 × 29.9 cm)

Signed and dated, lower left (pencil):

D. W. TRYON 1915

15.130

58 *After Sunset: Looking East*

1915

Pastel on taupe paper mounted on
paperboard

7 ¹⁵⁄₁₆ × 11 ¹¹⁄₁₆ in. (20.1 × 29.7 cm)

Signed and dated, lower left (pencil):

D. W. TRYON 1915

15.131

59 *Sunrise*

1915

Pastel on dark tan paper mounted on
paperboard

8 ¹⁄₁₆ × 11 ¹⁵⁄₁₆ in. (20.4 × 30.3 cm)

Signed and dated, lower left (pencil):

D. W. TRYON 1915

15.132

60 *Afternoon*

1915

Pastel on dark tan paper mounted on
paperboard

7 ¹⁵⁄₁₆ × 11⅞ in. (20.1 × 30.2 cm)

Signed and dated, lower right (pencil):

D. W. TRYON 1915

15.133

61 *Before Sunrise*

1915

Pastel on dark tan paper mounted on
paperboard

7⅞ × 11⅞ in. (20 × 30.2 cm)

Signed and dated, lower left (pencil):

D. W. TRYON 1915

15.134

62 *Moonlit Sea*

1915
Pastel on taupe paper mounted on paperboard
7 9/16 × 11 15/16 in. (19.2 × 30.2 cm)
Signed and dated, lower left (pencil):
D. W. TRYON 1915
16.121

63 *Northwest Wind*

1915
Pastel on light taupe paper mounted on paperboard
7 15/16 × 11 13/16 in. (20.2 × 30 cm)
Signed and dated, lower right (pencil):
D. W. TRYON 1915
16.122

64 *Moonlight*

1915
Pastel on brown paper mounted on paperboard
7 7/16 × 11 7/16 in. (18.8 × 29.0 cm)
Signed and dated, lower left (chalk and pencil): D. W. TRYON 1915
Signed and dated, lower right (pencil):
D. W. TRYON 1915
16.123

65 *Northeast Wind*

1915
Pastel on dark tan paper mounted on paperboard
7½ × 11½ in. (19 × 29.5 cm)
Signed and dated, lower left (pencil):
D. W. TRYON 1915
Inscribed, verso: East Wind
16.124

66 *A Misty Morning*

1915
Pastel on dark tan paper mounted on paperboard
8 × 11⅞ in. (20.4 × 30.2 cm)
Signed and dated, lower left (pencil):
D. W. TRYON 1915
16.125

67 *Afternoon Clouds*

1916
Pastel on tan paper mounted on paperboard
7 15/16 × 11⅞ in. (20.1 × 30.1 cm)
Signed and dated, lower left (pencil):
D. W. TRYON 1916
17.1

68 *Rocks, Sea, and Sky: Morning—Wind* NNE

1916
Pastel on brown paper mounted on paperboard
7⅞ × 11⅞ in. (20.6 × 30.2 cm)
Signed and dated, lower right (pencil):
D. W. TRYON 1916
17.2

Tryon customarily arrived at the coast of Maine each September in time to catch pollack, energetic fish carried into the river by the tides. He told Walter Copeland Bryant, who had introduced him to Ogunquit in 1906, that nowhere else could he find such wonderful sport.[1] But the sight of the sea was another attraction, and one year when the fishing was poor, Tryon fell back on painting in pastel for amusement. All through the autumn of 1915 he worked to record his observations of atmospheric conditions, and by November had produced a series of marines, "pastels of the Sea representing different hours of the day and night," which he titled "Sea Phases."[2]

The previous year, in 1914, Tryon had painted a single seascape in pastel called *Night* (cat. no. 49). Though thematically related to the pastel pictures that followed, *Night* remains technically distinct; as if to indicate its separate status, Tryon took care to note the date of execution twice, at the lower left and lower right of the picture. The resonant tonalities of the pastel set it apart from the others stylistically as well. One critic observed that between the clouds of the night sky the "deep azure of the infinite glows and palpitates like rare jewels."[3]

Night is a sort of prelude to the pastels of 1915 (cat. nos. 50–66), which constituted a more interesting collection, Tryon told Freer, than any group of pictures he had painted before.[4] Freer purchased thirteen of them at once (including *Night*), then five more the following month.[5] During the next season at Ogunquit, when Tryon was again driven indoors by a month of rainy days, he completed several more "Sea Moods," as they came to be called, to supplement the original set. "If the bad weather caused you to paint more than usual," Freer remarked, "all art lovers should be thankful, and I am sure that some at least will thank the cause."[6]

Closely related in size, color, and compo-

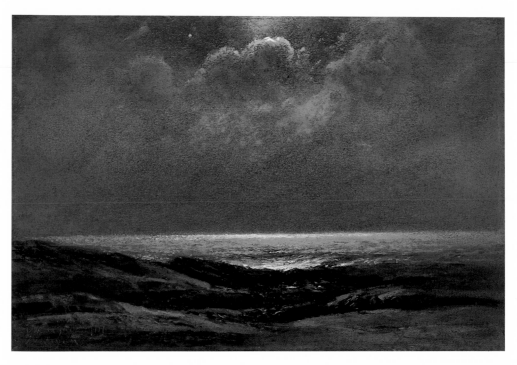

49 *Night*

sition, the "Sea Moods" are Tryon's most accomplished variations on a theme. As Tryon told Freer, they are especially impressive when viewed all together—"they seem to gain in this way as they supplement each other and show a wider scope than when seen separately."[7] Yet they are individually titled, not only to allow each pastel to stand on its own as a work of art (a few were sold separately from the series) but also to assist the viewer in observing the singularity of each element of the ensemble, of every different mood of the sea. A few of the titles name a particular time of day (*Sunrise; Afternoon; Night*) and many indicate atmospheric conditions (*A Shift of Wind from East to Northwest; Northwest Wind; A Northeaster*), a practice, as Mary Ellen Hayward has observed, that parallels Asian tradition.[8] Other titles specify subjects (*Rocks, Sea, and Sky; Drifting Clouds and Tumbling Sea; Moonlight*)

and some, such as *Early Evening: Looking East* and *After Sunset: Looking East,* suggest that the artist maintained a constant point of view while the aspect of the ocean changed with the hours.

When George Alfred Williams, the young painter from Maine who befriended Tryon and adopted him as a mentor, offered to write about the artist's work, Tryon replied that any discussion of his art would have to reckon with the Sea Moods.[9] Williams saw the series in April 1916, and found the set of twenty or more pastel paintings impossible to forget: "Each work revealed its emotional message with an emphasis balanced and true," he wrote.[10] His essay on the pastels, produced with Tryon's assistance, focused on the seascapes as the artist's crowning achievement.

The Sea Moods culminate Tryon's ten years of efforts to make pastel a "personal

method of expression." In them he found a way to fix "from the bottom up," which allowed him to build a pastel painting in layers as if he were working with oil, and use to advantage the inevitable darkening of colors caused by the fixative. Tryon's technique allowed him to make the medium respond to his feelings and at the same time express the variable temperaments of the sea.[11] Like the oil paintings, the pastels were distillations of experience: "That they came direct from the fountain head of suggestion, Nature, I can assure you," Tryon advised Williams. "I can also assure you that they went through the alembic of my mind before they were 'writ on canvas.' "[12]

Tryon himself was convinced that these pastel paintings, though small in size, were among his finest works. More than any of his other productions, he said, they excited the "enthusiasm of the right people."[13] Freer, for one, found the series "intensely interesting,"[14] a compliment Tryon was happy to convey. "The best judges of art whom I know," Tryon wrote Williams, "seem to think they touch a new and unusually high plane of thought and feeling."[15] He intended to exhibit the pastels at M. Knoedler & Co. in New York, but when Freer purchased almost the entire lot, Tryon decided instead to have a special showing at Smith College, where the exhibition was well attended and ardently praised.[16] In April 1916, Tryon continued to show the pastels to those who came to his studio especially to see them. "I never saw people so enthusiastic over my things as they are of these pictures," Tryon wrote. "If I keep on I think I may make a first class lecturer and showman."[17] But as the artist himself acknowledged, the Sea Moods required little explanation for anyone possessing sensitivity to beauty. "They seem to rouse universal enthusiasm," Tryon said, "not only among those who see but also among those who only feel."[18]

1. "What Some Famous Artists Have Said to Me," Walter Copeland Bryant's journal, Bryant Papers/AAA.

2. Tryon to George Alfred Williams, 6 February and 6 January 1916, Nelson White Papers/AAA; "Dwight W. Tryon: List of Pictures by the Artist Since 1909, with the Names of Their Owners," typescript, Forbes Library, Northampton, Massachusetts.

3. Williams 1924.

4. Tryon to Freer, 21 November 1915 (182).

5. List A, "American Paintings, Other than by Whistler," Freer Papers/FGA. Freer purchased *Afternoon Clouds* and *Rocks, Sea, and Sky: Morning—Wind NNE* (cat. nos. 67 and 68) in January 1917.

6. Tryon to Freer, 13 August 1916 (196); Freer to Tryon, 15 August 1916 (197).

7. Tryon to G. A. Williams, 13 February 1916, Nelson White Papers/AAA.

8. Hayward 1979, 124.

9. Tryon to G. A. Williams, 18 March 1916, Nelson White Papers/AAA.

10. Williams 1924.

11. Tryon to G. A. Williams, 12 November 1916, 7 October and 15 September 1916, Nelson White Papers/AAA.

12. Ibid., 11 April 1916.

13. Ibid., 6 January and 6 February 1916.

14. Freer to Alfred Vance Churchill, 6 March 1916, Churchill Papers/SC Archives.

15. Tryon to G. A. Williams, 18 March 1916, Nelson White Papers/AAA.

16. Tryon to Freer, 5 January 1916 (187), 12 January 1916 (188), and 28 February 1916 (191); Tryon to A. V. Churchill, 12 January 1916, Churchill Papers/SC Archives.

17. Tryon to Freer, 12 April 1916 (192).

18. Tryon to G. A. Williams, 13 February 1916, Nelson White Papers/AAA.

Illustrations for catalogue numbers 50–68 follow.

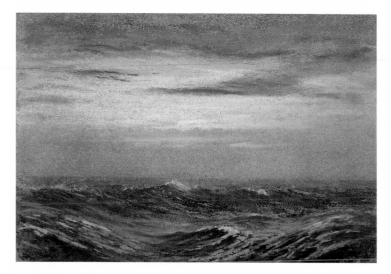

50 *The Sea: Evening*

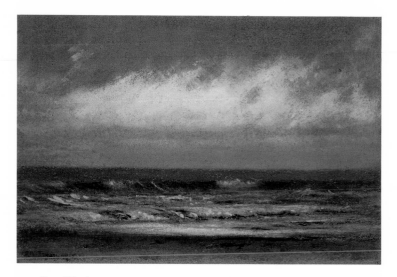

51 *East Wind*

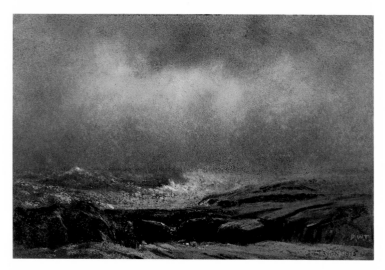

52 *A Northeaster*

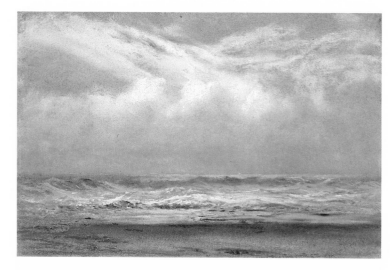

53 *A Shift of Wind from East to Northwest*

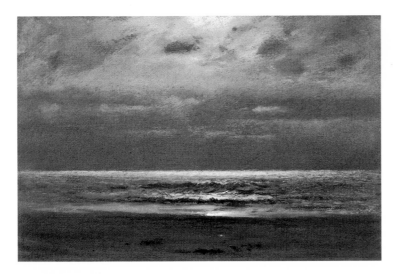

54 *The Sea: Night*

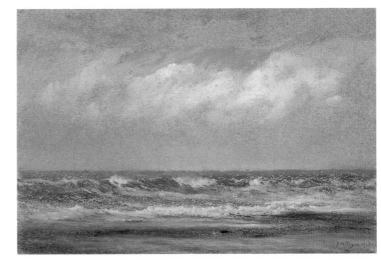

55 *Drifting Clouds and Tumbling Sea*

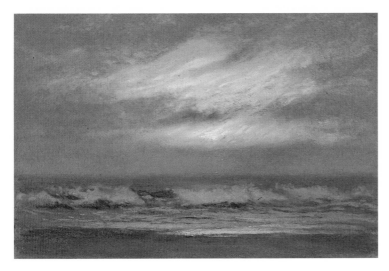

56 *Sunrise*

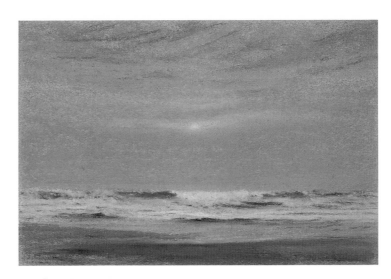

57 *Early Evening: Looking East*

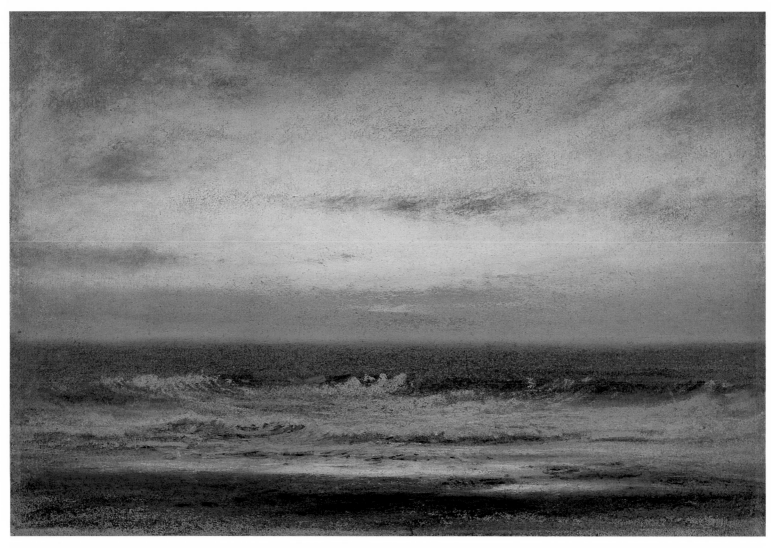

58 *After Sunset: Looking East*

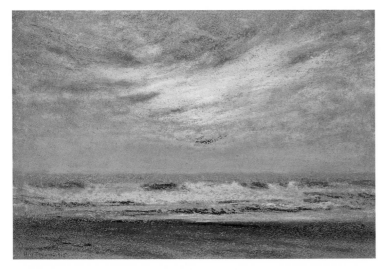

59 *Sunrise*

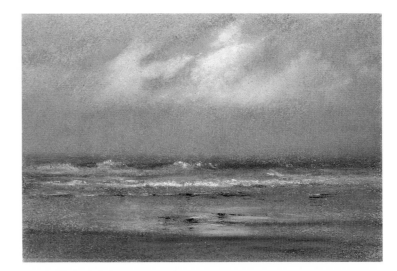

60 *Afternoon*

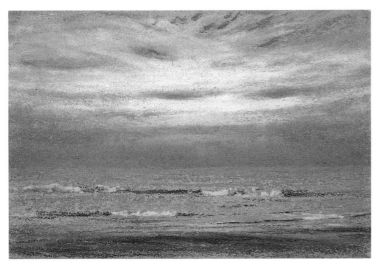

61 *Before Sunrise*

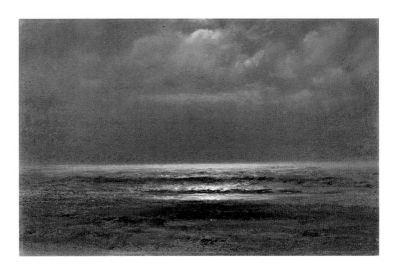

62 *Moonlit Sea*

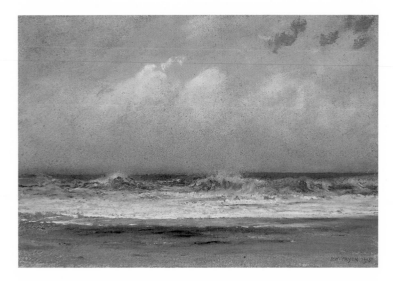

63 *Northwest Wind*

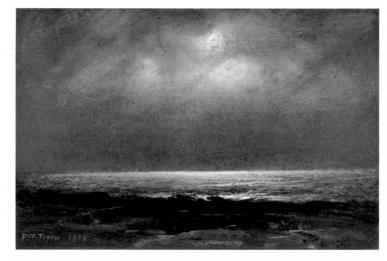

64 *Moonlight*

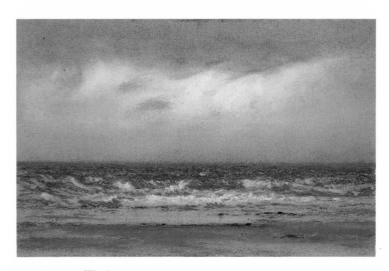

65 *Northeast Wind*

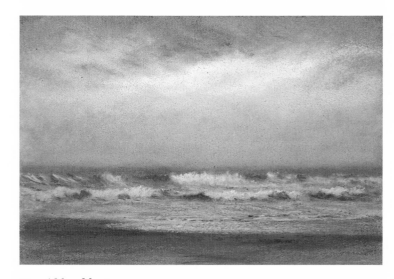

66 *A Misty Morning*

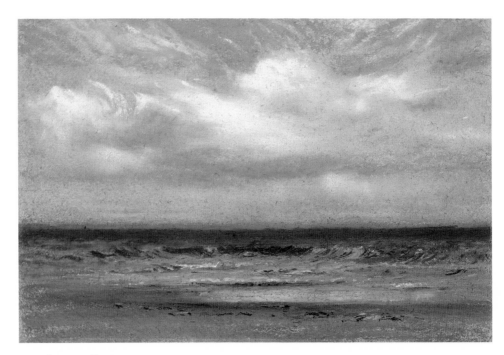

67 *Afternoon Clouds*

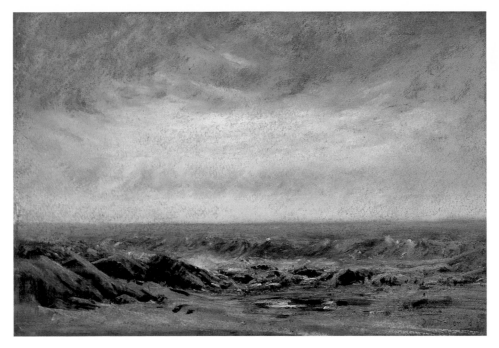

68 *Rocks, Sea, and Sky: Morning—Wind* NNE

69 *Autumn Night*

1916
Oil on wood panel
9⅞ × 13⅞ in. (25.0 × 35.6 cm)
Signed and dated, lower left:
D. W. TRYON 1916
17.3

Autumn Night came into the Freer collection at a time when Freer was applying his dwindling energies to the acquisition of ancient Chinese art, and Tryon expressed the hope that his modest painting would hold its own among "its brothers from over the sea, created before Columbus set sail."[1] Following the extended production of the "Sea Moods" series in pastel (cat. nos. 50–66), Tryon had returned to oil painting eager to exploit the advantages of the medium. "I am again at work in oils," Tryon wrote his friend George Alfred Williams, "and it seems like beginning again."[2]

The color tones of *Autumn Night* are richer than pastel pigments could be, and the painting's surface is so dense with oil glazes that it had to dry for several weeks before Tryon could apply a final varnish.[3] Rich layers of paint create an artistic effect impossible in pastel, but the intimacy of the scene, which recalls the spirit of the Sea Moods, encourages contemplation. Indeed, *Autumn Night* is only slightly larger than Tryon's pastels on paper. Convinced that there was a reason the poems and music he liked best were never very long, Tryon experimented with oil paintings on a scale that allowed him to work quickly and observe the ways in which colors in close contact reacted with one another. "The more I paint," he said, "the more I believe in small surfaces and finer qualities."[4]

1. Tryon to Freer, n.d. [ca. 8 January 1917] (200).

2. Tryon to G. A. Williams, 9 February 1916, Nelson White Papers/AAA.

3. Tryon to Freer, 11 December 1916 (199).

4. Tryon to G. A. Williams, 8 February 1923 an 4 February 1921, Nelson White Papers/AAA.

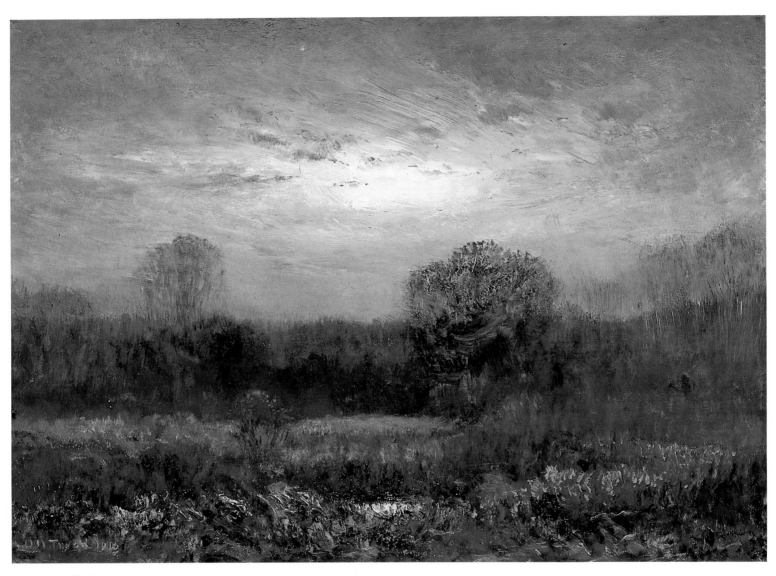

69 *Autumn Night*

70 *Evening: Late October*

1916
Oil on wood panel
28¾ × 42 in. (73.2 × 106.6 cm)
Signed and dated, lower left:
D. W. TRYON 1916
16.354

71 *Autumn: New England*

1916–17
Oil on wood panel
20 × 30 in. (50.9 × 76.3 cm)
Signed and dated, lower right:
D. W. TRYON 1916–7
17.201

Perhaps because the fall of 1916 in New England had been a "record-breaker for beauty," the oil paintings Tryon produced during the winters of 1916 and 1917 show the autumn landscape with unaccustomed clarity, as if the memory of the season had been italicized in the artist's mind.[1] The first to be completed, *Evening: Late October*, emphasizes the strident colors of autumn. High-intensity, hard-edged shades of blue, green, and yellow create an almost surrealistic effect, especially beside the soft, muted tones of earlier compositions. Tryon worked on this painting (which he called "Autumn Twilight"; Freer gave it the present title to distinguish it from a painting of the same name already in his collection) over the course of four years, completing it just before his annual escape to the country in mid-April 1916. "I feel it strikes a deeper

chord than anything of the kind I have painted," Tryon wrote Freer, "and I have been much gratified that all who have seen it seem so much impressed."[2] In comparison with his earlier, more subtle autumn scenes, the chord Tryon strikes in *Evening: Late October* seems, however, sadly out of tune; it compels attention but fails to satisfy the senses.

A second autumn landscape occupied Tryon through nearly three seasons of work, and from February until April 1917, Tryon struggled to finish *Autumn: New England*. When it was finally complete he declared it to be one of his three most important paintings.[3] In many ways the work is typical of Tryon: the panel measures twenty by thirty inches, his favorite size, and the row of trees bordering a meadow is familiar from countless other landscapes. But this

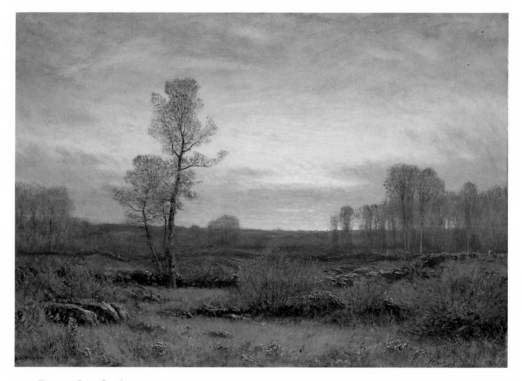

70 *Evening: Late October*

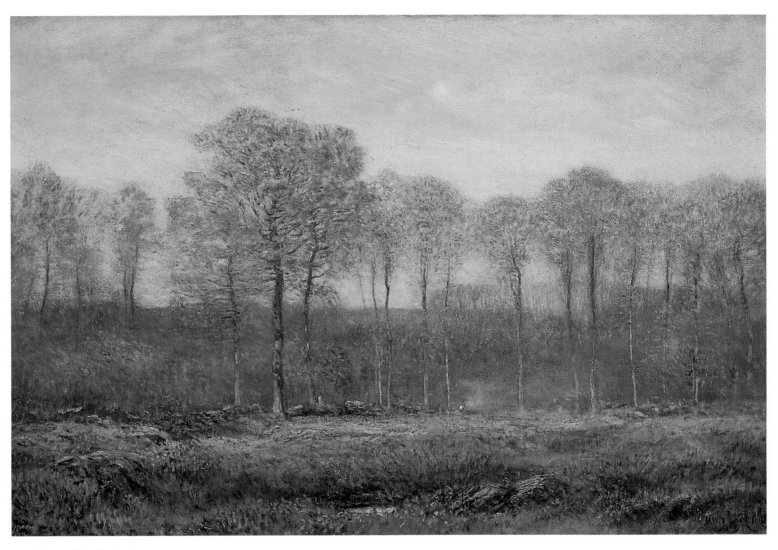

71 *Autumn: New England*

vibrant painting with colors translucent as stained glass celebrates the extravagant beauty of a New England autumn in a way Tryon's characteristic meadows veiled in mists or moonlight cannot. A wisp of smoke from a fire in the middle distance, a touch of human interest the artist customarily avoids, evokes the scent of burning leaves.

These uncommonly conservative works mark Tryon's temporary return to traditional American landscape painting forty years after he left for Europe in search of a style remote from the Hudson River school. Painted on the eve of America's entry into the First World War, *Autumn: New England* and *Evening: Late October* may have been inspired by a patriotic spirit.

1. Tryon to George Alfred Williams, 12 November 1916, Nelson White Papers/AAA.

2. Tryon to Freer, 12 April 1916 (192).

3. Tryon to G. A. Williams, 16 April 1917, Nelson White Papers/AAA.

72 *Portrait of Himself*

1918
Oil on heavy cardboard
11⅞ × 9⅝ in. (30.0 × 24.7 cm)
Signed and dated, lower right:
D. W. TRYON 1918 AET 68
17.410

Some months after Tryon's retirement from the faculty of Smith College in 1923, Alfred Vance Churchill, who was then director of the art museum at Smith, asked for permission to reproduce the artist's self-portrait (fig. 96) in a special issue of the museum bulletin dedicated to Tryon's career at the college. "I think it is a great thing to show our students and the great public that art is after only one thing," Churchill wrote Tryon, "that the man who can paint the way you can, can paint a portrait if he wants to and could paint a cow or a 'harmless necessary cat' if he wanted to."[1] Tryon, however, always contended that portraiture was not art. In reply to Churchill's request, he submitted a photograph of himself, arguing that he would not be recognized from a self-portrait painted more than thirty years before.[2]

But Tryon could not refuse Freer's request for a self-portrait to hang with the permanent collection in Washington, and during the winter of 1918 dutifully prepared two. "I wish they were better," he wrote Freer, "but my need of wearing glasses to paint makes it difficult for me to work in a mirror from myself. I have the feeling that I could do much better had I [a] sitter I cared more to paint."[3] Not knowing which was best (or "worst," he said), Tryon decided to leave the choice to Freer, who was gravely ill when presented with two works for inspection in March 1919.[4] The self-portrait he selected, the last painting by Tryon to enter the Freer collection, was the gift of the artist. Freer wrote in gratitude that he counted the painting among his many blessings. Together with other recent accessions to the collections, he said, Tryon's self-portrait promised to serve "future students and lovers of beauty."[5]

1. A. V. Churchill to Tryon, 8 January 1924, carbon copy, Churchill Papers/SC Archives.

2. "What Some Famous Artists Have Said to

Me," Walter Copeland Bryant's journal, Bryant Papers/AAA; Tryon to A. V. Churchill, 9 January 1924, Churchill Papers/SC Archives. The photograph (unattributed, but probably by Theodosia Chase) appeared in the *Smith Alumnae Quarterly* (November 1925): 8, and is reproduced in White 1930, opposite p. 110.

3. Tryon to Freer, 26 February 1919 (201).

4. Ibid., 7 August 1918 (209); Freer to Tryon, 7 March 1919 (211).

5. Freer to Tryon, 28 August 1918, Nelson White Papers/AAA. The alternative portrait seems to have disappeared; presumably, Tryon destroyed it himself.

Fig. 96 *Self-Portrait* (verso of *Fishing*, fig. 31), 1891. Oil on canvas, 22 × 17¾ in. (55.9 × 45.1 cm). Smith College Museum of Art (1891:3–1).

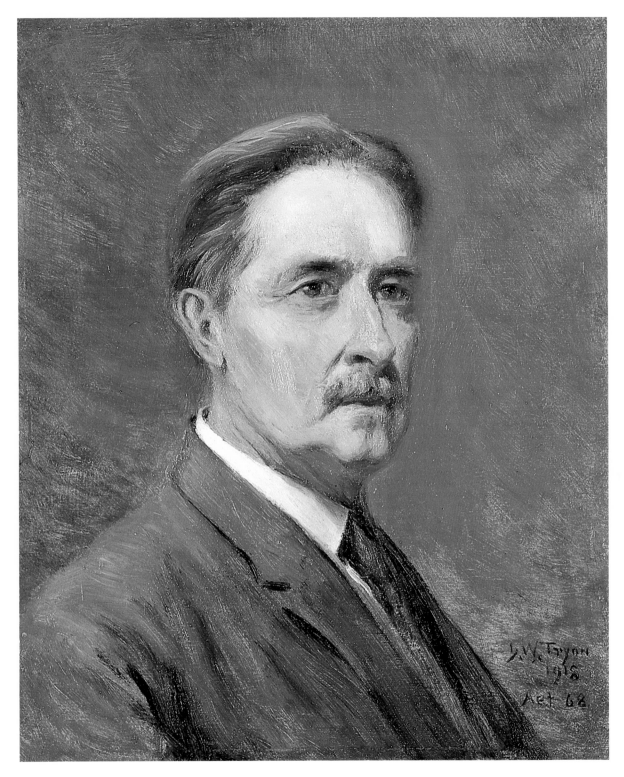

72 *Portrait of Himself*

HISTORY

ACQUISITION All of the American works in the Freer Gallery of Art were purchased by Charles Lang Freer. Exact dates of purchase, based on extant vouchers and correspondence in the Freer Papers/FGA, are provided whenever possible; in some cases supporting documents have not survived and the date given for acquisition is the one noted in List A, "American Paintings, Other than by Whistler, Acquired since Making-Up Smithsonian Inventory, May 1906," or List A2, "Oil Paintings and Watercolors, D. W. Tryon," Freer Papers/FGA.

EXHIBITION Since Charles Freer's death in 1919 and the subsequent transfer of his collection to the Smithsonian Institution, no works from the collection have ever been exhibited outside the Freer Gallery, in accordance with Freer's will. The exhibition history cites all occasions of a painting's exhibition before 1919. Full titles and dates, when known, are given in Exhibitions (pp. 186–87).

PUBLICATION Full references can be found in the Selected Bibliography (pp. 188–91). Reproductions are indicated (r), followed by a page number if different from the text reference. The publication history includes only major published sources that make specific mention of a work in the Freer collection, and omits archival materials and contemporary reviews (which often appear in notes to catalogue entries), theses, and dissertations; exhibition catalogues are cited only when a work of art is reproduced in their pages, or when they offer descriptive or critical analysis. General sources relevant to Tryon's career are included in the Selected Bibliography.

1 *A Lighted Village,* ca. 1887 06.74
ACQUISITION: Purchased from the American Art Association (Thomas B. Clarke collection), no. 52, February 1899.
EXHIBITION: 1893 Chicago, no. 991, as "Night" (lent by Thomas B. Clarke); 1900 New York, no. 6.
PUBLICATION: Caffin 1909, 71; Britannica 1973, 570.

2 *Moonlight,* 1887 91.2
ACQUISITION: Purchased from the American Art Association (George I. Seney collection), no. 115, 17 February 1891.
EXHIBITION: 1887 New York, no. 214, as "Night" (Medal of Honor); 1891 New York, no. 115; 1900 New York, no. 10, as "Night"; 1903 New York, as "Night."
PUBLICATION: Caffin 1909, 71; Burke 1980, 108.

3 *The Rising Moon:*
 Autumn, 1889 89.31
ACQUISITION: Purchased from Tryon, May 1889.
EXHIBITION: 1889 Chicago, no. 417, as "The Rising Moon—Autumn" (Potter Palmer Prize); 1892 Munich (Gold Medal); 1893 Chicago, no. 987 (Gold Medal); 1893 Philadelphia, no. 34; 1896 Pittsburgh, no. 275; 1899 New York Montross; 1900 New York, no. 8.
PUBLICATION: Caffin 1909, 71; Caffin 1913, 166; White 1930, 77–78; Jackman 1940, 177 (r/180); Saarinen 1958, 123; Freer Gallery of Art 1967 (r/plate 15); Hobbs 1977, 84 (r/82); Hayward 1979, 118 (r/119); Clark 1979, 55 (r); Burke 1980, 108; Gerdts, Sweet, and Preato 1982, 44; Curry 1983, 176 (r/179); Curry 1984, 32 (r).

4 *The Sea: Sunset,* 1889 06.76
ACQUISITION: Purchased from Tryon, 18 February 1890.
EXHIBITION: 1890 New York, no. 181, as "Sunset"; 1890 Chicago, no. 308, as "Sunset at Sea"; 1893 Chicago, no. 986, as "Sunset at Sea"; 1900 New York, no. 2.
PUBLICATION: Caffin 1909, 71; Clark 1979, 56–58 (r); Gerdts, Sweet, and Preato 1982, 44 (r/40).

5 *Winter: Central Park,* 1890 00.12
ACQUISITION: Purchased from the American Water Color Society, New York, 24 February 1891, as "Early Snow."
EXHIBITION: 1900 New York, no. 11.
PUBLICATION: Caffin 1909, 71.

6 *The Sea: Night,* 1892 06.84
ACQUISITION: Purchased from Tryon, 12 April 1893.
EXHIBITION: 1900 New York, no. 3; 1915 San Francisco, no. 2395, as "Night: The Sea."
PUBLICATION: Mechlin 1907, 367; Caffin 1909, 71; Hayward 1979, 121 (r/122); Brunk 1981 (r/16).

7 *The Sea: Morning,* 1892 06.85
ACQUISITION: Purchased from Tryon, 12 April 1893.
EXHIBITION: 1900 New York, no. 4; 1907 New York.
PUBLICATION: Mechlin 1907, 367; Caffin 1909, 71; Brunk 1981 (r/16).

8 *Springtime,* 1892 93.14
ACQUISITION: Purchased from Tryon, 12 April 1893.
EXHIBITION: 1893 Chicago, no. 988; 1894 Northampton, Mass.; 1896 New York, no. 126, as "Spring—one of a series of decorations for a Hall"; 1896 Philadelphia, no. 314.
PUBLICATION: Hartmann 1902, (r/131, as "Spring"); Caffin 1909, 71; Caffin 1913 (r/160, as "Spring Blossoms"); White 1930, 82; Hobbs 1977, 84; Hayward 1979, 120–21 (r); Brunk 1981 (r/14); Detroit 1983, 224; Curry 1984, 24 (r).

9 *Summer,* 1892 93.15
ACQUISITION: Purchased from Tryon, 12 April 1893.
EXHIBITION: 1898 Philadelphia, no. 435.
PUBLICATION: Caffin 1909, 71; Hobbs 1977, 84; Brunk 1981 (r/15).

10 *Autumn,* 1892 93.16
ACQUISITION: Purchased from Tryon, 12 April 1893.
EXHIBITION: 1893 Chicago, no. 985.
PUBLICATION: Caffin 1909, 71; Hobbs 1977, 84; Brunk 1981 (r/15); Detroit 1983, 224.

11 *Winter,* 1893 93.17
ACQUISITION: Purchased from Tryon, 12 April 1893.
EXHIBITION: 1893 New York, no. 187; 1903 New York, as "Evening—Winter."
PUBLICATION: Caffin 1909, 71; White 1930, 82; Hobbs 1977, 84; Brunk 1981 (r/18); Curry 1983, 171 (r/173).

12 *Dawn,* 1893 06.86
ACQUISITION: Purchased from Tryon, 12 April 1893.
EXHIBITION: 1901 Philadelphia, no. 99, as "Dawn; Decoration for a Hall"; 1903 New York; 1907 New York.
PUBLICATION: Caffin 1909, 71; White 1930, 82–83; Brunk 1981 (r/18).

13 *Twilight: Early Spring,* 1893 93.12
ACQUISITION: Purchased from N. E. Montross, New York, 7 April 1893, as "Springtime, Evening."
EXHIBITION: 1900 New York, no. 5; 1901 Buffalo, no. 651, as "Evening, April"; 1910 New York, no. 7.
PUBLICATION: Caffin 1909, 71 (r/56); Britannica 1973, 570; Hobbs 1977, 84 (r/82); Hayward 1979, 121 and 123 (r); Burke 1980, 111; Cikovsky and Quick 1985, 59 (r/62).

14 *Central Park:*
 Moonlight, 1894 06.87
ACQUISITION: Purchased from Tryon, April 1894.
EXHIBITION: 1904 St. Louis, no. 1292d; 1912 Kansas City.
PUBLICATION: Caffin 1909, 72.

15 *Winter: Connecticut*
 Valley, 1894 06.88
ACQUISITION: Purchased from Tryon, April 1894.
EXHIBITION: 1904 St. Louis, no. 1292c; 1912 Kansas City.
PUBLICATION: Caffin 1909, 72.

16 *Late Spring,* 1894 06.89
ACQUISITION: Purchased from Tryon, April 1894.
EXHIBITION: 1904 St. Louis, no. 1292e.
PUBLICATION: Caffin 1909, 72; Clark 1979 (r/61).

17 *Night: A Landscape,* 1894 06.90
ACQUISITION: Purchased from Tryon, 13 September 1894.
EXHIBITION: 1904 St. Louis, no. 1292j.
PUBLICATION: Caffin 1909, 72; Clark 1979 (r/61).

18 *Night: A Harbor,* 1894 06.92
ACQUISITION: Purchased from N. E. Montross, 12 December 1895.
EXHIBITION: 1900 New York, no. 9; 1904 St. Louis, no. 1292l.
PUBLICATION: Caffin 1909, 72.

19 *Pasture Lands:*
 Early Spring, 1896 00.11
ACQUISITION: Purchased from Tryon, 5 February 1900, as "Pasture Lands—April."
EXHIBITION: 1900 New York, no. 12; 1912 Kansas City.
PUBLICATION: Caffin 1909, 71.

20 *Early Spring in*
 New England, 1897 06.77
ACQUISITION: Purchased from Tryon, 7 July 1897.
EXHIBITION: 1897 Buffalo; 1898 Pittsburgh, no. 60 (Medal of the First Class); 1899 New York/SAA, no. 316; 1899 Philadelphia, no. 62; 1899 Cincinnati, no. 1; 1901 Buffalo, no. 650, as "Early Spring, New England"; 1913 New York Montross, no. 16, as "Springtime."
PUBLICATION: Carnegie Institute 1898 (r/plate 22); Caffin 1902, 164–65 (r/160), as "Early Spring, New England"; Caffin 1909, 28–35 and 71 (r/frontispiece), as "Springtime"; Caffin 1913, 164–66 (r/161), as "Early Spring, New England"; White 1930, 162–65 (r); Eliot 1957, 155 (r/156), as "Springtime"; Brunk 1981 (r/26).

21 *Sunrise: April,* 1897–99 06.79
ACQUISITION: Purchased from Tryon, April 1899.
EXHIBITION: 1900 New York, no. 7; 1901 Buffalo, no. 649, as "Sunrise."
PUBLICATION: Caffin 1909, 71; Caffin 1913, 166, as "Sunrise."

22 *Daybreak: May,* 1897–98 06.78
ACQUISITION: Purchased from Tryon, 27 March 1898.
EXHIBITION: 1900 New York, no. 1, as "Daybreak"; 1901 Buffalo, no. 653, as "Daybreak"; 1904 New York, no. 161; 1905 Buffalo, no. 160; 1910 Buffalo, no. 225; 1910 New York, no. 6.
PUBLICATION: Caffin 1909, 71 (r/44); Buffalo 1910, 61 (r); Buffalo Academy Notes 1910, 8 (r); Hayward 1979, 123; Curry 1983, 172.

23 *Niagara Falls,* 1898 06.91
ACQUISITION: Gift from Tryon, February 1898.
EXHIBITION: 1904 St. Louis, no. 1292g; 1912 Kansas City.
PUBLICATION: Caffin 1909, 71.

24 *New England Hills,* 1901 06.80
ACQUISITION: Purchased from N. E. Montross, 19 August 1901.
EXHIBITION: 1903 New York; 1904 New York, no. 163; 1906 Philadelphia, no. 432.
PUBLICATION: Caffin 1909, 71.

25 *Twilight: May,* 1904 06.81
ACQUISITION: Purchased from N. E. Montross, 2 April 1904, as "The Big Trees."
EXHIBITION: 1906 Philadelphia, no. 431; 1910 Berlin and Munich, as "Maiabend."
PUBLICATION: Mechlin 1907 (r/370); Caffin 1909, 71; White 1930 (r/supplementary plates); Country Beautiful Foundation 1965 (r/51).

26 *Early Night,* 1903 06.93
ACQUISITION: Probably purchased from N. E. Montross, 24 March 1905, as "Night."
EXHIBITION: 1912 Kansas City; 1912 Washington, D.C./Smithsonian, no. 33; 1915 San Francisco, no. 2392.
PUBLICATION: Caffin 1909, 72.

27 *November Afternoon,* 1905 05.289
ACQUISITION: Purchased from Tryon, 8 December 1905.
EXHIBITION: 1912 Kansas City; 1915 Minneapolis, no. 299.
PUBLICATION: Caffin 1909, 72.

28 *The Evening Star,* 1905 06.82
ACQUISITION: Purchased from N. E. Montross, 24 March 1905, as "Twilight—The Lake."
EXHIBITION: 1905 Buffalo, no. 156; 1906 Philadelphia, no. 433; 1908 New York; 1909 Columbia, Mo.
PUBLICATION: Caffin 1909, 71.

29 *Morning,* 1906 06.83
ACQUISITION: Purchased from Tryon, 14 February 1906.
EXHIBITION: 1915 Minneapolis, no. 296.
PUBLICATION: Caffin 1909, 71.

30 *The Sea: Moonlight*, 1905 06.94
ACQUISITION: Purchased from N. E. Montross, 24 March 1905.
EXHIBITION: 1912 Kansas City; 1912 Washington, D.C./Smithsonian, no. 34; 1915 Minneapolis, no. 293.
PUBLICATION: Caffin 1909, 72.

31 *The Sea: East Wind*, 1906 06.264
ACQUISITION: Purchased from Tryon, 17 November 1906.
EXHIBITION: 1907 New York; 1909 Columbia, Mo.; 1912 Kansas City; 1915 San Francisco, no. 2396.
PUBLICATION: Caffin 1909, 72.

32 *The Sea: A Freshening Breeze*, 1906 06.265
ACQUISITION: Purchased from Tryon, 17 November 1906.
EXHIBITION: 1907 New York; 1912 Kansas City; 1915 San Francisco, no. 2403.
PUBLICATION: Caffin 1909, 72; Curry 1983 (r/173).

33 *The Sea: Evening*, 1907 07.151
ACQUISITION: Purchased from Tryon, 3 August 1907.
EXHIBITION: 1908 Washington, D.C., no. 144; 1908 New York; 1910 New York, no. 10; 1912 Washington, D.C./Smithsonian, no. 31.
PUBLICATION: Caffin 1909, 71; White 1930, 168–69 (r/supplementary plates), as "Twilight Seas"; Hobbs 1977, 84–86 (r/82); Clark 1979, 66 (r); Hayward 1979, 124–25 (r); Czestockowski 1982, 134 (r); Sutton 1983, 119 (r/121).

34 *Easterly Storm*, 1907 08.1
ACQUISITION: Purchased from Tryon, 8 January 1908.
EXHIBITION: 1912 Kansas City; 1915 Minneapolis, no. 294.
PUBLICATION: Caffin 1909, 72.

35 *Autumn Day*, 1907–09 09.2
ACQUISITION: Purchased from Tryon, 15 January 1909.
EXHIBITION: 1910 New York, no. 8; 1912 Washington, D.C./Smithsonian, no. 30.
PUBLICATION: Caffin 1909, 71.

36 *October*, 1908 08.22
ACQUISITION: Purchased from Tryon, 6 April 1908.
EXHIBITION: 1908 Washington, D.C., no. 92; 1909 New York; 1910 New York, no. 9; 1912 Toledo, no. 93.
PUBLICATION: Caffin 1909, 71.

37 *April Morning*, 1908 08.16
ACQUISITION: Purchased from Tryon, 19 March 1908, as "April, Morning."
EXHIBITION: 1908 New York, as "Dawn, April"; 1915 Minneapolis, no. 297, as "April."
PUBLICATION: Caffin 1909, 71.

38 *An Autumn Evening*, 1908 13.33
ACQUISITION: Tryon to N. E. Montross to William T. Evans; purchased from the American Art Association (William T. Evans collection), no. 113, 2 April 1913.
EXHIBITION: 1913 New York/Am. Art Assoc., no. 113.
PUBLICATION: Caffin 1909, 56; American Art Association 1913, no. 113 (r); Truettner 1971, 78.

39 *Autumn Morning*, 1908–09 10.4
ACQUISITION: Purchased from Tryon, 21 January 1910.
EXHIBITION: 1909 New York; 1909 Buffalo, no. 166; 1909 St. Louis, no. 166; 1910 New York, no. 11; 1910 Ann Arbor, no. 66; 1912 Washington, D.C./Smithsonian, no. 32; 1913 New York/Montross, no. 14 as "Autumn—Morning"; 1915 San Francisco, no. 2397.
PUBLICATION: Buffalo 1909 (r/59); St. Louis 1909 (r/59); Michigan 1910 (r).

40 *Night,* 1909 09.39
ACQUISITION: Purchased from N. E. Montross, 19 February 1909.
EXHIBITION: 1909 New York; 1910 Philadelphia, no. 453; 1910 Pittsburgh, no. 279; 1913 New York/Montross, no. 15.
PUBLICATION: Caffin 1909, 71.

41 *Twilight: Autumn*, 1909–10 10.11
ACQUISITION: Purchased from Tryon, 21 March 1910.
EXHIBITION: 1910 Ann Arbor, no. 67; 1910 New York, no. 12, as "Autumn—Twilight"; 1915 San Francisco, no. 2390.

42 *Evening: September*, 1912 12.7
ACQUISITION: Purchased from Tryon, 2 March 1912.
EXHIBITION: 1912 Washington, D.C./Corcoran, no. 182; 1915 San Francisco, no. 2398.

43 *Twilight: November*, 1912 12.14
ACQUISITION: Purchased from Tryon, 14 May 1912.
PUBLICATION: Sherman 1918, 38 (r/32); Sherman 1919, 17 (r/18).

44 *Night: The Sea*, 1912 12.15
ACQUISITION: Purchased from Tryon, 14 May 1912.
EXHIBITION: 1915 San Francisco, no. 2395.

45 *Moonlight*, 1912 13.7
ACQUISITION: Purchased from Tryon, 27 January 1913.
EXHIBITION: 1915 San Francisco, no. 2400.

46 *Sunset before Storm*, 1913 14.11
ACQUISITION: Purchased from Tryon, 24 January 1914.
EXHIBITION: 1915 San Francisco, no. 2393.

47 *Autumn Evening,* 1913 14.12
ACQUISITION: Purchased from Tryon, 24 January 1914.
EXHIBITION: 1915 Minneapolis, no. 298.

48 *Morning Mist,* 1914 14.32
ACQUISITION: Purchased from Tryon, March 1914.
EXHIBITION: 1915 Minneapolis, no. 295.
PUBLICATION: Clark 1979, 63 (r).

49 *Night,* 1914 14.98
ACQUISITION: Purchased from Tryon, December 1915.
EXHIBITION: 1916 Northampton, Mass.

50 *The Sea: Evening,* 1915 15.123
ACQUISITION: Purchased from Tryon, December 1915.
EXHIBITION: 1916 Northampton, Mass.
PUBLICATION: White 1930, 167.

51 *East Wind,* 1915 15.124
ACQUISITION: Purchased from Tryon, December 1915.
EXHIBITION: 1916 Northampton, Mass.
PUBLICATION: White 1930, 167.

52 *A Northeaster,* 1915 15.125
ACQUISITION: Purchased from Tryon, December 1915.
EXHIBITION: 1916 Northampton, Mass.
PUBLICATION: White 1930, 167; Freer Gallery of Art 1967 (r/plate 16).

53 *A Shift of Wind from East to Northwest,* 1915 15.126
ACQUISITION: Purchased from Tryon, December 1915.
EXHIBITION: 1916 Northampton, Mass.
PUBLICATION: White 1930, 167.

54 *The Sea: Night,* 1915 15.127
ACQUISITION: Purchased from Tryon, December 1915.
EXHIBITION: 1916 Northampton, Mass.
PUBLICATION: White 1930, 167.

55 *Drifting Clouds and Tumbling Sea,* 1915 15.128
ACQUISITION: Purchased from Tryon, December 1915.
EXHIBITION: 1916 Northampton, Mass.
PUBLICATION: White 1930, 167 and 189; Hayward 1979, 124.

56 *Sunrise,* 1915 15.129
ACQUISITION: Purchased from Tryon, December 1915.
EXHIBITION: 1916 Northampton, Mass.

57 *Early Evening: Looking East,* 1915 15.130
ACQUISITION: Purchased from Tryon, December 1915.
EXHIBITION: 1916 Northampton, Mass.

58 *After Sunset: Looking East,* 1915 15.131
ACQUISITION: Purchased from Tryon, December 1915.
EXHIBITION: 1916 Northampton, Mass.
PUBLICATION: White 1930, 167.

59 *Sunrise,* 1915 15.132
ACQUISITION: Purchased from Tryon, December 1915.
EXHIBITION: 1916 Northampton, Mass.

60 *Afternoon,* 1915 15.133
ACQUISITION: Purchased from Tryon, December 1915.
EXHIBITION: 1916 Northampton, Mass.
PUBLICATION: White 1930, 167.

61 *Before Sunrise,* 1915 15.134
ACQUISITION: Purchased from Tryon, December 1915.
EXHIBITION: 1916 Northampton, Mass.
PUBLICATION: White 1930, 167.

62 *Moonlit Sea,* 1915 16.121
ACQUISITION: Purchased from Tryon, 13 January 1916.
EXHIBITION: 1916 Northampton, Mass.
PUBLICATION: White 1930, 167; Hayward 1979, 124.

63 *Northwest Wind,* 1915 16.122
ACQUISITION: Purchased from Tryon, 13 January 1916.
EXHIBITION: 1916 Northampton, Mass.
PUBLICATION: White 1930, 167, as "Northwest Wind Making Up"; Hayward 1979, 124, as "Northwest Wind Making Up."

64 *Moonlight,* 1915 16.123
ACQUISITION: Purchased from Tryon, 13 January 1916.
EXHIBITION: 1916 Northampton, Mass.
PUBLICATION: White 1930, 167.

65 *Northeast Wind,* 1915 16.124
ACQUISITION: Purchased from Tryon, 13 January 1916.
EXHIBITION: 1916 Northampton, Mass.
PUBLICATION: White 1930, 167, as "A Light Northeast Wind."

66 *A Misty Morning,* 1915 16.125
ACQUISITION: Purchased from Tryon, 13 January 1916.
EXHIBITION: 1916 Northampton, Mass.
PUBLICATION: White 1930, 167.

67 *Afternoon Clouds,* 1916 17.1
ACQUISITION: Purchased from Tryon, 8 January 1917.

68 *Rocks, Sea, and Sky: Morning—*
Wind NNE, 1916 17.2
ACQUISITION: Purchased from Tryon, 8 January 1917.

69 *Autumn Night,* 1916 17.3
ACQUISITION: Purchased from Tryon, 8 January 1917.

70 *Evening: Late October,* 1916 16.354
ACQUISITION: Purchased from Tryon, 24 April 1916.

71 *Autumn: New England*
1916–17 17.201
ACQUISITION: Purchased from Tryon, April 1917.

72 *Portrait of Himself,* 1918 17.410
ACQUISITION: Gift of the artist, August 1918.

EXHIBITIONS

1887 NEW YORK American Art Association. Third Prize Fund Exhibition. April.

1889 CHICAGO Art Institute of Chicago. Inter-State Industrial Exposition, Seventeenth Annual Exhibition. September 4 to October 19.

1890 NEW YORK Society of American Artists. Twelfth Exhibition at the Fifth Avenue Art Galleries. April 28 to May 24.

1890 CHICAGO Art Institute of Chicago. Inter-State Industrial Exposition, Eighteenth Annual Exhibition. September 3 to October 18.

1891 NEW YORK American Art Galleries. "Mr. George I. Seney's Important Collection of Modern Paintings." January 28 to February 13.

1892 MUNICH VI Internationale Kunst—Ausstellung (Sixth International Art Exposition). June 1 to October 31.

1893 NEW YORK Society of American Artists. Fifteenth Annual Exhibition at the Galleries of the American Fine Arts Society. April 17 to May 13.

1893 CHICAGO World's Columbian Exposition, Department of Fine Arts. May 1 to October 26.

1893 PHILADELPHIA The Pennsylvania Academy of the Fine Arts. The Sixty-Third Annual Exhibition. December 18, 1893, to February 24, 1894.

1894 NORTHAMPTON, MASS. Hillyer Art Gallery, Smith College. April.

1896 NEW YORK Society of American Artists. Eighteenth Annual Exhibition at the Galleries of the American Fine Arts Society. March 28 to May 2.

1896 PITTSBURGH Carnegie Art Galleries, Carnegie Institute. The First Annual Exhibition. November 5, 1896, to January 1, 1897.

1896 PHILADELPHIA The Pennsylvania Academy of the Fine Arts. The Sixty-Sixth Annual Exhibition. December 21, 1896, to February 22, 1897.

1897 BUFFALO The Buffalo Fine Arts Academy. May.

1898 PHILADELPHIA The Pennsylvania Academy of the Fine Arts. The Sixty-Seventh Annual Exhibition. January 10 to February 22.

1898 PITTSBURGH Carnegie Art Galleries, Carnegie Institute. The Third Annual Exhibition. November 3, 1898, to January 1, 1899.

1899 NEW YORK/MONTROSS Montross Gallery (1380 Broadway). Inaugural exhibition. January.

1899 PHILADELPHIA The Pennsylvania Academy of the Fine Arts. The Sixty-Eighth Annual Exhibition. January 16 to February 25.

1899 NEW YORK/SAA Society of American Artists. Twenty-First Annual Exhibition at the Galleries of the American Fine Arts Society. March 25 to April 29.

1899 CINCINNATI Cincinnati Museum Association, Cincinnati Art Museum. Sixth Annual Exhibition of American Art. May 20 to July 10.

1900 NEW YORK Montross Gallery (372 Fifth Avenue). "Loan Exhibition of Paintings by D. W. Tryon." February 1 to 22.

1901 PHILADELPHIA The Pennsylvania Academy of the Fine Arts. The Seventieth Annual Exhibition. January 14 to February 23.

1901 BUFFALO Pan-American Exposition, Division of Fine Arts. May 1 to November 1.

1903 NEW YORK Montross Gallery (372 Fifth Avenue). "Paintings by D. W. Tryon." March.

1904 NEW YORK Society of Art Collectors. "Comparative Exhibition of Native and Foreign Art at the Galleries of the American Fine Arts Society." November 15 to December 11.

1904 ST. LOUIS Louisiana Purchase Exposition (World's Fair), Department of Art, United States Section. Pastels and watercolors by Whistler, Dewing, and Tryon. April 30 to December 1.

1905 BUFFALO The Buffalo Fine Arts Academy, Albright Art Gallery. The Inaugural Loan Collection of Paintings. May 31 to July 1.

1906 PHILADELPHIA The Pennsylvania Academy of the Fine Arts. The 101st Annual Exhibition. January 22 to March 3.

1907 NEW YORK Montross Gallery (372 Fifth Avenue). "Exhibition of Paintings by T. W. Dewing and D. W. Tryon." February 20 to March 9.

1908 NEW YORK Montross Gallery (372 Fifth Avenue). "Pictures by T. W. Dewing and D. W. Tryon." February 18 to 29.

1908 WASHINGTON, D.C. The Corcoran Gallery of Art. "Second Exhibition of Oil Paintings by Contemporary American Artists." December 8, 1908, to January 17, 1909.

1909 COLUMBIA, MO. University of Missouri. Art Lovers' Guild of Columbia, Missouri. February 1 to March 1.

1909 NEW YORK Montross Gallery (372 Fifth Avenue). "Exhibition of Paintings by D. W. Tryon and T. W. Dewing." February 1 to March 1.

1909 BUFFALO The Buffalo Fine Arts Academy, Albright Art Gallery. The Fourth Annual Exhibition of Selected Paintings by American Artists. May 10 to August 30.

1909 ST. LOUIS The City Art Museum of St. Louis. The Fourth Annual Exhibition of Selected Paintings by American Artists. Opened September 12.

1910 PHILADELPHIA The Pennsylvania Academy of the Fine Arts. The 105th Annual Exhibition. January 23 to March 20.

1910 NEW YORK Montross Gallery (550 Fifth Avenue). "Loan Exhibition of Pictures by T. W. Dewing, A. H. Thayer, D. W. Tryon, and J. A. McNeill Whistler." February 10 to 26.

1910 BERLIN AND MUNICH Könighliche Akademie der Künste (Royal Academy of Arts), Berlin, and Könighliche Kunstverein (Royal Art Society), Munich. Ausstellung Amerikanischer Kunst (Exhibition of American Art). Spring.

1910 PITTSBURGH Carnegie Art Galleries, Carnegie Institute. The Fourteenth Annual Exhibition. May 2 to June 30.

1910 ANN ARBOR University of Michigan, Alumni Memorial Hall. "Exhibition of Oriental and American Art, under the Joint Auspices of the Alumni Memorial Committee and the Ann Arbor Art Association." May 11 to 30.

1910 BUFFALO The Buffalo Fine Arts Academy, Albright Art Gallery. The Fifth Annual Exhibition of Selected Paintings by American Artists. May 11 to September 1.

1912 TOLEDO Toledo Museum of Art. The Inaugural Exhibition. January 17 to February 12.

1912 KANSAS CITY Kansas City Exposition. January.

1912 WASHINGTON, D.C./SMITHSONIAN The National Gallery of Art, Smithsonian Institution. "A Selection of Art Objects from the Freer Collection Exhibited in the New Building of the National Museum." April 15 to June 15.

1912 WASHINGTON, D.C./CORCORAN The Corcoran Gallery of Art. "Fourth Exhibition of Oil Paintings by Contemporary American Artists." December 17, 1912, to January 26, 1913.

1913 NEW YORK/MONTROSS Montross Gallery. "Exhibition of Pictures by D. W. Tryon." January 20 to February 1.

1913 NEW YORK/AM. ART ASSOC. American Art Association. "Collection of American Paintings formed by the Widely Known Amateur William T. Evans, Esq., of New York." March 26 to April 2.

1915 MINNEAPOLIS The Minneapolis Institute of Arts. The Inaugural Exhibition. January 7 to February 7.

1915 SAN FRANCISCO Panama-Pacific International Exposition, Department of Fine Arts, United States Section. February 20, 1915, to December 4, 1916.

1916 NORTHAMPTON, MASS. Smith College. Exhibition of the "Sea Moods" pastels. February.

SELECTED BIBLIOGRAPHY

American Art
Association 1913

Illustrated Catalogue of the Collection of American Paintings Formed by the Widely Known Amateur William T. Evans, Esq. Sale catalogue. New York: American Art Association, 1913.

Bermingham 1975

Bermingham, Peter. *American Art in the Barbizon Mood.* Exhib. cat., National Collection of Fine Arts. Washington, D.C.: Smithsonian Institution Press, 1975.

Bixby Collection/MHS

William K. Bixby Collection, 1872–1934. Missouri Historical Society, St. Louis. Gift of Ralph F. Bixby.

Britannica 1973

Britannica Encyclopaedia of American Art. Chicago: Encylopaedia Britannica Educational Corp., 1973.

Brunk 1981

Brunk, Thomas W. " 'The House That Freer Built.' " *Dichotomy* 3 (Spring 1981): 4–53.

Bryant Papers/AAA

Walter Copeland Bryant (1867–1919) Papers. Microfilm, Archives of American Art, Smithsonian Institution, Washington, D.C. Lent by the Brockton Art Museum (now the Fuller Museum of Art), Brockton, Massachusetts, 1982.

Buffalo 1909

The Buffalo Fine Arts Academy. *Catalogue of the Fourth Annual Exhibition of Selected Paintings by American Artists.* Exhib. cat., Albright Art Gallery. Buffalo: Buffalo Fine Arts Academy, 1909.

Buffalo 1910

The Buffalo Fine Arts Academy. *Catalogue of the Fifth Annual Exhibition of Selected Paintings by American Artists.* Exhib. cat., Albright Art Gallery. Buffalo: Buffalo Fine Arts Academy, 1910.

Buffalo Academy
Notes 1910

"The Fifth Annual Exhibition of Selected Paintings by American Artists." (Buffalo Fine Arts) *Academy Notes* (July 1910): 7–15.

Burke 1980

Burke, Doreen Bolger. *American Paintings in the Metropolitan Museum of Art.* Vol. 3, *A Catalogue of Works by Artists Born between 1846 and 1864.* New York: Metropolitan Museum of Art in association with Princeton University Press, 1980.

Caffin 1902

Caffin, Charles Henry. *American Masters of Painting: Being Brief Appreciations of Some American Painters.* Garden City, N.Y.: Doubleday, Page and Company, 1902.

Caffin 1905

Caffin, Charles Henry, "The Story of American Painting: Development of Foreign Influence." *American Illustrated Magazine* (December 1905): 190–203.

Caffin 1907

Caffin, Charles Henry. *The Story of American Painting: The Evolution of Painting in America from Colonial Times to the Present.* New York: Frederick A. Stokes Company, 1907.

Caffin 1909

Caffin, Charles Henry. *The Art of Dwight W. Tryon, An Appreciation.* New York: Forest Press, 1909.

Caffin 1913 Caffin, Charles Henry. *American Masters of Painting*. Garden City, N.Y.: Doubleday, Page and Company, 1913. (Reprint, Freeport, N.Y.: Books for Libraries Press, 1970.)

Carnegie Institute 1898 *The Third Annual Exhibition Held at the Carnegie Institute*. Exhib. cat., Carnegie Art Galleries. Pittsburgh: Carnegie Art Galleries, 1898.

Churchill Papers/ sc Archives Alfred Vance Churchill Papers. Smith College Archives, Smith College, Northampton, Massachusetts.

Churchill, Alfred Vance. "Dwight W. Tryon, M.A., N.A.: Professor of Art, Smith College, 1886–1923." *Bulletin of Smith College Hillyer Art Gallery* (30 March 1924).

———. "Tryon at Smith College, 1886–1923." *Smith Alumnae Quarterly* (November 1952): 8–10.

———. "The Tryon Gallery." *Smith Alumnae Quarterly* (February 1927): 133–40.

Cikovsky and Quick 1985 Cikovsky, Nicolai, Jr., and Michael Quick. *George Inness*. Exhib. cat., Los Angeles County Museum of Art. New York: Harper and Row; Los Angeles: Los Angeles County Museum of Art, 1985.

Clark 1979 Clark, Nichols. "Charles Lang Freer: An American Aesthete in the Gilded Era." *American Art Journal* 11 (Autumn 1979): 54–68.

———. "Charles Lang Freer: Patron of American Art in the Gilded Era." Master's thesis, University of Delaware, 1973.

Connecticut 1971 Museum of Art, University of Connecticut, Storrs. *Dwight W. Tryon: A Retrospective Exhibition*. Exhib. cat. Storrs: University of Connecticut Museum of Art, 1971.

Corn 1972 Corn, Wanda M. *The Color of Mood: American Tonalism, 1880–1910*. Exhib. cat., M. H. De Young Memorial Museum and the California Palace of the Legion of Honor. San Francisco: De Young Memorial Museum, 1972.

Cortissoz, Royal. *American Artists*. New York: Charles Scribner's Sons, 1923.

Cortissoz 1895 Cortissoz, Royal. "Some Imaginative Types in American Art." *Harper's Monthly Magazine* 91 (July 1895): 171–74.

Country Beautiful Foundation 1965 *The Beauty of America in Great American Art*. Waukesha, Wis.: Country Beautiful Foundation, 1965.

Curry 1983 Curry, David Park. "Charles Lang Freer and American Art." *Apollo* 118 (August 1983): 168–79.

Curry 1984 Curry, David Park. *James McNeill Whistler at the Freer Gallery of Art*. New York: W. W. Norton and Co., 1984.

Czestockowski 1982 Czestockowski, Joseph S. *The American Landscape Tradition: A Study and Gallery of Pictures*. New York: E. P. Dutton, 1982.

Detroit 1983 *The Quest for Unity: American Art between World's Fairs, 1876–1893*. Exhib. cat. Detroit: Detroit Institute of Arts, 1983.

Eliot 1957 Eliot, Alexander. *Three Hundred Years of American Painting*. New York: Time, 1957.

Freer Gallery of Art 1967 "Paintings, Pastels, Drawings, Prints, and Copper Plates by and attributed to American and European Artists together with a list of Original Whistleriana, in the Freer Gallery of Art." Compiled by Burns A. Stubbs. *Freer Gallery of Art Occasional Papers* 1, no. 2 (1967): 7–11.

Freer Papers/FGA Charles Lang Freer (1854–1919) Papers. Freer Gallery of Art/Arthur M. Sackler Gallery Archives.

Gerdts, Sweet, and Preato 1982 Gerdts, William H., Diana Dimodica Sweet, and Robert R. Preato. *Tonalism: An American Experience*. Exhib. cat., Grand Central Art Galleries, N.Y. New York: Grand Central Art Galleries Art Education Association, 1982.

Hamlin, Talbot Faulker. "The Tryon Art Gallery—An Appreciation." *Bulletin of Smith College Museum of Art* (15 June 1926).

Hartmann 1902 — Hartmann, Sadakichi. *A History of American Art*. 2 vols. Boston: L. C. Page and Company, 1902.

Hartmann, Sadakichi. [Sidney Allan, pseud.]. "Repetition with Slight Variation." *Camera Work* 1 (January 1903): 30, 33–34. Reprinted in *The Valiant Knights of Daguerre: Selected Critical Essays on Photography and Profiles of Photographic Pioneers*, edited by Harry W. Lawton and George Knox. Berkeley: University of California Press, 1978.

Hartmann, Sadakichi. "W. D. [*sic*] Tryon. A Painting in Prose." *Art News* 1 (April 1897): 1–2.

Hayward 1978 — Hayward, Mary Ellen [Yehia]. *Dwight W. Tryon: An American Landscape Painter*. Ph.D. diss., Boston University, 1977. Ann Arbor: University Microfilms, 1978.

Hayward 1979 — Hayward, Mary Ellen. "The Influence of the Classical Oriental Tradition on American Painting." *Winterthur Portfolio* 14 (Summer 1979): 107–42.

Hobbs 1977 — Hobbs, Susan. "A Connoisseur's Vision: The American Collection of Charles Lang Freer." *American Art Review* 4 (August 1977): 76–101.

Hunt 1875 — *W. M. Hunt's Talks on Art*. Compiled by Helen M. Knowlton. Boston: Houghton and Company, 1875.

Isham, Samuel, with supplemental chapters by Royal Cortissoz. *The History of American Painting*. New York: Macmillan, 1927, 1944.

Jackman 1940 — Jackman, Rilla Evelyn. *American Arts*. Chicago: Rand McNally, 1940.

Kingsley — Kingsley, Elbridge. "Life and Works of Elbridge Kingsley, Painter-Engraver." Unpublished manuscript. Forbes Library, Northampton, Massachusetts.

Littmann 1923 — Littmann, Minna. "Man Who Disappointed Mark Twain." *New Bedford* (Mass.) *Sunday Standard*, 19 August 1923, Tryon Papers/FGA.

Littmann 1930 — Littmann, Minna. "Padanaram Real Home of D. W. Tryon, Artist." *New Bedford* (Mass.) *Sunday Standard*, 16 November 1930, Tryon Papers/FGA.

Mechlin, Leila. "Contemporary American Landscape Painting." *Studio International* 39 (November 1909): 3–14.

Mechlin 1907 — Mechlin, Leila. "The Freer Collection of Art." *Century Magazine* 73 (January 1907): 357–63.

Merrick 1923 — Merrick, Lula. "Tryon, Devotee of Nature." *International Studio* 77 (September 1923): 498–504.

Michigan 1910 — *Exhibition of Oriental and American Art*. Exhib. cat., University of Michigan, Alumni Hall. Ann Arbor: University of Michigan, 1910.

NAD 1973 — *The National Academy of Design Exhibition Record, 1861-1900*. Edited by Maria Naylor. 2 vols. New York: Kennedy Galleries, 1973.

Novak, Barbara, and Annette Blangrund. *Next to Nature: Landscape Paintings from the National Academy of Design*. Exhib. cat. New York: National Academy of Design, 1980.

Phillips 1918 — Phillips, Duncan. "Dwight W. Tryon." *American Magazine of Art* 9 (August 1918): 391–92.

Richardson 1956 — Richardson, Edgar P. *Painting in America: The Story of 450 Years*. New York: Thomas Y. Crowell Company, 1956.

Rihani, Ameen. "Landscape Painting in America." *International Studio* 70 (May 1920): lxi–lv.

Rossiter Papers/AAA — Thomas Prichard Rossiter Papers, 1840–1956. Archives of American Art, Smithsonian Institution, Washington, D.C. Gift of Mrs. W. T. Bevan, 1957.

Ruge 1906 — Ruge, Clara. "The Tonal School of America." *Studio International* 27 (January 1906): 57–68.

Saarinen 1958 Saarinen, Aline B. *The Proud Possessors: The Lives, Times, and Tastes of Some Adventurous American Art Collectors*. New York: Random House, 1958.

St. Louis 1909 *Fourth Annual Exhibition of Selected American Paintings*. Exhib. cat. St. Louis: City Art Museum, 1909.

Shaw Papers/AAA Edwin C. Shaw (1863–1941) Papers. Archives of American Art, Smithsonian Institution, Washington, D.C. Lent by the Akron Art Institute (now the Akron Art Museum), Ohio, 1976.

Sherman 1917 Sherman, Frederic Fairchild. *Landscape and Figure Painters of America*. New York: Privately printed, 1917.

Sherman 1918 Sherman, Frederic Fairchild. "The Landscape of Dwight W. Tryon." *Art in America* 7 (December 1918): 31–38. Reprinted, New York, 1918.

Sherman 1919 Sherman, Frederic Fairchild. *American Painters of Yesterday and Today*. New York: Privately printed, 1919.

Sutton 1983 Sutton, Denys. "The Lure of the Golden Bowl." *Apollo* 118 (August 1983): 118–26.

Tomlinson, Helen Nebeker. *Charles Lang Freer, Pioneer Collector of Oriental Art*. Ph.D. diss., Case Western Reserve University, 1979. Ann Arbor: University Microfilms, 1981.

Truettner 1971. Truettner, William H. "William T. Evans, Collector of American Paintings." *American Art Journal* 3 (Fall 1971): 50–79.

Tryon Papers/AAA Dwight W. Tryon (1849–1925) Papers. Archives of American Art, Smithsonian Institution, Washington, D.C. Lent by Nelson C. White, Waterford, Connecticut, 1978.

Tryon Papers/FGA Dwight William Tryon Papers. Freer Gallery of Art/Arthur M. Sackler Gallery Archives.

Tryon Papers/SC Archives Dwight William Tryon Papers. Smith College Archives, Smith College, Northampton, Massachusetts.

Tryon, Dwight W. "Benjamin Rutherford Fitz." Introduction, *Catalogue of Paintings by the Late B. R. Fitz, April 21–22, 1892*. Exhib. cat., Fifth Avenue Galleries. New York: John G. Rankin, 1892.

Tryon 1896 Tryon, Dwight W. "Charles-François Daubigny." In *Modern French Masters: A Series of Biographical and Critical Reviews*. Edited by John C. Van Dyke. New York: Century Company, 1896.

Tryon, Dwight W. "Dwight W. Tryon: List of Pictures by the Artist Since 1909, with the Names of Their Owners." Unpublished typescript, 3 pp. Forbes Library, Northampton, Massachusetts.

Weber, Bruce, and William H. Gerdts. *In Nature's Ways: American Landscape Painting of the Late Nineteenth Century*. Exhib. cat., The Norton Gallery of Art. West Palm Beach, Fla.: Norton Gallery, 1987.

Henry White Papers Henry C. White (1861–1952) Papers, ca. 1925–1954. Archives of American Art, Smithsonian Institution, Washington, D.C. Gift of Nelson C. White, Waterford, Connecticut, 1978.

White, Henry C. "D. W. Tryon—An Appreciation." *Bulletin of Smith College Hillyer Art Gallery* (30 March 1924).

White 1930 White, Henry C. *The Life and Art of Dwight William Tryon*. Boston: Houghton Mifflin Co., 1930.

Nelson White Papers Nelson C. White (1900–1989) Papers, ca. 1875–1951. Archives of American Art, Smithsonian Institution, Washington, D.C. Gift of Nelson C. White, 1959.

Williams 1924 Williams, George Alfred. "The Pastels of Dwight William Tryon, An Appreciation." Unpublished typescript of an essay (1924), Nelson White Papers/AAA.

PAINTINGS BY DWIGHT W. TRYON IN THE FREER GALLERY OF ART

Title/Date	Cat. No.	Acc. No.	Title/Date	Cat. No.	Acc. No.
After Sunset: Looking East, 1915	58	15.131	*A Lighted Village*, ca. 1887	1	06.74
Afternoon, 1915	60	15.133	*A Misty Morning*, 1915	66	16.125
Afternoon Clouds, 1916	67	17.1	*Moonlight*, 1887	2	91.2
April Morning, 1908	37	08.16	*Moonlight*, 1912	45	13.7
Autumn, 1892	10	93.16	*Moonlight*, 1915	64	16.123
Autumn Day, 1907–09	35	09.2	*Moonlit Sea*, 1915	62	16.121
An Autumn Evening, 1908	38	13.33	*Morning*, 1906	29	06.83
Autumn Evening, 1913	47	14.12	*Morning Mist*, 1914	48	14.32
Autumn Morning, 1908–09	39	10.4	*New England Hills*, 1901	24	06.80
Autumn: New England, 1916–17	71	17.201	*Niagara Falls*, 1898	23	06.91
Autumn Night, 1916	69	17.3	*Night*, 1909	40	09.39
Before Sunrise, 1915	61	15.134	*Night*, 1914	49	14.98
Central Park: Moonlight, 1894	14	06.87	*Night: A Harbor*, 1894	18	06.92
Dawn, 1893	12	06.86	*Night: A Landscape*, 1894	17	06.90
Daybreak: May, 1897–98	22	06.78	*Night: The Sea*, 1912	44	12.15
Drifting Clouds and Tumbling Sea, 1915	55	15.128	*Northeast Wind*, 1915	65	16.124
Early Evening: Looking East, 1915	57	15.130	*A Northeaster*, 1915	52	15.125
Early Night, 1903	26	06.93	*Northwest Wind*, 1915	63	16.122
Early Spring in New England, 1897	20	06.77	*November Afternoon*, 1905	27	05.289
East Wind, 1915	51	15.124	*October*, 1908	36	08.22
Easterly Storm, 1907	34	08.1	*Pasture Lands: Early Spring*, 1896	19	00.11
Evening: Late October, 1916	70	16.354	*Portrait of Himself*, 1918	72	17.410
Evening: September, 1912	42	12.7	*The Rising Moon: Autumn*, 1889	3	89.31
The Evening Star, 1905	28	06.82	*Rocks, Sea, and Sky: Morning—Wind* NNE, 1916	68	17.2
Late Spring, 1894	16	06.89	*The Sea: East Wind*, 1906	31	06.264

Title/Date	Cat. No.	Acc. No.
The Sea: Evening, 1907	33	07.151
The Sea: Evening, 1915	50	15.123
The Sea: A Freshening Breeze, 1906	32	06.265
The Sea: Moonlight, 1905	30	06.94
The Sea: Morning, 1892	7	06.85
The Sea: Night, 1892	6	06.84
The Sea: Night, 1915	54	15.127
The Sea: Sunset, 1889	4	06.76
A Shift of Wind from East to Northwest, 1915	53	15.126
Springtime, 1892	8	93.14
Summer, 1892	9	93.15
Sunrise, 1915	56	15.129
Sunrise, 1915	59	15.132
Sunrise: April, 1897–99	21	06.79
Sunset before Storm, 1913	46	14.11
Twilight: Autumn, 1909–10	41	10.11
Twilight: Early Spring, 1893	13	93.12
Twilight: May, 1904	25	06.81
Twilight: November, 1912	43	12.14
Winter, 1893	11	93.17
Winter: Central Park, 1890	5	00.12
Winter: Connecticut Valley, 1894	15	06.88

INDEX

Italic numerals designate page numbers of illustrations.

Photo Credits

The author wishes to thank the museums, archives, libraries, and private collectors who supplied photographs of works of art in their possession and/or granted permission for works in their collections to be reproduced as illustrations. All photographic material was obtained directly from the collection indicated in the caption, except for the following: fig. 36, courtesy R. H. Love Galleries, Inc., Chicago, Ill.; fig. 73, reprinted from *Architecture: The Professional Architectural Monthly* 48 (September 1923): 292; fig. 91, reprinted from *Chinese Painting of the Sung and Yuan Dynasties*, ed. Tokyo National Museum (Kyoto: Benrido Co., 1926), plate 110, by permission of the Chishaku-in Temple and the Benrido Company, Ltd., Kyoto, Japan.

Figures 3, 5, 6, 33, and 65 are reproduced by permission of Nelson C. White. Figure 71 is reproduced by permission of Joanna T. Steichen. All rights to the works illustrated in figures 49 and 56–58 are reserved © The Detroit Institute of Arts, Michigan. All rights to the works illustrated in figures 43, 79, 84, and 85 are reserved © The Metropolitan Museum of Art, New York.

Photographers not cited are: E. Irving Blomstrann, figs. 9, 63; Theodosia Chase, fig. 66; R. S. De Lamater, Hartford, Conn., fig. 10; Davis Garber Photos, New York, fig. 45; C. M. Hayes & Co., Detroit, Mich., fig. 46; Marceau, New York, p. 14 and fig. 2; Maynard Workshop, Waban, Mass., fig. 74; Sarony, New York, fig. 47; Henry C. White, fig. 33; Nelson C. White, fig. 5.

Typeset in Fournier
by Graphic Composition, Inc., Athens, Georgia
Printed on Phoenix Imperial Ivory
by Amilcare Pizzi, S.p.A., Milan, Italy
Edited by Jane McAllister
Designed by Carol Beehler

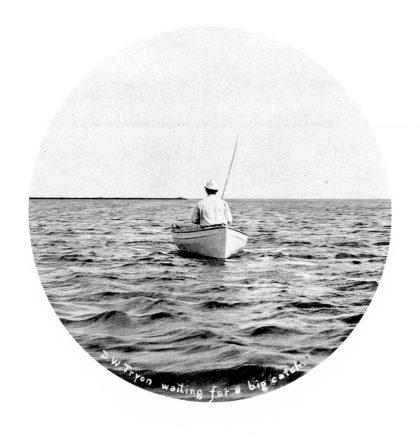

DW Tryon waiting for a big catch.